The ear catches the eye

Music in Japanese prints

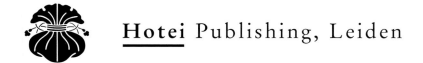

Hotei Publishing, Leiden

Publisher
Hotei Publishing
Zoeterwoudsesingel 56
2313 EK Leiden
The Netherlands
Website: www.hotei-publishing.com

ISBN 90-74822-30-4
NUGI 921

Editorial consultant
Amy Reigle Newland
Perth, Australia

Design
Robert Schaap
Bergeijk, The Netherlands

Printing
Snoeck-Ducaju & Zoon
Gent, Belgium

Photography
Rob Kollaard
Den Haag, The Netherlands

Cover illustration
Keisai Eisen (1791-1848)
A woman plays the *shamisen* (detail) cat. 129

The ear catches the eye
was published in conjunction with the exhibition
Het oor streelt het oog
Gemeentemuseum Den Haag
28 October 2000 - 14 January 2001

Lenders to the exhibition
Rijksmuseum voor Volkenkunde, Leiden
Rijksmuseum, Amsterdam
Josephine Asselbergs-Siebers
Matthi Forrer
Arendie and Henk Herwig
Robert Schaap

Contents

Preface

The exhibition *The ear catches the eye - Music in Japanese prints* at the Gemeentemuseum Den Haag marks one of the last in a series of exhibits and events which have been organised this year to commemorate 400 years of Japanese-Dutch relations. Of the numerous cultural genres and themes that have been presented during these celebrations, the Gemeentemuseum chose to display a selection of Japanese woodblock prints from its own collection. Each of these works are in some way related to music. As Magda Kyrova, Curator of the Gemeentemuseum's Music department and organiser of the exhibition, explains in her introductory essay, these prints can be viewed as an important source of visual information on the Museum's collection of Japanese musical instruments. As such they form a part of the holdings of the Music department.

Our understanding and appreciation of Japanese woodblock prints often centres around their subject matter and design as well as - and perhaps more specifically - their high technical quality. This fact makes them invaluable objects in any print collection. The pieces in the exhibition from the Gemeentemuseum are further enriched by items taken from the Museum voor Volkenkunde (National Museum of Ethnology) in Leiden, a number of important prints from the Print Room of the Rijksmuseum in Amsterdam and a few items from private collections. The works in the show were selected by Magda Kyrova and Matthi Forrer, Curator of the Japanese department at the National Museum of Ethnology and a leading expert on Japanese woodblock prints. In addition to placing Dr Forrer's expertise at our disposal, the National Museum of Ethnology also made the prints selected for the exhibition available for further examination and photography well in advance. Indeed, its cooperation has been so generous that the entire project, encompassing exhibition and catalogue, must be seen as a joint undertaking by the two institutions.

A number of authors, each conversant in his or her own field, contributed essays on the various aspects dealt with in the exhibition: Matthi Forrer wrote detailed descriptions of the prints; Onno Mensink a succinct overview of traditional Japanese music, the focus of the exhibition; Linda Fujie an explanation of festivals and other celebrations which even today form an integral part of Japanese life; Erika de Poorter a view of the diverse elements of Nō theatre; and Thomas Leims an introduction to Kabuki, Japan's 'total theatre'. In the final essay Margarita Winkel paints a picture of the Yoshiwara, the scintillating entertainment quarter which so fascinated print designers and which provided the subject matter for many of their prints.

All of the musical instruments portrayed in the prints are described in the *Checklist of traditional Japanese musical instruments*, written by Paul Wolff and published by the Gemeentemuseum in 1988. The annotated list of instruments in the exhibition catalogue, which was compiled by Onno Mensink, comprises only those instruments which are included in the exhibition and illustrated in the prints.

Very special thanks must be extended to Hotei Publishing in Leiden, in particular to Chris Uhlenbeck and Frank Vermeer. They possessed the insight into the exceptional nature and beauty of the subject which the Gemeentemuseum and the National Museum of Ethnology wished to address in this exhibition. They did their utmost to make time for this publication in a year already exceedingly full of events dedicated to Japan. We are grateful for their hard work, and we hope that museum-goers will enjoy the resulting exhibition and catalogue.

Wim van Krimpen
Director, Gemeentemuseum Den Haag

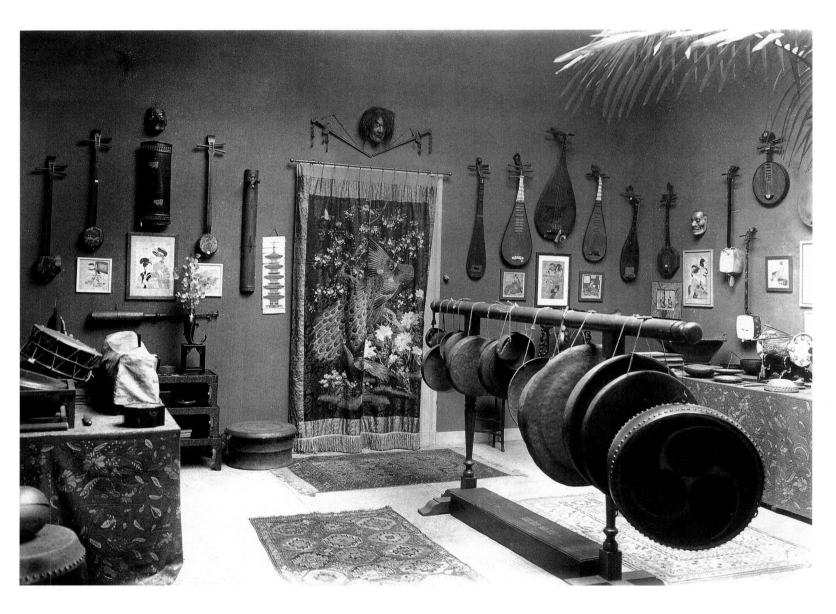

Fig. 1. Display of East-Asian objects in the 'Scheurleer Museum of Music History'. Photograph c. 1920.

Japanese woodblock prints
in the Gemeentemuseum Den Haag

Magda Kyrova

The first exhibition of Japanese prints to be held at the Gemeentemuseum took place in early 1938 on the initiative of the well-known collector Berend Modderman (1870-1944) from Bovenkerk near Amsterdam.[1] Modderman's original idea was to exhibit only a selection of prints from his own collection, but this was expanded at the request of Hendrik E. van Gelder (1876-1960), then director of the Gemeentemuseum, to form a major exhibition of 355 items entitled *Oude Japansche prentkunst* ('Traditional Japanese prints'). The exhibit was accompanied by lectures, guided tours and an illustrated catalogue containing descriptions of every print. Writing in the Museum's Annual report of 1939, van Gelder stated that the '"well-attended" exhibition achieved its aim of bringing to a broad public a well-organised overview of one of the finest art forms the East has had to offer'.[2] In addition to the loans by Modderman were those by other private collectors, including Adolphe Stoclet (1871-1949), Ferdinandus Lieftinck (1879-1959), Gerard Knuttel Jr (1880-1961) and Felix Tikotin (1893-1986). The works from these holdings were augmented by loans from the National Museum of Ethnology in Leiden (Rijksmuseum voor Volkenkunde, Leiden) and the Gemeentemuseum.

The Scheurleer collection

Although the 1938 exhibition was related to the Department of East Asian Art, the Museum's collection of Japanese woodblock prints was at the time under the care of the Department of Music History. The Department of Music History was the predecessor to the present-day Music Department, which is still in charge of the collection. The former was established in 1933 when the Municipality of The Hague acquired the collection of the 'Scheurleer Museum of Music History', the private collection of the local banker and musicologist D.F. Scheurleer (1855-1927). Over the years Scheurleer had assembled a collection that encompassed not only a music library, western and non-western musical instruments but also paintings, prints and drawings

relating to music. The preservation of this multi-faceted collection was now guaranteed by its inclusion in a public museum. Scheurleer had consciously striven to improve upon the coherence of his collection and had amassed visual materials illustrating the use of both European and Japanese musical instruments. He felt that such materials could provide valuable information about the construction of different types of instruments from the West and especially from other cultures as well as about the way they were played. The scenes of music-making depicted in Japanese woodblock prints more than satisfied his desire for information, and he also used them to enliven the display of musical instruments in his museum.

The origin of the Japanese prints in Scheurleer's collection can be traced to some extent from surviving invoices. He bought some prints from antiquarian bookshops like that of Leo Liepmannssohn in Berlin where, in 1898, he purchased not just western prints but also three *Japanische Originaldrucke* ('original Japanese prints') for three marks each. Others were acquired from companies importing *objets d'art* like musical instruments, prints and photographs directly from China and Japan. For example, a 1903 invoice from Rex & Co. of Berlin lists the sum of two marks and ten schillings for *6 Surimonos* and five marks for *5 bunte Photos* ('5 colour photographs', i.e. the hand-tinted photographs common in the late 19th century). Scheurleer probably also bought items at Dutch auction houses like Kleykamp in The Hague and from Dirk Boer's Koninklijke Bazar in the Zeestraat, also in The Hague, though this cannot be proven. What is known for certain is the time-frame within which he built up his collection of Japanese prints and musical instruments. In 1893, for example, the Japanese section of an exhibition of Scheurleer's music collection consisted solely of instruments, whilst the first edition of a picture album dating to 1913 devoted to his house and museum illustrates a number of Japanese prints on display in the gallery containing Asian objects.[3] The second edition of this album, published in 1920, shows a much wider selection of

Japanese prints, photographs and musical instruments (fig. 1).[4] This demonstrates that Scheurleer was collecting Japanese prints between approximately 1895 and 1920.

The 'Scheurleer Museum of Music History' stood in the garden of a house which was built for Scheurleer in The Hague's Laan van Meerdervoort in 1905. In 1917, the Museum was extended from the original four exhibition areas to eight. It was not open to the public, but appointments could be made for guided tours that were led by Scheurleer himself. The displays in each area combined musical instruments with visual materials and were all arranged along the same principle. The different types of musical instruments were hung on the walls and interspersed with framed prints, drawings and photographs. Some of the visual materials related to the instruments on view, but others were quite unrelated in content and merely chosen to create a pleasing symmetrical effect. When the Gemeentemuseum mounted its own displays of musical instruments in 1935, they were installed in much the same way. For example, the musical instruments in the East Asian gallery were interspersed with Japanese prints which, according to a contemporary guidebook, 'clarify the use of these often highly elegant items' (fig. 2).[5] In addition to this permanent(!) display of Japanese woodblock prints in the Department of Music History, the temporary exhibition of prints in 1938 mentioned at the beginning of this essay was followed by a series of such events in the 1950s. However, none of these temporary shows had any direct connection to the then Music Department.

Exhibitions at the Gemeentemuseum Den Haag: 1949-present

Private collectors played a major role in the preparations for temporary exhibitions. The Hague residents, Rob de Bruijn and Felix Tikotin, were particularly important in this respect.[6] They gave advice, made generous loans of prints and wrote catalogue descriptions. The vast majority of the items in the 1949 exhibition of prints and drawings by Utagawa Hiroshige (1797-1858), for example, came from the Tikotin collection.[7] The show was opened by the art critic W. Jos de Gruyter (1899-1979), who wrote the introduction to the exhibition catalogue. He also contributed introductions to the catalogues of the following two exhibitions, held in 1950 and 1952. The 1950 exhibition, *Toneel en Dans in de Japanse Kunst* ('Drama and dance in Japanese art'), included prints, drawings, masks and puppets in addition to several musical instruments from the

Museum's collection. This was followed in 1952 by *Van Moronobu tot Harunobu. Japanse primitieve kunst* ('From Moronobu to Harunobu. Japanese primitive art'). The underlying aim of the exhibition was to demonstrate the significance of traditional Japanese prints to modern European art of the period. The Museum's director, Louis J.F. Wijsenbeek, wrote in the preface of the catalogue that it was 'the aesthetic qualities, which have continued to satisfy our generation … that have once more appealed to young artists in recent years and, following a sharp decline in interest between the wars, have again brought Japanese prints to our attention'.[8]

In 1953, the Museum undertook the theme of the reciprocal influence between East and West with the organisation of a show of prints by Kitagawa Utamaro (1753-1806) to run concurrently with an exhibition commemorating Vincent van Gogh (1853-90). Museums and private collectors in the Netherlands and elsewhere lent their most treasured masterpieces and Jack Hillier (1912-95), an authority on the subject, wrote an introductory article for the catalogue.[9] The 1954 exhibition *Tekeningen van Utagawa Kuniyoshi uit de verzameling van Ferd. Lieftinck* ('Drawings by Utagawa Kuniyoshi from the collection of Ferd. Lieftinck') was possibly the result of a collaboration between Tikotin and de Bruijn. Based on the catalogue of the Lieftinck collection entitled *Drawings by Utagawa Kuniyoshi*, which was written by B.W. Robinson and published the previous year, de Bruijn compiled the catalogue for the Gemeentemuseum's exhibition and delivered a lecture at its opening. Three years later, in 1957, this series of exhibitions of Japanese prints and drawings ended with *Surimono en spookprenten* ('*Surimono* and ghost prints') from the collection of Dr J.L. Addens of Ter-Apel in the Netherlands' northeast. Catalogue entries for this exhibition of 119 *surimono* (de-luxe, privately printed works) and seven ghost prints were provided by C. Ouwehand, then Curator of the Japanese department at the National Museum of Ethnology in Leiden.

Japan continued to be the subject of exhibitions at the Museum from the late 1950s onwards. In 1958, there was a major exhibition of Japanese art, *Japanse kunst* ('Japanese art'), and a smaller one on kimono, and in the 1960s there were several presentations of modern Japanese art. The last was in 1963, when de Gruyter, by that time head of the Museum's Modern Art Department, organised an exhibition of paintings by the eccentric Zen priest-painter Gibon Sengai (1750-1837). It would not be until 1976 that Japanese woodblock prints again featured in the Museum's exhibition programme, this

time in *Japanse prenten met muziek* ('Japanese prints with music'). It was organised by the Music Department and composed entirely of items from its own collections. The Museum was once again assisted by de Bruijn along with fellow collector and The Hague resident Heinz M. Kaempfer. They compiled descriptions of the prints for the accompanying publication.

Another enthusiastic connoisseur of Japanese prints who contributed to an exhibition at the Gemeentemuseum was F.K. Lotgering of Wageningen. He proposed the idea for the exhibition *Kabuki - onbekende aspecten* ('Kabuki: little-known aspects'), which was held in 1982 on the occasion of the Congress of the European Association of Japanese Studies in The Hague. This and the three subsequent small shows in 1983, 1986 and 1991 took place at the Music Department and comprised items from departmental collections. The 1986 exhibit of prints and hand-tinted photographs was designed to celebrate the Museum's hosting of the first conference of the International Council for Traditional Music's Study Group for Musical Iconography. The 1983 display consisted of the Museum's acquisitions of Japanese woodblock prints since 1977.

Private collectors

It is clear from this account that the majority of the above exhibitions could not have been organised without the generous support of private collectors. In this light it is worth noting that Berend Modderman met Felix Tikotin in 1937 during the preparations for the first exhibition of prints to be held at the Gemeentemuseum in 1938. Through Tikotin he came into contact with others interested in Japanese art, including Gerard Knuttel Jr and T. Volker. Together they decided to establish an association for Japanese art enthusiasts, and on 27 November 1937 they founded the *Vereeniging voor Japansche grafiek en kleinkunst* ('Society for Japanese prints and crafts'). The Society still exists today, although under the name *Vereniging voor Japanse Kunst* ('Society for Japanese arts'), and boasts of more than 800 members worldwide. Since 1981, the Society has been responsible for the publication of the magazine *Andon*. In 1987, the Society marked its 50th anniversary with the exhibition *Meiji, Japanese art in transition* at the Gemeentemuseum Den Haag. It principally featured artworks selected from the collections of Society members.

Tikotin was the only art dealer amongst the aforementioned individuals, and as far as is known the Gemeentemuseum never purchased prints from him or indeed from any of the collectors. Their holdings were either sold or bequeathed to other museums, in particular to the Print Room of the Rijksmuseum in Amsterdam. The Rijksmuseum's purchase of the splendid Lieftinck collection in 1956 was the first step towards an active policy of acquiring Japanese prints. The Gemeentemuseum's acquisitions policy in this field, or its lack thereof, was long influenced by the fact that its collection of Japanese woodblock prints was related to music and that it was viewed as having greater documentary than aesthetic value. However, the tide has since turned and as the present exhibition and the essays in this catalogue demonstrate, works of great artistic worth are also invaluable sources of cultural and historical information.

Notes

1. The present-day Gemeentemuseum building was designed by architect H.P. Berlage and opened in 1935.

2. *Mededeelingen van den Dienst voor Kunsten en Wetenschappen der Gemeente 's-Gravenhage* VI ('s-Gravenhage, 1939), 2.

3. *Catalogus der tentoonstelling van muziekinstrumenten, prenten, photografieën en boeken daarop betrekking hebbende* ('s-Gravenhage, 1893).

4. The title of this picture album is *Eene wooninge in welcke ghesien worden veelderhande gheschriften, boeken, printen ende musicaale instrumenten* ('s-Gravenhage, 1913, 1920).

5. Hendrik E. van Gelder, *Gemeentemuseum 's-Gravenhage. Een rondgang door de verzamelingen* (The Hague: Gemeentemuseum 's-Gravenhage, 1937), 52.

6. Rob de Bruijn was a judge and an amateur collector of Japanese prints. See Matthi Forrer, 'Mr. R. de Bruijn as I remember him', *Andon. Bulletin of the Society for Japanese Arts/Vereniging voor Japanse Kunst* LXI (1999), 26-32. Felix Tikotin came to Holland in the 1930s, where he started a gallery for Japanese art. See Rob de Bruijn, 'In memoriam Felix Tikotin 1893-1986', *Andon. Bulletin of the Society for Japanese Arts/Vereniging voor Japanse Kunst* VI (1986), 23, 66-8.

7. *Hiroshige* (The Hague: Gemeentemuseum 's-Gravenhage, 1949).

8. Louis J.F.Wijsenbeek, 'Woord vooraf' in *Van Moronobu tot Harunobu. Japanse primitieve kunst* (The Hague: Dienst voor Schone Kunsten der Gemeente 's-Gravenhage, 1952), n.p.

9. Jack R. Hillier, *Utamaro* (The Hague: Gemeentemuseum 's-Gravenhage, 1953).

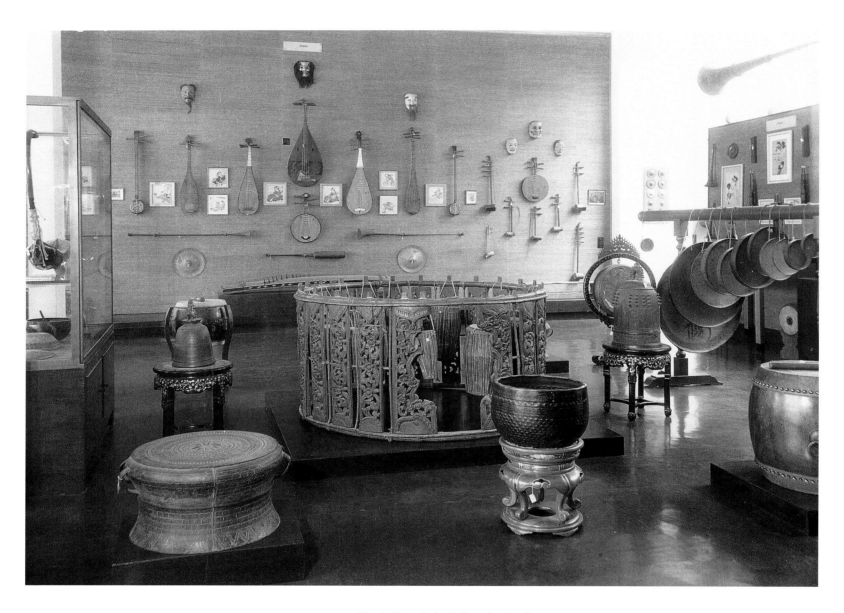

Fig. 2. East Asia Gallery in the Gemeentemuseum.
Photograph c. 1935.

Traditional Japanese musical genres and instruments: their illustration in woodblock prints

Onno Mensink

Introduction

Approximately 1000 years ago, Sei Shōnagon, a lady at the court of the Japanese empress Fujiwara no Sadako (976-1000), wrote the following passage in her notebook: *It is delightful when the dancers move in rhythm with the sacred songs, stamping their feet on the boards of the wooden bridge. The sound of running water blends with the music of the flute, and surely even the Gods must enjoy such a scene.*[1] This lyrical description of a scene of almost intangible beauty brings together a number of disparate, but related, elements to form a single perfect image which expresses an ideal that has underlain Japanese aesthetics for centuries. The musical element therein is determined not only by the presence of sounds deliberately made by musical instruments, specially created for the production of 'music', but equally by the sounds generated by other instruments and objects, or indeed by nature itself. Through the centuries, the Japanese have been sensitive to the presence of ambient sounds and noises, and have succeeded in integrating them with intentionally produced musical sounds to yield a complete 'audio experience'. From daily life at the imperial court and the headquarters of military leaders down to the smallest village or country lane, this has resulted in an integrated sound that could be heard in formal and informal genres of music, story-telling, dance and theatre. The cities and highways of ancient Japan must have been alive with people trying to attract attention by creating a wealth of sounds, be it street vendors, monks, prostitutes, conjurers or clowns, to name a few. One consequence of this was the manufacture of informal 'musical instruments' or rather 'sound-makers'. Sadly, this rich tapestry of background sound is no longer heard in modern Japan.

Historical overview

Sei Shōnagon's sojourn at the imperial court coincided with the middle of the Heian period (794-1185). Her refined tastes were typical of court circles of the time

and were seen in other of her contemporaries such as Lady Murasaki Shikibu, the authoress of the celebrated classic, the *Genji monogatari* ('Tale of Genji', c. 1000). The literary works by these court ladies still number amongst the masterpieces of world literature. The main musical instrument in this exquisite and highly literary setting was the *biwa* (lute), which was used to accompany singing and story-telling. However, the imperial court was also entertained by a formally organised type of court ensemble which played a purely instrumental and rigidly conventionalised music known as *gagaku*.

The *gagaku* court ensemble originated on the East Asian mainland. During the preceding Nara period (710-94), the culture of Tang China (618-907) had an enormous influence on everyday life in Japan: language and writing, urban and political structures, and the arts, including music, were all based on Chinese models. The imperial court at Nara imposed Chinese-style centralised rule upon the country, and its music and musicians originated from China and Korea. By this time both Confucianism and Buddhism had been introduced to Japan, and with them came the music tradition associated with their respective ceremonies. This had a tremendous impact on courtly and popular music, and it was integrated into indigenous Japanese Shinto practices.

The Heian was followed by the Kamakura period (1185-1333) during which time the political power of the imperial court declined as control of the country was increasingly in the hands of military leaders. Buddhism and, in particular, Zen Buddhism, which was popular in military circles, gained enormous ground as a religion and as a philosophy. The significance of imperial court music waned as a result of these developments, and various types of theatre with musical accompaniment became extremely popular, especially with the military. The same was true of the recitation of poems celebrating martial heroes which was performed with a musical accompaniment provided by the *biwa*.

During the Muromachi period (1333-1568), the

power of the emperor remained weak and at the same time the authority of the military leaders also diminished. Local feudal warlords emerged as the country's actual rulers, and clan loyalty witnessed a shift towards loyalty on the local family level. Much of the music of this period was designed as an indispensable accompaniment to the various increasingly popular types of theatre. Dance dramas and acrobatic shows (the predecessors of the Nō theatre) were in great demand.

A number of developments were occurring outside theatres that would lead to the future flowering of Japanese music. These included the existence of itinerant story-tellers who created their own musical accompaniment or employed others to provide it, the introduction of the *shamisen* from the Ryūkyū islands in southern China and the improved production of the *koto* and *shakuhachi*. In short, conditions were set for the evolution of traditional Japanese music into the form which we know today.

The flourishing of traditional Japanese music came about during the Tokugawa period (1600-1868) when the shogun Tokugawa Ieyasu (1542-1616) took steps to effectively cut off Japan from the outside world. In its isolation Japan was forced to rely on its own strengths. There was a boom in 'bourgeois' art forms, particularly in cities like Edo (present-day Tokyo), Kyoto and Osaka, and urban areas offered great scope for all kinds of cultural events and entertainment. Nō, Bunraku, Kabuki and many other types of theatre provided townspeople with numerous opportunities for amusement, of which music was an inextricable part. This world is richly illustrated in Ukiyo-e prints as testified by the selections in the current exhibition. At the same time, urban culture spawned the rapid development of the repertoire for solo instruments like the *koto*, *shakuhachi* and *shamisen*. Their repertoires were wide ranging, both in solo and group performances. There was additionally the 'hidden landscape' of Japanese folk music, anonymous, but omnipresent and persisting through the centuries. Less subject to political constellations and social changes than music in urban areas, Japanese folk music has remained relatively unchanged. It has preserved a wealth of different instruments and local genres.

The end of the Tokugawa period and the dawning of the Meiji (1868-1912) coincided with the end of Japan's isolation and with the start of a new era of increasingly close contact with western culture. The beginning of the Meiji period was marked by an event, whose musical

accompaniment was portentous. During the Meiji the imperial house was restored to its previous dignity and was once again at the centre of public life. Accordingly, in the spring of 1869 when the procession conveying the emperor's palanquin could be seen advancing along the Tōkaidō, the main east-west highway from Kyoto to Tokyo, the British regimental band was summoned to greet it in the vicinity of Yokohama. It was such that the imperial party entered Tokyo and the 'new era' to the tune of 'The British grenadiers'![2]

The resulting large-scale assimilation of western cultural elements by the Meiji Japanese included the introduction of western concepts into traditional Japanese music. This spelt the end of this extraordinary wealth and variety of sound. The exposure of Japan to western musical influences resulted in an experimentation with new musical forms and instruments resembling those in the West. Families of instruments, for example, were constructed comparable to the western family of stringed instruments including the violin, viola, cello and double bass. These new-style instruments had lost all links with the traditional ideals of Japanese music, and the development of this new musical taste caused the disappearance of the informal sound-makers of the past. Reduced in number and diversity, they survived only as *gezabayashi* (the 'sound effects' ensemble) of the Kabuki theatre, where they can still be heard played in the wings.

Genres and musical instruments

The woodblock prints in this exhibition are the product of the culture of the Tokugawa period. They illustrate scenes of music-making or scenes containing musical elements that are drawn from everyday life and from famous contemporary Nō, Kabuki and Bunraku plays featuring stories from the past. Some portray contemporary actors or courtesans performing within some kind of musical context or as in the case of *surimono* (de-luxe, privately printed works) musical instruments within an exquisite literary context. Musical instruments can be depicted in contemporary situations or in settings which were even by the Tokugawa period historical in nature. It may be useful, therefore, to place the instruments within their cultural and musical context, and to discuss select examples in greater detail.

Religious music: Buddhism and Shinto

The primary religions in Japan prior to the Meiji restoration in 1868 were the various Buddhist sects, the

most important being Tendai, Shingon, Amidism and Zen, and an array of indigenous beliefs and practices collectively known as Shinto. Originating in India, Buddhism was introduced to Japan from China in the mid-6th century. The earliest datable mention of the use of music as relates to the recitation of Buddhist prayers dates from 720.[3] The term for the Japanese Buddhist technique of chanting, *shōmyō*, was derived from the Chinese translation of the Sanskrit word *sabdavidya*. There was constant interaction between the differing Buddhist sects, although practices within them varied. Moreover, there was an influence on certain more worldly musical genres. One such example is *heikyoku*, the recitation of ballads from the *Heike monogatari* ('Tale of Heike', early Kamakura period) that was accompanied by the *heike biwa* (see below). The Tendai and Shingon schools still represent the major classical trends within *shōmyō*.

The name Shinto (literally, 'the way of the gods') was adopted after the introduction of Buddhism to Japan in order to distinguish native cults and rites from the 'new' religion. Shinto possesses its own distinctive musical forms that are collectively known as *kagura*. The first historical accounts of these date from the second half of the 8th century when musicians practising the genre were appointed to the imperial court. *Mi-kagura* belongs to the repertoire of court music and is distinct from *sato kagura* in which older ritual elements can be traced. *Sato kagura* is still performed in countless temples and shrines throughout Japan (see also essay by Linda Fujie). One form of *sato kagura* is *yamabushi kagura*, so named after the *yamabushi* priests who used to wander the mountains carrying and blowing on *horagai* (shell trumpets). *Sato kagura* was originally performed in open air, but later in special halls which imbued the performance with a more theatrical character. The musical instruments usually employed for *sato kagura* included *taiko* ('drums'), *fue* ('flutes') or *yokobue* (literally, horizontal blown *fue*) and *suzu* (bell tree).

Court music: gagaku

The term *gagaku* (literally, 'elegant music') is employed to describe a type of court music. It is divided into *kangen* (music played only by an instrumental ensemble); *bugaku* (dance music); *saibara* and *rōei* (songs and chants); and *kagura* (the repertoire for Shinto rituals, see above). The composition of the ensembles for *kangen* and *bugaku* varies somewhat. As a rule the instruments in the largest ensembles can be classed into three groups: wind instruments (three of each), stringed

instruments (two of each) and percussion instruments (one of each).

The wind instruments include a *ryuteki* (flute), *hichiriki* (double-reed instrument) and *shō* (mouth organ); the stringed instruments a *gakusō* (zither) and *gaku biwa* (lute) and the percussion instruments a *kakko* (double-headed drum), *shoko* (bronze gong, and *tsuridaiko* (large double-headed drum, and in *bugaku*). The *kakko* player is the leader of the ensemble. Stringed instruments are omitted when the music accompanies dance. For dance music originally from Korea the *ryuteki* is replaced by the *komabue* (a slightly shorter flute with six rather than seven finger-holes) and the *kakko* by the *sanno tsuzumi* (a double-headed drum with a body shape different from the *kakko* [not illustrated]).

When *gagaku* was introduced during the Nara period, the ensemble is said to have consisted of more than eighteen kinds of musical instruments. The standard format today was established early in the Heian period. The gradual decline in imperial power over the centuries led to some neglect of *gagaku*. Not surprisingly, however, this 'exclusive imperial ensemble' regained its previous position and standard of performance following the Meiji restoration. In 1959, the official *gagaku* court ensemble made its first trip abroad, touring the United States. Since then it has made numerous appearances worldwide. In Japan several *gagaku* ensembles have been founded as off-shoots of the official court ensemble.

The biwa

The aforementioned *biwa* refers to a type of lute which originated in China (there known as *pipa*); it was imported to Japan as part of the *gagaku* ensemble. The use of the *biwa* was extended during the Heian period to include the accompaniment of Buddhist chanting, and it became known as the *moso biwa* in that it was played by *moso* (blind priests). The *moso biwa* is rarely played today.

From the early Kamakura period onwards, the *biwa* was employed as an accompaniment to recitations of the epic *Tale of Heike* which dramatically accounts the feud between the medieval Taira and Minamoto clans. The violent narrative and moods of this piece are underlined to great effect by the *heike biwa*. Smaller than the *gaku biwa* but larger than the *moso biwa*, the *heike biwa* is the most frequently played form of the *biwa* today. Other variants such as the *satsuma biwa* and the *chikuzen biwa*, named after the former provinces of Satsuma and

Chikuzen respectively, were devised in the Meiji period. They have slimmer bodies, thinner strings and a lighter timbre than the other types mentioned above. Moreover, they are held in a slightly more upright position and unlike earlier types are played by holding down the strings between the frets rather than on them. It is clear from the appearance of the *gaku biwa* that the instrument is composed of two separate parts: the underside of the body which, along with the neck, is formed from a single piece of wood and hollowed out, and a slightly undulating sound board which is glued onto the underside. By contrast, the *heike biwa* neck is made from a separate piece of wood. The three or four strings are stretched over the sound board which is protected by a *bachigawa* (a strip of cloth or leather). The *bachigawa* prevents damage from the sharp edges of the *bachi* (plectrum), which can be used with great gentleness and subtlety or with considerable force. This protective strip is very often so beautifully ornamented that the player may well avoid the decorated area when striking the strings. The *bachigawa* is such a striking feature of the instrument that its fine decorative detail is frequently depicted in prints (ills. 4, 6, 76).

Theatre: Nō, Bunraku and Kabuki

Nō

Of the three major types of Japanese theatre (Nō, Bunraku and Kabuki), Nō is the oldest and dates back to the late 14th and early 15th centuries (see also essay by Erika de Poorter). The music associated with Nō is one of the most important genres within traditional Japanese music. It has had a major influence on the music of the Kabuki and Bunraku theatres and on instrumental music for the *koto*. Nō includes solo singing by the principal actor, the *shite* ('player'); intoned monologues and dialogues by the *shite* and supporting actors, the *waki* ('side'); singing by a chorus and an instrumental accompaniment provided by three or four musical instruments that make up the *nōhayashi*.

The four instruments of the Nō ensemble are the *nōkan* (flute), *kotsuzumi*, *ōtsuzumi* and *shimedaiko* (each a type of drum). The *nōkan* is a flute (a type of *fue* or *yokobue*) specific to the *nōhayashi* and equipped with seven finger-holes. The player covers these with the middle phalanx rather than the fingertips, a technique clearly illustrated in many prints by Yoshitoshi (ills. 43-45, 47) and one which enables the production of a special intonation. The drums can be divided into two types: the *tsuzumi* and the *shimedaiko*. They have wooden

bodies with skins attached at both ends that are kept taut by bracing hoops and ropes. The difference between the two types lies chiefly in the shape of the instrument body and the manner in which they are played. The form of the body of the *tsuzumi* resembles an hourglass and is held with the left hand and struck with the right, whilst the *kotsuzumi* (literally, 'small drum') is positioned on the right shoulder and the *ōtsuzumi* (literally, 'big drum') on the left hip. By contrast, the *shimedaiko* is more barrel shaped; it is hung on a stand (*shimedaiko* literally means 'hanging *taiko*') and beaten with two sticks. In each case, the players use the highly formalised gestures appropriate to the stylised environment of Nō that produce very effective and specific sounds. Some of the attitudes and gestures of the drummers are so striking that they are recognisable in woodblock prints. The imagery in prints also demonstrates that many of the instruments belonging to these formally organised ensembles could also be played in much more casual situations. Illustration 50 depicts a complete *nōhayashi* and a pair of cymbals being played during a ceremonial court occasion, whilst illustration 73 shows the same combination in a totally non-theatrical setting.

Bunraku

The term 'Bunraku' refers to all the major types of Japanese traditional puppet theatre. The word is derived from Bunrakuken (the stage name of Masai Yohei, 1737-1810), who introduced the tradition of puppet theatre from the island of Awaji to Osaka in the 18th century. His successor Bunrakuken II (the stage name of Masai Kahei, c. 1784-1819) founded a theatre near the Inari Shibai temple in Nanba Jinja near Osaka and even today Osaka remains the leader in Japanese puppetry. The main musical genre associated with the puppet theatre is *jōruri*, which originated in the narration of the 15th-century *Jōruri junidan sōshi* ('Tale of Lady Jōruri in twelve episodes'). Tales of this kind were initially accompanied on the *biwa* and later on the *shamisen*.

In 1648, the famous piece *Yotsugi no Soga*, written by playwright Chikamatsu Monzaemon (1653-1724), was produced with music written by Takemoto Gidayū (1651-1714). Takemoto's music was called *gidayū bushi* to distinguish it from the numerous other sorts of *jōruri* then being played in competing theatres. Today there are four types of *gidayū* performance: that which accompanies Bunraku, in Kabuki, in concerts or recitals and as dance music.

In Bunraku theatre, *gidayū* is performed by a *tayu* (singer) and an accompanist on the *shamisen*, who

always sits to the left of the singer. The singer and his accompanist sit to the left of the stage entrance and are almost totally concealed from the audience. The *gidayū shamisen* is the largest *shamisen*. It possesses a considerably heavier sound than that produced by the *shamisen* used for the genres associated with Kabuki and in chamber music (see below). Its heavy timbre is perfectly suited to the dramatic singing and recitation of the *tayu*.

Kabuki

Kabuki is a truly popular form of drama and at the same time 'total theatre' (see also essay by Thomas Leims). Its musical accompaniment is provided by two ensembles: the *debayashi*, which performs on stage in full view of the audience, and the *gezabayashi*, which is concealed off-stage. The *debayashi* uses diverse drums, flutes and several different types of *shamisen* music, most commonly the *gidayū*, *nagauta*, *kiyomoto* and *tokiwazu*. When plays derived from the Bunraku repertoire are performed, a *gidayū* singer and his *shamisen* accompanist sit at side-stage and provide commentary on the action taking place on the main stage. However, when plays from the Nō repertoire are included in the programme, the musical accompaniment is provided by a *hayashi* ('ensemble'). They are lined up in a single row at the back of the main stage and equipped with twice the normal number of Nō instruments. The invisible off-stage *gezabayashi* sets the mood for the play by providing background music and, more importantly, provides suitable sound effects to accompany the on-stage action. Many of its instruments produce sounds strongly reminiscent of historical and literary situations, and still recall the rich tapestry of sound against which Japanese life took place in the past. They include instruments and implements that evoke the surroundings of a temple such as a temple bell (*denshō*), the imitation of wind or rain, the rattle (*tokei*), bell tree (*suzu*), jingle stick (*ekiro*) or bell (*kane*) of an itinerant monk; a joyful, sprightly scene through the xylophone (*mokkin*); dramatic action with loud noises via wood blocks (*tsukegi*) or that provide signals (*hyōshigi*). There are also drums in endless shapes and sizes, as used in folk music and at festivals, to produce varying timbres having particular effects and to call forth specific atmospheres.

'Chamber music': koto, shakuhachi, shamisen, and kokyū

Mention has already been made of the various styles of solo *biwa* playing. The *koto*, *shakuhachi* and *shamisen* are three other instruments with large repertoires for both solo and combined performance. The ensemble form, known as *sankyoku* ('music for three'), a name referring to the three separate melodic instruments, is a fine example of Japanese chamber music.

Koto

The *koto* is an elongated zither, most commonly with thirteen strings. These are stretched over movable bridges which can be adjusted in advance to achieve the desired series of tones. Similar to the *biwa* the *koto* originated in China; it is frequently cited in the *Tale of Genji* and the *Tale of Heike*. Several *koto* schools were established in the early 16th century, and this development marked the beginning of a very popular solo genre. A famous composer for the *koto* was the blind Yatsuhashi Kengyo (1614-85). Some of his popular compositions still figure in the contemporary repertoire. The two major schools of *koto* performance are the Yamada and Ikuta, who differ in technique and interpretation.

The strings of the *koto* are plucked using plectrums resembling long, reinforced nails that are attached to finger-stalls worn on the thumb, the index and middle finger of the right hand. The plectrums of the Yamada school are slightly rounded, whilst those of the Ikuta school are rectangular. Specific details like these are clearly visible in a number of prints (ills. 1, 109). The fingers of the left hand can be used to vary the tension and hence modify the pitch by depressing the strings to the left of the bridges. The resulting sound is highly distinctive and characteristic of *koto* music, and the easily recognisable gesture of the left hand is frequently depicted in prints (ills. 15, 109). *Koto* music is collectively known as *sōkyoku*, but this is broken down into *shirabemono* (purely instrumental compositions) and *jiuta*. *Jiuta* is the principle form of *koto* music. Its compositions include both purely instrumental passages and vocal passages with instrumental accompaniment.

Shakuhachi

The *shakuhachi* is an end-blown notched bamboo flute. It, too, is said to have come from China during the Nara period, as part of the *gagaku* ensemble. However, there is no evidence to substantiate this, and the story is

unlikely in view of the instrument's quiet tone which makes it better suited to solo use. The main development in *shakuhachi* music occurred during the Tokugawa period when the instrument became widely known, in particular, at the hands of wandering monks. It became increasingly popular as a solo instrument with an extended repertoire of its own that is divided into three categories: *honkyoku* ('original music'), consisting of the 'classic' compositions of the past; *gaikyoku* ('music from outside'), derived from the repertoire of the *shamisen* and *koto*; and *shinkyoku* ('new music'), an extensive and still growing repertoire written especially for the *shakuhachi* and including many experimental 'western-style' compositions.

The *shakuhachi* is made from the culm of a bamboo, just at the place where it bends as it emerges from the ground and where the root system is cut off. The resulting structure of the bamboo, so important to the appearance of the instrument, is often precisely depicted in prints (ills. 99, 104). The size and strength of the bamboo *shakuhachi* also made it an effective weapon! In this role it was frequently associated with ronin, the masterless samurai of the Tokugawa age. Forbidden to carry swords, ronin armed themselves instead with *shakuhachi*. These vagrants with their musical weapons figured quite prominently in the Kabuki theatre and were striking enough to be portrayed in woodblock prints (ill. 99).

Shamisen

The *shamisen* or *sangen* is a three-stringed lute with a long neck and a wooden body tightly covered with catskin on the front and back. Like most instruments originating from China, the *shamisen* (Chinese: *san xian*) was imported to Japan during the late Muromachi period via the Ryūkyū islands. The *shamisen* was initially played by itinerant story-tellers, and it is within the story-telling genre that the *shamisen* comes into its own. As mentioned above, the story-telling genre of *jōruri* derived from a predecessor of the Bunraku puppet theatre. The *shamisen* was also frequently employed to accompany popular songs and ditties, giving rise to the *utamono* (lyrical *shamisen* music) genre. Songs of this kind were known as *ko-uta* ('short songs') and were a favourite sentimental genre of the late Tokugawa period. In addition to its recurrent use in the theatre, the *shamisen* also became immensely popular as an instrument played by geisha in the pleasure quarters in cities like Edo, Osaka and Kyoto (see also essay by Margarita Winkel). The numerous prints illustrating

geisha with their instruments or with *shamisen* cases bear witness to this fact. This merits a more detailed discussion of this instrument and the manner in which it is depicted.

Judging from the countless Ukiyo-e portraying geisha making music, it is safe to assume that print designers were frequent visitors to the places where geisha entertained and that geisha playing and handling the *shamisen* were a familiar, and no doubt charming, sight. Woodblock prints depict the diverse use of the *shamisen*. They present a series of 'snapshots' of the instrument's preparation before playing and details of actual performance. In addition, they give an accurate picture of the instrument's construction. For example, illustration 149 demonstrates the exact composition of the *shamisen* with a body and a neck which passes through the body with a curve and emerges as a stump to which the strings are attached with elegantly knotted fabric (see e.g. ills. 143-4). There is a pegbox and three pegs at the top of the neck. Below this is a broader area of the neck, which is visible in woodblock prints. Three strings are stretched over a bridge, which is clearly positioned on the lower part of the catskin front. The prints additionally show an extra preformed, in this case black, cover strapped to the side of the body of the instrument so as to prevent perspiration from the player's right forearm dulling the magnificent cherry wood and impeding the player's efforts (for a view of the position of the player, see e.g. ill. 25). Illustration 122 also portrays a semi-circular patch of skin (the *bachigawa*) placed under the strings; this hinders damage by the sharp points of the plectrum to the underlying catskin (see also above relating to the *biwa*). Moreover, the parts of two *shamisen* can be seen hanging on the wall, the body of one enveloped in a sheath.

Illustration 140 shows a *shamisen* case being transported, probably to a client, whilst in illustration 150 the instrument is being removed from the case or possibly returned to it. A broken string is being replaced in illustration 24 and in illustration 29 the string is being wound onto the peg so that it can be tuned (the operation seen in ills. 28, 30). Finally, in illustration 126 the taut strings passing over the neck are being rubbed with a cloth to warm them and so prevent them from expanding and going out of tune whilst the instrument is being played. Prior to playing, the bridge is positioned under the strings (ill. 31), after which the music can begin (ills. 129, 146).

Despite careful preparations, strings often go out of tune and the player uses the pegs to retune them

without interrupting the music (ill. 141). The music played by geisha generally consisted of a series of songs with instrumental accompaniment, interspersed with purely instrumental passages. Countless other prints show similar actions and scenes. The shape of the plectrum is clearly depicted (ill. 26, in the player's hand, and ill. 143, lying on a pile of tissues), and in illustration 25 a hairpin is being used as a plectrum. That a *shamisen* is constructed of separate components that can be dismantled for transport is deducible from the *surimono* in illustration 27.

In addition to the many prints that portray the *shamisen* being played by a seated figure, there are also examples of ambulatory musicians, as seen in the diptych in illustration 82, together with similar players of the *kokyū*. The differences in size of the two instruments and the attitudes of the players are clear in illutrations 128-9. These last two prints belong to a triptych or possibly pentaptych from which the centre sheet is missing. Part of a *koto* can still be seen in the right-hand sheet, and from this it can be concluded that the composition was of a *sankyoku* ensemble.

Kokyū

As mentioned above, the *koto*, *shakuhachi* and *shamisen* were oftentimes played together, and this *sankyoku* genre was highly developed. Today many pieces are still being composed for such ensembles, either alone or in combination with other acoustic or electronic instruments. During the Tokugawa period, the traditional combination was sometimes varied by replacing the *shakuhachi* with an entirely different instrument, the *kokyū* (ills. 17, 128).

This *kokyū* is the only bowed Japanese instrument. Its shape and construction are identical to the *shamisen*, albeit somewhat smaller. Due to this size difference the *kokyū* is thinner in sound, and for this reason the top string is sometimes doubled to strengthen the sound. In that the *kokyū* is a bowed instrument, its bridge contrasts that of the *shamisen* as it is not placed on the lower part of the catskin front but higher up. This difference in position is occasionally overlooked by print designers as seen in illustration 17.

Other details of the instrument are also portrayed in prints. For example, illustrations 1 and 3 additionally depict *sankyoku* ensembles, in both cases still preparing their instruments before playing. In illustration 1 the *shamisen* is being tuned up, whilst the *koto* player is fitting the plectrums onto her fingers. The shape of the plectrums suggest that they are of the Yamada school.

The *kokyū* player is not yet holding the instrument in the playing position. In fact, the hairs are still hanging loose from the bow. Illustration 3 portrays a similar scene. All the pictures of *sankyoku* ensembles in this exhibition are of those with the *kokyū* rather than the *shakuhachi*. But this is not an accurate reflection of how things actually were. The *kokyū* was never particularly popular, and in the street music of the Meiji period it was replaced by a saxophone. Recently, however, the instrument has made something of a comeback.

Conclusion

To a superficial observer, the products of the music industry serving the modern Japan of Emperor Akihito seem virtually identical to those in the western world. The only difference is that they are heard in a Japanese setting. The visitor wishing to attend a symphony concert, a string quartet performance or a recital of Lieder in Tokyo or Osaka will have no difficulty in finding performances of that kind, though procuring tickets may well be another matter! The same experience may await the fan of Big Band, Heavy Metal or House Music. Similarly, the connoisseur of modern Japanese music will find performances of *gendai hogaku* (contemporary compositions in a traditional Japanese idiom), where he or she will encounter like-minded enthusiasts. And of course a visit to a Nō, Bunraku or Kabuki theatre will still provide enjoyment for those wishing to experience traditional musical genres as would a trip to any of the countless traditional festivals. But what if you want to experience the last echoes of the almost vanished soundscape of the distant past? There is only one way to accomplish this. Trek out into the mountains one rainy day. Take a moment to pause on a pathway leading to a temple, sit down on a stone, shut your eyes and listen to the tolling of the temple bell as it merges with the other sounds of the world around you.

Notes

1. Ivan Morris (ed. and trans.), *The pillow book of Sei Shōnagon* (Harmondsworth, UK: Penguin Books, 1976), 161.

2. Richard Storry, *A history of modern Japan* (Harmondsworth, UK: Penguin Books, 1975), 104.

3. G.B. Sansom, *Japan, a short cultural history* (Stanford, CA: Stanford University Press, 1978), 20 sqq.

Suggestions for further reading

Kishibe Shigeo. *The traditional music of Japan*. Tokyo, 1984.

Malm, William. *Japanese music and musical instruments*. Rutland, VT and Tokyo, 1959, 1965.

Mensink, Onno. 'Strings, bows and bridges, some provisional remarks on the *kokyū* in woodblock prints'. *Andon* XV (1984), 1-9.

Mensink, Onno. 'Images of Japanese music, a note on musical iconography in Japanese woodblock prints'. *Mededelingenblad Vereniging van Vrienden der Aziatische Kunst Amsterdam* XIII (1983), 6-11.

Mensink, Onno. 'Hachogane, " 't gebeyer of 't musiek van achten" ', 7-23. *Jaarboek Haags Gemeentemuseum*. The Hague: Gemeentemuseum Den Haag, 1992.

Mensink, Onno. 'Hachogane, "The musick of eight". Andon LVIII (1988), 3-18.

Motegi Kiyoko. *The genesis of sound, the creation of music*. Exh. brochure. Niigata: Niitsu Art Forum, 1999.

Notes to instrument descriptions

In the first line the general Japanese nomenclature of musical instruments has been given.

The second line refers to the West European typology of musical instruments, as given by Erich M. von Hornbostel and Curt Sachs, 'Systematik der Musikinstrumente, Ein Versuch', in *Zeitschrift für Ethnologie*, 4/5, 1914, translated and commented on by Anthony Baines and Klaus P. Wachsmann, 'Classification of musical instruments', in *Galpin Society Journal* XIV, 1961.

Unless otherwise stated, all sizes are given in centimetres.

Fig. 3. *Horagai*
End-blown conch with mouthpiece
38 x 20 (diameter)
Gemeentemuseum Den Haag MUZ-1933-0025

Shell (Latin: *Charonia Tritonis*) with brass mouthpiece pushed onto apex (7 cm long, 4 cm of which cover apex). Round hole (8 mm in diameter) in open edge. Knotted net around shell.

Fig. 4. *Hyōshigi*
Concussion sticks or stick clappers
20 x 3.5 x 2.5 (each)

> Gemeentemuseum Den Haag MUZ-1982-0004 a, b

Two wooden staves, straight in length, oval in section with an axis cut off at right angles at both sides.

Tsukegi
Concussion sticks or stick clappers
23 x 5 x 4 (each)

> Gemeentemuseum Den Haag MUZ-1982-0023 a, b

Two rectangular wooden blocks. Two sides feature incised criss-cross lines.

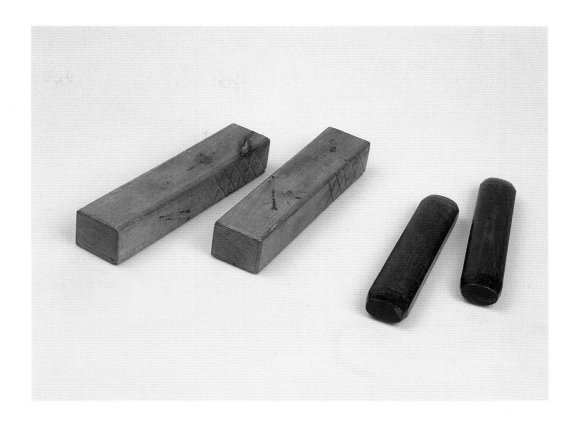

Fig. 5. *Chappa*
Cymbals
1.7 x 9.7 (diameter) (each)

> Gemeentemuseum Den Haag MUZ-1933-0665

Two brass plates with everted rim and central knob. A hole in the middle is used to fasten a cord; they are joined by a cord.

Fusegane
Percussion vessel
5 x 19 (diameter)

> Gemeentemuseum Den Haag MUZ-1933-0937

Bronze plate hollowed out on one side, creating a short cylinder with one closed end. The open side is curved outwards. The front features concentric circles in relief. Two ornamented ears on the rim for hanging; three short legs. Black characters written on the inside. Wooden hammer-shaped beater.

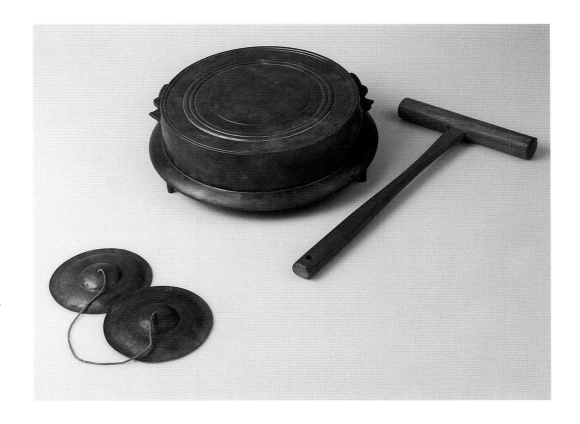

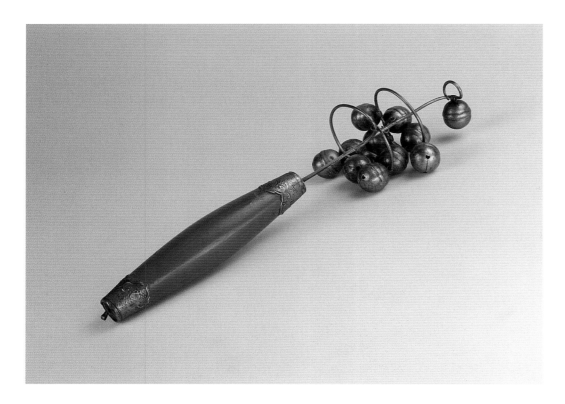

Fig. 6. *Suzu*
Set of vessel rattles (bell-tree)
39 x 8 (diameter)
Gemeentemuseum Den Haag MUZ-1933-0038

A wooden handle, 19.5 cm long, lacquered red, with brass fittings at the top and bottom. The fittings are decorated with cloud motifs in relief. There is a brass eye at the bottom. A brass rod protrudes from the top of the handle and is split into three thick wires. These wires form three successive rings, the lowest one being the biggest and the top one the smallest. Six brass bells hang on the lowest ring, five on the middle ring. The top ring carries a single bell.

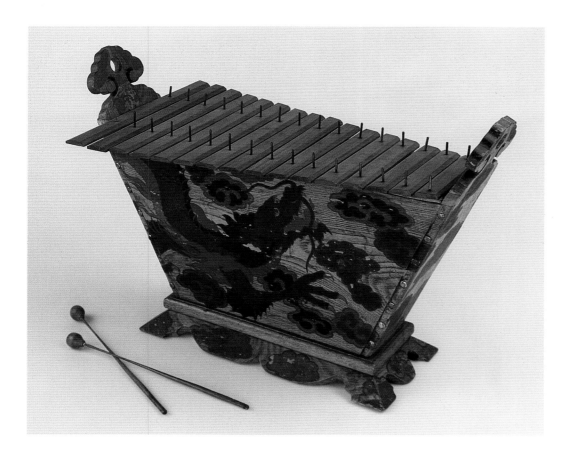

Fig. 7. *Mokkin*
Set of percussion sticks (xylophone)
33 x 51 x 15.5
Gemeentemuseum Den Haag MUZ-1933-0044

A box of paulownia wood (Japanese: *kiri*; Latin: *Pauwlonia imperialis*) on a pedestal. The two sides mounted on the almost rectangular base, lean strongly outwards, whilst the front and back panels lean only slightly outwards. Sixteen copper pins protrude through strips of cloth on top edge of front and back panels. The keys rest on the cloth and are kept in place by the pins. The sides protrude above the horizontal platform formed by the keys and are carved in the form of cloud motifs. Clouds are painted in red, blue and green on outside of the box and pedestal. A green and red rain dragon is painted around the box and set against a gold ground. The instrument has sixteen hardwood keys, each with two holes. All keys are of the same width and thickness, whilst the length varies from 15.5 to 12.5 cm. The two sticks have horn handles and hardwood heads.

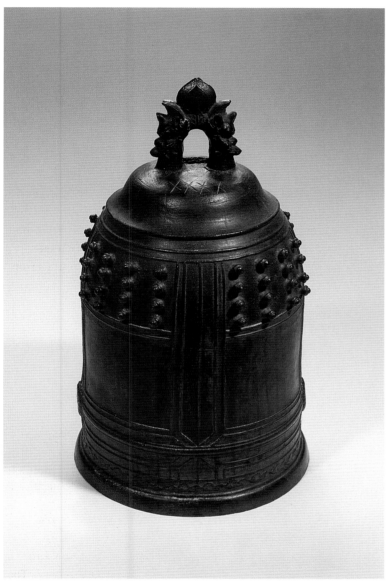

Fig. 8. *Hontsurigane*
Bell
52.5 x 31 (diameter)

Gemeentemuseum Den Haag

MUZ-1933-0261

Almost cylindrical bronze bell
with slightly wider lower end.
The inside is smooth and the
outside is divided into four
sections separated by vertical
lines. The upper and lower ends
of the vertical lines are bordered
by horizontal lines. Each section
is divided into two. The upper
part of each section contains
four rows of four nipples; the

lower part is smooth. A
chrysanthemum is featured at
the convergence of vertical and
horizontal lines on both sides of
the bell. The rim is decorated
with a twine motif. The bell has
a handle consisting of two
downward-facing dragon heads
emerging from a fire motif. Rods
protruding from the bell are
held by in the mouths of the
dragons. Four crosses are
stretched along the top of the
bell. Wooden hammer-shaped
beater.

Fig. 9. *Tsuridaiko*
Double-skin frame drum
16.5 x 43 (diameter)

Gemeentemuseum Den Haag

MUZ-1933-0042

Wooden body, slightly barrel
shaped. The decoration includes
red, blue and green painting on
a gold ground. Three iron
fastening rings on the body.
Two nailed membranes, each
featuring a red, light blue and
dark blue lion on a gold ground.
Wooden stand (128 x 80 x 58 cm)
consisting of a hoop on post
supported by a crossed base and

featuring incised cloud motifs in
red, blue and green. Two cut-out
rain dragons are wound around
the hoop. Above the hoop a
woodcarving in the form of a
cloud and fire motif containing a
pearl of fortune. Two rings are
fixed to the outside of the hoop
for hanging the drumsticks. Two
beaters with brass fittings on the
handles and leather on the
heads.

Fig. 10. *Kakko*
Double-skin barrel-shaped drum
32 x 24.5 (diameter)

Gemeentemuseum Den Haag MUZ-1933-0236

Wooden body, slightly barrel shaped on the outside, hourglass form on the inside. A green, gold and silver rain dragon is set against a gold ground with red, blue and green clouds. Two membranes are fastened to iron hoops. Each membrane has eight holes strengthened by metal rosettes. Leather strokes, wound around the hoops, stretch beyond the holes. Leather tension cord with silk laces. Wooden stand carved with cloud motifs, painted black with gold edges.

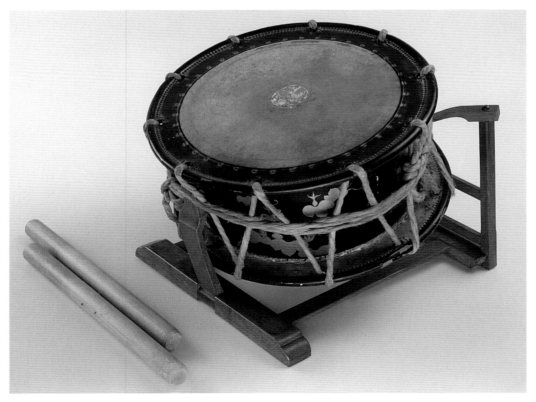

Fig. 11. *Shimedaiko*
Double-skin frame drum
15.5 x 34.5 (diameter)

Gemeentemuseum Den Haag MUZ-1933-0240

Wooden body, slightly barrel shaped. Grasses, leaves and flowers (bindweed) are lacquered in gold, red and greyish-blue on a black ground. A stamp is painted in red and three characters in gold. Two membranes, each stitched to iron hoops. The edge of the outer part of each membrane is lacquered black, whilst the edge of the inner is red. The upper membrane is strengthened in the middle by a small round membrane. Between the membranes a tension cord is fastened, passing through ten holes in each membrane. The insides of the membranes bear one painted character and four written characters. Wooden folding stand.

Fig. 12. *Kotsuzumi*

Double-skin hourglass-shaped drum

26 x 20 (diameter)

Rijksmuseum voor Volkenkunde, Leiden 360-2438

Wooden body, hourglass shaped. The decoration is lacquered in gold on a black ground. Two membranes, each stitched to iron hoops. A tension cord is fastened between the membranes, passing through holes in them. Three leaves in black lacquer at each tension cord hole.

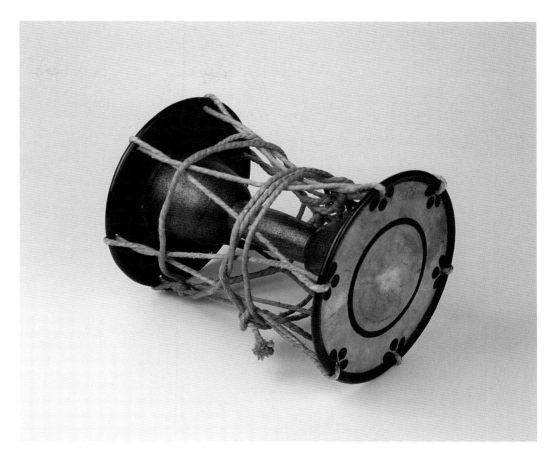

Fig. 13. *Ōtsuzumi*

Double-skin hourglass-shaped drum

29 x 22.5 (diameter)

Gemeentemuseum Den Haag MUZ-1933-0238

Wooden body, hourglass shaped. The decoration is lacquered in gold on a black ground, featuring two heads with horns and eye-teeth, a Chinese lion and three triple comma motifs in a roof-tile motif. Two membranes, each stitched to iron hoops. A tension cord is fastened between the membranes, passing through holes in them.

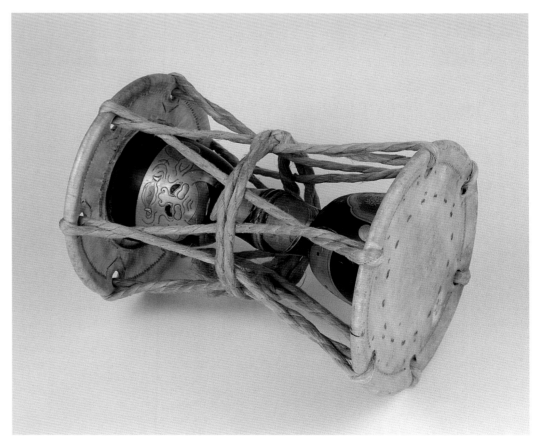

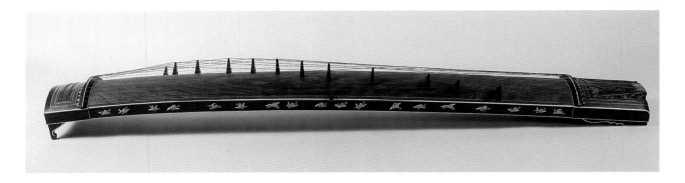

Fig. 14. *Koto*
Heterochord half-tube zither
193 x 25 x 17
Gemeentemuseum Den Haag MUZ-1933-0254

Wooden sound-box, upper side of paulownia wood (Japanese: *kiri*; Latin: *Pauwlonia imperialis*). Erratic grain. Upper side, front, back and left side are in one piece. Two bridges, mutual distance 155.5 cm. The front, upper and rear sides are decorated between the bridges with mosaic veneer in ivory, green and black. Wood glued on to the front and rear sides features seventeen and eighteen ivory cranes, respectively. On the right side is an extensive rectangular inlaid mosaic (23 x 8 cm); the central square contains silver with incised waves.

There are thirteen string-holes in the width just beyond the bridges to the left and right. Each hole is strengthened by ivory and decorated with a small mother-of-pearl flower. The bridges and the parts beyond are in hardwood. Beyond the left bridge an inlaid mosaic contains tortoiseshell, upon which is painted two swaying or dancing women, each holding a flower. Above this is a leaf-shaped wooden ornament, covered with brocade over which the strings run. The underside has two keyhole-shaped sound-holes. All square edges of the *koto* are finished in ivory. On the right side are two arched and notched thickened areas to support the instrument; on the left are two short legs. The right side is sealed with tortoiseshell.

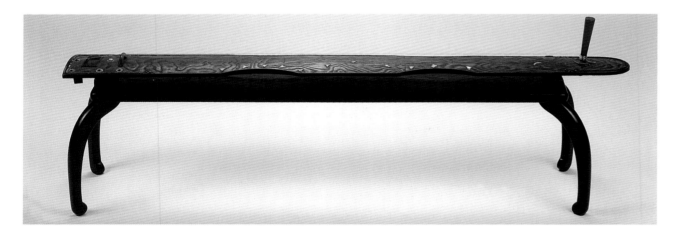

Fig. 15. *Ichigenkin*
Heterochord half-tube zither
108 x 11.5 x 1
Gemeentemuseum Den Haag MUZ-1933-0163

A dark brown plank of paulownia wood (Japanese: *kiri*; Latin: *Pauwlonia imperialis*). The lower side is flat, the upper side slightly rounded. Two constrictions, divided into three parts. Accentuated watermark structure on upper side; plank bordered with dark wood. Eleven

plovers and a crescent in mother-of-pearl are glued to the upper side. On the right side seven, and on the left side two inlaid cherry blossoms in mother-of-pearl. A rectangular lowered section, framed with wood and covered with tortoiseshell, appears on the right. On the right-side a string-hole, decorated and strengthened by a cherry blossom in mother-of-pearl and an ivory centre. On the left a tuning-peg hole strengthened on top by a hexagonal piece of wood. One round tuning-peg.

Fig. 16. *Shamisen*
Spike box lute or spike guitar
96 x 20 x 9.5

Gemeentemuseum Den Haag MUZ-1933-0235

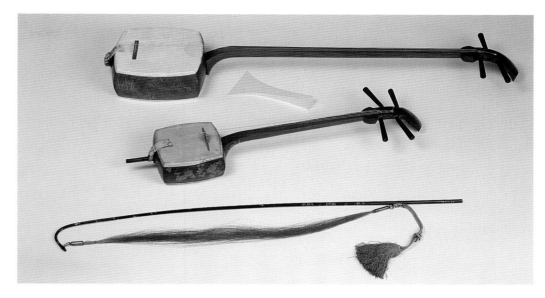

Sound-box consisting of rounded-off rectangular wooden frame, the front and back sealed with glued membrane. Semicircular piece of membrane glued to front membrane. Frame length and width equals 20 x 19 cm. Inscriptions on the inside of sides and lower side. In the upper side a rectangular hole, in the lower side a round hole; the neck passes through both holes. The lower hole is decorated or strengthened by a metal rosette. On the four sides water plants and waves are painted on a light brown ground. The neck divides into two. It has a brass point, a flat front and a round back. The part in the sound-box bears an inscription. The neck is painted light brown and features a flower leaf above the peg-box. The tuning-peg holes are decorated and strengthened by a metal rosette. Three hexagonal tuning-pegs, the sides incised alternately with slanting lines and squares. The end of the pegs are also incised with squares. Plectrum of synthetic material.

Kokyū
Spike box lute or spike guitar
65 x 17.5 x 7

Gemeentemuseum Den Haag MUZ-1950-0067

Sound-box consisting of rounded-off rectangular wooden frame, the front and back sealed with membrane. Frame length and width equals 12.5 x 11.5 cm. In the upper side a rectangular hole, in the lower side a round hole; the neck passes through both holes. The lower hole is decorated and strengthened by a metal rosette. The four sides are lacquered with a floral motif on a dark brown ground. The neck has a brass point, a flat front and a round back. It is painted dark brown and lacquered with a floral motif similar to that of the sound-box: one at the top and one at the bottom of the back. Tuning-peg holes decorated and strengthened by a metal rosette. Four round tuning-pegs, grooved in the length. The bow has been lacquered black with motifs painted in gold: waves, plovers and clouds.

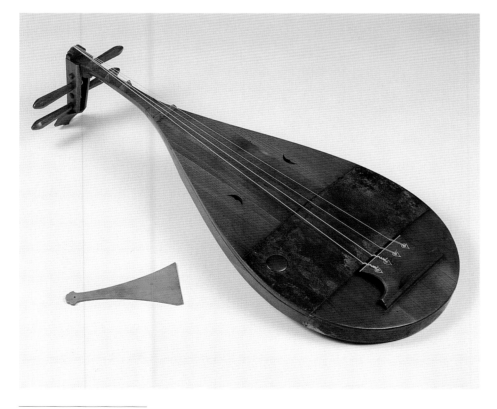

Fig. 17. *Biwa*
Necked bowl lute
91 x 36 x 22

Gemeentemuseum Den Haag MUZ-1933-0170

Brown wooden sound-box, hollowed-out back, sound-table glued on. Undulating and oval grain in back. Straight-grained sound-table is 9 mm thick, with two crescent-shaped sound-holes; under the string-holder a third, rounded-off, rectangular sound-hole. String-holder of two types of wood, glued to the sound-table above the hollow areas. Inlaid tear-shaped ornaments in wood and ivory around the string-holes. Neck made of separate piece of wood, becoming narrower at the top; the front is flat and the back round. Four triangular wooden frets, three glued to the neck, one to the sound-table. Glued bridge. Peg-box with four octagonal tuning-pegs. Piece of dark leather with light green and grey tints glued to sound-table, with circular metal knob attached. Leather glued around lower edge of sound-box. Plectrum made of wood.

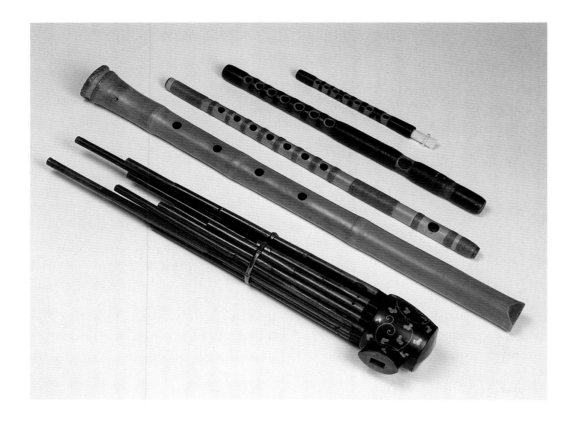

Fig. 18. *Hichiriki*
Oboe with cylindrical bore
18.1 x 1.5 (diameter)
Gemeentemuseum Den Haag MUZ-1933-0654

Bamboo tube, inverted conical. Seven by two finger-holes, ovoid. Inside lacquered black from top to first finger-hole to bottom. Bound with black-lacquered bast above, between and below finger-holes. Loose double-reed mouthpiece.

Yokobue
Open side-blown flute
39 x 2 (diameter)
Gemeentemuseum Den Haag MUZ-1950-0154

Bamboo tube, cylindrical. Mouth-hole, oval; seven finger-holes, oval. The tube is sealed and filled up with wax and lead above the blowing-edge; length of open tube is 28.7 cm. The inside is lacquered red; the lacquer shows on the outside of the blowing-edge and finger-holes. The outside of the stop is covered with a coin, filed to size; it is decorated with two lions in a shield, a crown, the cipher 'two' and the letter 's'. A rectangle

is cut out and a bowl-shaped protrusion inserted on the back, at the height of the node. The flute is bound with black-lacquered bast where there are no holes.

Shinobue
Open side-blown flute
45.5 x 2.1 (diameter)
Gemeentemuseum Den Haag MUZ-1933-0183

Bamboo tube, cylindrical. Mouth-hole, oval; seven finger-holes, oval. The tube is sealed and filled up above the blowing-edge; length of open tube is 40.5 cm. The inside, including the stop, is lacquered red. The outside of the stop is covered with a smooth metal plate. An incised character on the back at the level of the blowing-edge. An incised, stylised character on the front under the lowest finger *(ki)*. The flute is bound with red-lacquered bast between the holes.

Shakuhachi
Open single end-blown flute
59.5 x 4.8 (diameter)
Gemeentemuseum Den Haag MUZ-1933-0431

Bamboo tube with five nodes and four internodes. Blowing-edge on upper node, bevelled on the front to create a sharp edge. Small piece of horn inlay. Four by one finger-holes, round. The top (6.5 cm) and the bottom (4.5 cm) of the inside are lacquered red.

Shō
Set of free reeds
48 x 8 (diameter)
Gemeentemuseum Den Haag MUZ-1933-0171

Wooden wind-chamber, lacquered black, with a peony and twining in red and gold. Silver plate on blowing-hole. Seventeen bamboo pipes. The upper part is painted brown, the lower part black. Three pipes have a silver cap with a cut-out heart slid on. One pipe has a silver ring on the finger-hole, two pipes have a silver rectangle around the pitch-hole. The pipes are held up by a silver band.

Nō and kyōgen

Erika de Poorter

Introduction

A number of different traditional theatre forms still exist in Japan today. The four principal types include Nō, the closely related *kyōgen*, Kabuki and Bunraku. Nō and *kyōgen* date from the 14th century, whilst Kabuki and Bunraku evolved later in the 17th century. This essay is concerned with the first two: Nō and *kyōgen*.

Nō plays have sometimes been compared with western opera in that a great deal of the script is sung to an orchestral accompaniment, the action includes dance and the plots are serious in nature. By contrast, *kyōgen* comprise humorous sketches without singing or dancing. They are performed in the intervals between Nō plays to provide comic relief. Traditionally, a complete programme consisted of five Nō plays and four *kyōgen* interludes. However, today programmes are much shorter with only two Nō plays and one *kyōgen* or one *kyōgen* and Nō play each.

Historical background

Originally Nō simply meant 'performance' or 'play'. Both *kyōgen* and Nō evolved out of theatrical productions known as *sarugaku* (literally, 'monkey music') or *sarugaku no nō* ('performances of monkey music'). These were made up of song and dance numbers interspersed with pantomimes and short comic interludes. In the mid-14th century there were numerous *sarugaku* troupes that travelled around the country enlivening festivities at temples and shrines with their performances. They competed with each other and even organised formal contests. The style of drama that later became known as Nō was developed chiefly by the *sarugaku* actors Kan'ami and Zeami, who came from the environs of Nara in Yamato province (present-day Nara prefecture).

Kan'ami (1333-84) was the founder and first leader of the Yūzaki theatre company, which still today exists under the name Kanze. He not only introduced revolutionary improvements in the song and dance techniques of his troupe but also refined and enriched the repertoire by reworking many existing *sarugaku* pieces and writing dozens of new ones. His son Zeami (1363-1443) is a pre-eminent figure in the history of Nō. He was a gifted actor, already treading the planks at the age of seven, as well as a great playwright. In addition, he produced some twenty theoretical treatises expounding his ideas about Nō. Performances by Kan'ami and Zeami achieved immediate success, especially after their company attracted the attention in around 1374 of the shogun Ashikaga Yoshimitsu (1358-1408), a lover of the arts who was to remain the theatre's patron for the rest of his life. Other *sarugaku* troupes adopted their repertoire and techniques, and performances were attended by a public representing all levels of society.

During the Tokugawa period (1600-1868), Nō and *kyōgen* were distinguished as official forms of theatre. They were performed to mark major events and festivities. The shogun and warrior aristocracy acted as patrons to the different families of actors. They organised command performances in their homes and employed actors to teach them how to perform *utai* and *shimai* (Nō singing and dancing) or to play the instruments of the Nō theatre. Ordinary people could witness Nō performances in temples and shrines, and in Edo, the capital city. Townspeople *(chōnin)* could even attend the large-scale open-air performances occasionally given at the shogunal palace. The middle classes likewise took up the hobby of Nō singing and dancing.

It is therefore not surprising that the abolition of the Tokugawa shogunate and the beginning of the Meiji period in 1868 triggered an acute economic crisis in the world of Nō. Actor families lost their patrons; they were forced to sell their collections of masks and costumes and leave the profession. Some of the smaller schools disappeared. However, thanks to the idealism of a few notable Nō actors such as Umewaka Minoru (1828-90) and Hōshō Kurō (1837-1917), the Nō theatre survived and eventually witnessed a renaissance. Today Nō has

found new patrons - not the warriors of the past but older intellectuals and affluent members of society. They, too, have turned to Nō singing and dancing as a hobby. Audiences are once again flocking to theatres. In Tokyo, for example, it is possible to attend a performance somewhere in the city on any given day. *Takigi nō* (outdoor performances lit by firelight) are also extremely popular.

There are four other Nō schools in addition to the surviving Kanze troupe, whose current leader is a distant descendant of Kan'ami. These are the Hōshō, Konparu and Kongō, which likewise trace their origins to the 14th-century *sarugaku* companies in Yamato, and the Kita, which was established in the mid-17th century. Of these, the Kanze troupe is the most important, and more than half of all present-day Nō actors belong to it. These five companies still exercise a monopoly over the Nō theatre. Over time they have developed their own distinctive styles of performance, and each represents a different school or movement within the Nō theatre. Skills are usually passed from father to son so that membership in the companies remains the reserve of a small number of traditional theatre families.

The stage

Sarugaku performances were initially open air on improvised structures. Later they took place on permanent stages in temple gardens and elsewhere. Today all major towns have modern buildings housing Nō theatres, but the traditional stage structure of the late 16th century survives unchanged in the form of a square, roofed platform of unpainted cypress wood, measuring approximately 6 by 6 m. On the left it is linked to the dressing-rooms by a long covered bridge along which the actors and musicians make their entrances, whilst the members of the chorus and the assistants invariably use the small, low-set sliding door on the right.

There are no theatre sets or props as such. The only permanent decoration is a painting of a large pine tree on the wooden panel at the back of the stage and another of a few branches of bamboo on the right-hand side. The motif of the pine tree recalls the Yōgō tree at the shrine, Kasuga-jinja, in Nara under which *sarugaku* actors performed. Sometimes simple objects may be positioned on the stage to indicate the outline of the object they are supposed to represent - a carriage, boat, house or burial mound - but these are removed once they have fulfilled their purpose in the play (ill. 57).

The performers

All roles in Nō are played by men. Both the principal character and the actor who plays it are known as the *shite* ('player'), and he is the focus of the play. The actor sings and dances, moving around the whole stage. He is attired in luxurious costumes and frequently wears a mask. He is supported by a subsidiary character whose primarily role is to ask questions and so give the protagonist the opportunity to tell his or her story. In other words, the function of the supporting character is to elicit the story of the *shite*. Accordingly, he frequently acts as a sort of intermediary between the principal character and the audience. His costumes are less showy, and he is never masked. Throughout the entire piece he remains seated on the right of the stage and is therefore known as the *waki* ('side'). Actors who play a *waki* never play a *shite* and vice versa.

Depending on the demands of the plot, the lead and supporting actors may each be accompanied by one or more 'attendants'. These usually enter together with the character they accompany, and their task is to sing or recite various passages together with him. There are *tsure* (attendants of the principal actor) and *wakizure* (attendants of the supporting actor). Only the *tsure* wear masks. In spectacular pieces with larger casts, the characters represented by the supporting actor and attendants are more highly developed. Walk-on parts like ferrymen, followers or villagers are played by *kyōgen* actors.

Some plays also involve *kokata* (a child actor in a 'boy's part'). The roles played by these young actors, the sons of principal actors, are not necessarily those of children. Sometimes they represent an emperor or aristocrat of a social class far superior to that of the other characters, but they are nevertheless subordinate to the dominant figure of the *shite*. They are never masked.

The *jiutai* ('chorus') consists of eight actors. They squat in two rows on the right-hand side of the stage and not only provide the narrative and descriptive elements of the script but also occasionally sing the words of the principal or supporting actor.

At the rear of the stage sit one or more actors who act as *kōken* ('assistants') during the performance. They bring on the props and help the principal player with his costumes. These stage assistants are themselves fully trained actors and can act as prompts, if necessary.

Traditionally there has been a distinction in the Nō theatre between actors who play protagonists and those

who play support parts. The first category also includes those who play the attendants of protagonists or child roles as well as the members of the chorus and the assistants. All the principal players are members of the five Nō schools mentioned above (Kanze, Hōshō, Konparu, Kongō and Kita). The supporting actors and their attendants have their own separate schools and traditions. There are three surviving schools of this kind: the Takayasu, Fukuō and Hoshō. *Kyōgen* actors likewise have their own separate schools (see below).

The small Nō orchestra is composed of a *nōkan* (flute), *kotsuzumi*, *ōtsuzumi* and *shimedaiko* (drums, see also essay by Onno Mensink). The *shimedaiko* (in Nō simply called *taiko*) is only used in plays involving a supernatural being. These instruments are employed to play the overture announcing the entrance of the main and supporting actors, and to accompany songs and dances. The drummers also use guttural cries to accentuate the rhythm. Like actors, musicians have their own schools. Today they include the Morita, Issō and Fujita for *nōkan* players; the Kanze, Kō, Kōsei and Ōkura for the *kotsuzumi*; the Kadono, Takayasu, Ōkura, Ishii and Kanze for the *ōtsuzumi*; and the Kanze and Konparu for the *taiko*.

Costumes and masks

Nō costumes are worn only by the soloists. The remaining actors, members of the chorus, musicians and assistants all wear the ceremonial dress of the Tokugawa period. The costumes of the protagonists are made of luxurious fabrics such as silks and brocades. Each character has its own established patterns and colours. For instance, a distinction is drawn in women's costumes between those 'with colour' and those 'without colour' (i.e. with or without red). Red fabric is worn exclusively by young women or by older women who were famous beauties in their day.

As mentioned above, only the protagonists and their attendants wear masks. Masks are used to act the parts of women, boys, fierce warriors, old people and the blind. There is also a series of masks for gods, devils and other supernatural beings. A masked actor can suggest different facial expressions by moving his head to change the angle of the mask. Actors in roles for which masks are not employed wear no greasepaint, but maintain a fixed and mask-like expression.

Gestures and dance

Actors on the Nō stage also maintain a fixed bearing with their bodies constantly leaning slightly forward. This provides the basis for the prescribed gestures of the drama and dance. The manner of perambulation on the stage is likewise subject to conventions: all the performers must move calmly and without raising their heels from the ground so that they appear to glide over the highly polished, mirror-like wooden floor.

The gestures used in acting and dancing are recorded in *kata* ('patterns') handed down from generation to generation, and actors must strictly adhere to them. There are three types of gestures. First and foremost are the gestures representing an action. These may be realistic (e.g. drawing a sword and attacking a person) or stylised (an open palm in front of the face to represent weeping). Then, there is a series of symbolic gestures expressing emotions. Taking three steps backwards and spreading the arms can represent indignation, astonishment or joy, depending on the words being intoned. Finally, there are purely abstract gestures which form part of the dance.

Nō dancing may be descriptive or abstract. The descriptive dances, which are always accompanied by vocal and instrumental music, illustrate the plot or express the psychological state of the protagonist. They may, for example, represent a fierce battle or an episode of madness. The abstract dances are accompanied only by the orchestra and exist in isolation from the plot. They constitute, as it were, an independent element within the Nō play. The type of dance depends on the kind of protagonist portrayed. The Nō dance is concentric and horizontal in movement. The dancer does not leave the ground, but stamps his feet.

As aforementioned, women do not act in Nō. Male actors playing female parts dress as women and wear female masks and wigs. They never actually imitate the female voice or make feminine gestures, but do use a quieter reciting and singing voice as well as slower and more graceful gestures than for male roles. The female nature of the part is also suggested by the inclusion of poetry and the use of a vocabulary that the Japanese regard as poetic and therefore feminine. This involves the use of words of Japanese origin, wherever possible, and the avoidance of names pronounced in a Sino-Japanese way. The music used for female roles is likewise more melodic.

Plays and themes

Some 2000 Nō plays still exist. Of these, 240 belong to the regular acting and musical repertoire. The scripts are mainly in verse form and are not easy for modern Japanese audiences to understand since they are written in classical Japanese.

The themes of Nō are derived from Japanese mythology, Chinese and Japanese legends, temple histories, stories in classical novels and warrior tales. However, the plots are not particularly important and are frequently an excuse for aesthetically pleasing singing and dancing. Numerous Nō plays feature the appearance of supernatural beings or the ghosts of people long dead.

There is no conflict between the characters, as in western drama, nor is there any attempt at deep psychological exploration. The aim is to create a particular atmosphere or represent an emotion. Rather than interpersonal conflict, Nō portrays extreme emotional tension within a single person. This is represented on stage by the use of poetic language, song and dance. The tension is finally resolved in the dance with which the Nō play reaches its climax. Peace is thereafter restored, and many Nō plays end with a serene description of the landscape.

Since the 17th century all Nō plays have been divided into five categories, depending on their themes and, more particularly, on the type of protagonist involved. Firstly, there are the *kamimono* ('god plays'), in which the principal character is generally a male deity. He or she may, for example, describe how a particular temple was founded and then perform a dance to bless the land and its people.

Secondly, there are the *shuramono* ('warrior plays'). They feature the ghosts of famous warriors, usually of a general who perished during one of the many battles between the Taira and Minamoto clans in the 12th century and ended up in hell. The warrior's ghost recounts his last battle to a monk and asks him to pray for the repose of his soul.

The third type has a woman as the main character, and the theme is often based on a famous love story from Japanese classical literature. In that there are no actresses the protagonist is played by a man wearing a mask and wig, hence the term *katsuramono* ('wig plays'). Pieces of this type have distinctively slow and melodious music. They feature serene and graceful dancing.

The fourth category, the *yobanmemono* ('fourth numbers'), is a rag-bag of plays which fit into no other category. They include plays about *kyōjomono* ('mad women') in which the protagonist is a woman driven mad by grief at some event such as the loss of her husband or child.

Finally, there are the *onimono* ('demon plays') which feature a devil, malign supernatural being or gruesome beast. These always include a lightning-quick dance or thrilling fight scene and are colourful pieces used to bring the programme to a spectacular conclusion.

Not included within these categories is the ritual *Okina* with which every programme traditionally began. Today it is only performed at the New Year or on ceremonial occasions. This piece is far older than other Nō plays. It has no plot and comprises four dances performed by three actors (ill. 60). The style of performance is also different. *Okina* is the only item in the repertoire during which the players don their masks on stage and remove them before exiting. Moreover, the musical accompaniment is provided by three *kotsuzumi* in addition to the customary flute and *ōtsuzumi*. This imbues it with a strongly rhythmic character.

From the 17th century onwards it became *de rigueur* that each day's programme should include one play from each category. There was also a set order: first the ritual *Okina*, then a 'god play', a 'warrior play', a 'wig play', a 'fourth number' (often about a mad woman) and finally a 'demon play'. Each of these were interspersed with *kyōgen* interludes.

Kyōgen

Similar to Nō theatre, *kyōgen* ('mad words') developed in the 14th century out of *sarugaku* performances. Zeami's treatises show that, even in his day, *kyōgen* pieces were already being performed as comic interludes between Nō plays. *Kyōgen* actors are trained in separate schools of which two survive: the Ōkura and Izumi.

Kyōgen is performed on a bare Nō stage without sets. They require only a few players, which include a protagonist (also called the *shite*) and one or more supporting parts *(ado)*. Musicians and chorus are not required. The actors, all male as in Nō, wear less luxurious costumes and are almost never masked, even for female roles. When playing women, they simply wear feminine clothes and a long white cloth around the head to symbolise hair.

The current *kyōgen* repertoire includes 200 plays. Originally, only the main outline of the plot was written

down, and the players improvised within that framework. It was only in the mid-17th century that complete scripts began to be recorded. Most *kyōgen* plays are set in 15th- or 16th-century Japan, and the language used is the spoken Japanese of that period. Favourite themes are those such as the stupid peasant, the crafty or credulous servant, the henpecked husband and the jealous spouse. In addition, the plays often include parodies of passages from Nō. In this case they also include singing and dancing.

Suggestions for further reading

Nō

Goff, Janet. *Noh drama and the Tale of Genji: the art of allusion in fifteen classical plays*. Princeton, NJ: Princeton University Press, 1991.

Hare, Thomas Blenham. *Zeami's style: the Noh plays of Zeami Motokiyo*. Stanford, CA: Stanford University Press, 1986.

Keene, Donald. *Nō: the classical theatre of Japan*. Tokyo and Palo Alto, CA: Kodansha International, 1966.

Keene, Donald (ed.). *Twenty plays of the Nō theatre*. New York and London: Columbia University Press, 1970.

Komparu Kunio. *The Noh theater: principles and perspectives*. New York, Tokyo and Kyoto: Weatherhill/Tankosha, 1983.

Nippon gakujutsu shinkōkai (ed.). *Japanese Noh drama*. 3 vols. Tokyo: Nippon gakujutsu shinkōkai, 1955-60.

O'Neill, P.G. *A guide to Nō*. Tokyo and Kyoto: Hinoki shoten, 1954. 1st edition.

Poorter, Erika de. *De kraanvogel en de schildpad: vijf Nō en vier kyōgen*. Oosterse Bibliotheek 12. Amsterdam: Meulenhoff, 1978.

Poorter, Erika de. *Zeami's talks on Sarugaku: an annotated translation of the Sarugaku dangi with an introduction on Zeami Motokiyo*. Japonica Neerlandica 2. Amsterdam: J.C. Gieben, 1986.

Poorter, Erika de. 'Nō which is no Nō: the ritual play Okina'. *Maske und Kothurn* XXXV nos. 2-3 (1989), 21-30.

Rimer, J. Thomas and Yamazaki Masakazu. *On the art of the Nō drama: the major treatises of Zeami*, Princeton, NJ: Princeton University Press, 1984.

Sieffert, René. *No et kyogen: théâtre du moyen age*. 2 vols. Paris: Publications Orientalistes de France, 1970.

Tyler, Royall. *Japanese Nō dramas*. London: Penguin Books, 1992.

Kyōgen

Kenny, Don. *A guide to kyogen*. Tokyo and Kyoto: Hinoki shoten, 1968.

Kenny, Don (comp.). *The kyogen book: an anthology of Japanese classical comedies*. Tokyo: The Japan Times, 1989.

Morley, Carolyn Anne. *Transformation, miracles and mischief: the mountain priest plays of kyogen*. Ithaca, NY: Cornell University, 1993.

Sakanishi Shio. *Japanese folk-plays: the ink-smeared lady and other kyogen*. Rutland, VT: Charles E. Tuttle, 1983. 6th printing.

Kabuki:
the 'total theatre'

Thomas Leims

Introduction

On the occasion of the centennial celebration of the Kabukiza in Tokyo in 1987-88, the then Japanese Prime Minister Nakasone Yasuhiro said in the simple terms of a politician, 'France has ballet, Italy has opera, England has Shakespeare and Japan has Kabuki'.[1] Indeed, the performing art of Kabuki can still be considered as the most representative genre of Japan's theatre culture today. In the latter half of the 19th century knowledge of Kabuki began to spread throughout Europe by means of the marvellous Ukiyo-e woodblock prints that depicted actors in characteristic poses. In 1928, the first true Kabuki troupe left Japan and performed in the then Soviet Union.[2] Since the 1960s many cities of western Europe, including Amsterdam, have been able to witness performances of this unique form of performing art.

The term 'Kabuki' is written with three Chinese characters, *ka* meaning 'song', *bu* for 'dance' and *ki* for 'action'. This form, which has been in use since the mid-17th century, has caused some authors to categorise Kabuki 'aesthetically' as a Japanese form of opera. Indeed, Kabuki incorporates a great deal of music and musical elements, yet it differs completely from the traditional European concept of opera. There are no singers, the actors do not perform recitatives and arias, and the music, although omnipresent throughout the performance, serves more to underline and re-enforce the actors' performance skills.[3] Nevertheless, music is of utmost importance in the overall aesthetic picture. Therefore, rather than being a classical form of 'opera' as understood in the West, Kabuki can best be described as 'total theatre' with a perfect balance of movement, acting, music and visualisation of emotions.

The origins of Kabuki

'Kabuki' can be translated as 'tilting in one direction', 'being out of focus', 'acting against existing social standards' or 'behaving in an outlandish, non-mainstream manner'. The fact that a highly aesthetic form of theatre was described with a rather pejorative term is strongly connected with its origins.

Kabuki was born around 1600 in the shrine precincts and dry river-beds in Kyoto, Japan's ancient capital. During the previous 150 years, Japan underwent civil war during which time local feudal warlords fought against the central forces. This period of war ended with the reunification of the country by Tokugawa Ieyasu (1542-1616), who was later granted the title of shogun. He moved the capital from Kyoto to Edo (present-day Tokyo), thereby marking the beginning of the Tokugawa period (1600-1868).

The years of civil war changed Japanese society. Many peasant farmers, who were conscripted to serve as foot soldiers, did not return to their villages following reunification because of the destruction of their rice paddies. Instead, they remained in cities such as Kyoto, Osaka and the newly constructed fortress town of Edo. As a consequence, these cities experienced exponential growth, and this became the basis for the development of an urban rather than a rural society. In the years leading up to the shogunate's establishment of a rigid system of rule, which was rooted in Neo-Confucian ideology, people enjoyed the relative freedom afforded by a 'chaotic' society.[4] For example, gangs of anti-establishment, eccentric men called *kabuki mono* ('Kabuki people') roamed the streets, often flouting social conventions. In winter they wore only thin cotton kimono whereas during the hot, humid summer they wore thick clothes and even ignited bonfires to 'warm up'. One would not want to encounter such *kabuki mono* in the streets as they would relentlessly fight their way through! This wild and energetic manner was implied in the term 'Kabuki', and the newly evolved dance in Kyoto borrowed the word in order to establish a place for itself in the 'amorphous' society of the early Tokugawa period.

Entertainment in early Tokugawa Japan: the role of women

Women, like men, also experienced a short period of freedom in the early years of the Tokugawa, especially vis-à-vis popular entertainment. In fact, they led the way in this genre: included amongst favourite female 'performances' were the mocking of men too shy to meet a woman or the imitation of a parvenu who visited the gay quarters without knowing the proper etiquette. A close connection between dance, the performing arts and *keiseigei* entertainment *(gei)* by highly trained women *(keisei)*, today commonly known as geisha, also developed at this time. *Keisei* would study the latest dances so as to keep up appearances. Around the same time a new musical instrument, the *shamisen*, introduced earlier from China via the Ryūkyū islands, became fashionable (see also essay by Onno Mensink). It quickly replaced the *biwa* ('lute') because it was much lighter, had a higher pitch and a greater variety of 'melodic' sounds. It soon became the favourite instrument of female entertainers. Women, in particular, liked the 'erotic' sound of the *shamisen*.

Early Kabuki

Women's Kabuki (onna kabuki) and young men's Kabuki (wakashu kabuki)

One of these early female performers, Izumo no Okuni, had a simple stage erected in a shrine precinct in Kyoto in April 1603. There she performed a new dance which she called *kabuki odori* ('Kabuki dance').[5] This dance must have contained novel elements because it was a resounding success and surpassed all other performances in popularity. Okuni was invited to perform before the empress and was even called into the residence of the newly appointed shogun Tokugawa Ieyasu. In a truly unique manner, Okuni and her followers combined their 'exotic' dance with the 'romantic' sound of the *shamisen* and the well-established Nō orchestra which consisted of three differently shaped drums and a flute[6] (see also essay by Erika de Poorter). The simple performance included dances possessing many erotic allusions, revue-style line dance and one-act sketches.

Kabuki odori soon became the staple performance for all kinds of entertainers, even male and female prostitutes in the early 17th century. The performance by the latter was called *yūjo kabuki* ('prostitute's Kabuki') and *onna kabuki* ('women's Kabuki'). Samurai as well as merchants competed for the favours of these dancers. Although prostitution was not officially banned, the increasingly frequent quarrels between poor samurai and wealthy merchants over the services of Kabuki women worried the shogunal government that their four-tiered society (samurai, farmer, artisan and merchant) was being jeopardised in the pleasure quarters. As a result, women's Kabuki was banned in 1624/1629.

Homosexual relations between samurai and merchants with young boys were also quite common at this time. Handsome young boys had likewise availed themselves of the new genre of entertainment. Although they were allowed to continue following the ban on *onna kabuki*, problems with prostitution persisted. Similar to the situation with *onna kabuki*, it was the fourth-ranked merchants who could afford the entertainment, whilst the less affluent but socially higher samurai had to miss out. The fears about *wakushu kabuki* and their potential threat to the moral fabric of Japanese society resulted in the shogunate's total ban on Kabuki in 1651/1652.

Kabuki as theatre

Kabuki had become so entrenched in the urban entertainment structure that the Tokugawa government eventually acquiesced in 1652 to the protests regarding the above ban. There is one heartening story of a theatre principal who sat in front of the government's licensing office for almost a year, refusing to wash or shave until Kabuki was once again permitted. It is not clear whether this story is true, but it illustrates well the demand for Kabuki. But in agreeing to reinstate Kabuki certain conditions were imposed. These included the banning of women from the stage and the requirement that boys undergo the coming-of-age ceremony (*genpuku*), in other words, i.e. the shaving of their forelocks.

These two measures practically put an end to overt eroticism in Kabuki, until then the main aesthetic element of the genre. Performers had to invent new ways to make Kabuki attractive to their audiences, and they took advantage of two other extant genres that were also quite popular at the time: *kyōgen* and *jōruri*. The performers of *kyōgen* and *jōruri* were responsible for the change of Kabuki from a popular, yet crude, form of entertainment to a true dramatic art.

Kabuki actors and their repertoire

Acting styles

Onnagata (female impersonators)

The banning of women from the stage dealt a heavy blow to the genre because romantic love stories required female roles. This need resulted in some actors impersonating female types. Early on femininity was perhaps imitated in a rather primitive way which might have resembled western travesties. Over the course of time and due to the experience of several generations of actors, however, the art of female impersonation was perfected so much so that it surpassed mere imitation and created a gender in its own right.[7] When the ban on women Kabuki actors was lifted in the late 19th century, there were attempts to reinstate women on the Kabuki stage. But these attempts were futile because the aesthetic means of female impersonators, the *onnagata*, had become such an integral part of Kabuki that 'real' femininity paled in comparison to their artificial 'perfect' beauty.

Tachiyaku (leading male roles): aragoto, wagoto, jitsugoto

Aragoto (male rough style)

By the early 18th century Edo had become the largest and most populated city in the world. About 90 percent of the population consisted of members of the third (artisans/artists) and fourth (merchants) social ranks, collectively known as *chōnin* ('townspeople'). The remaining city dwellers were samurai. They either belonged to the shogun's personal army or were soldiers serving the 250 or so local retainers who were required to keep residences in the capital and live there in alternate attendance.[8] But due to the country's relative peace at this time, these armed samurai had little to do. They must have been longing for entertainment and diversion, perhaps attempting to escape their boredom by slipping into fantasies of military heroics and behaviour. The Kabuki actors Ichikawa Danjūrō I (1684-1740) and his son Danjūrō II (1710-40) were therefore very successful in creating an acting style called *aragoto* (literally, 'rough stuff') that matched these fantasies. The Ichikawa family came to specialise in *aragoto*, making it a family art *(ie no gei)*, and even today they monopolise the genre.

The *aragoto* style is virile, employing loud hoarse voices, exaggerated movements, large dimensional props and a characteristic face make-up that was meant to underline the facial blood vessels. Red colours indicated the good hero, blue the villain and brownish-violet the ghosts.[9] The rough, 'masculine' style was aimed at and appealed to the ethos of Edo audiences in contrast to the more delicate style of *wagoto* from the Osaka/Kyoto region.

Wagoto (male elegant style)

Osaka and particularly Kyoto, located some 550 km southwest of Edo, enjoyed a much longer history than Edo. The country's old capital, Kyoto had been the seat of the emperor since 790 and even today epitomises Japanese aristocratic culture. Many Buddhist sects were active in and around Kyoto, and Buddhism incorporated the best of Chinese culture that was brought to Japan, often via Korea. By contrast, Osaka long served as a distribution centre for rice and numerous other commodities. Moreover, whereas Edo consisted of many peasants-turned-merchants, Osaka could boast of an established lineage of merchant families whose status approximated that of the nobility.

The social composition of Kyoto and Osaka Kabuki audiences demanded a dramatic style more elaborate and artificial than the distinctly Edo *aragoto*. Such a style was for example accommodated by the talents of the actor Sakata Tojūrō I (1647-1709). He developed a subdued acting style of sheer gorgeous elegance, what would eventually became known as *wagoto* (literally, 'soft stuff').

Jitsugoto (realistic style)

Kabuki also developed a more subdued style with less emphasis on artificial gesture, somewhat closer to the western concept of 'realistic' acting. This style, called *jitsugoto* (literally, 'real stuff'), became fashionable in the early 19th century, when dramatists such as Tsuruya Nanboku IV (1755-1829) and Kawatake Mokuami (1816-93) placed more emphasis on the dramatic plot than on mere 'beauty'. And yet Kabuki always adhered to its aesthetic principles.

Dance

Kabuki has never denied its roots in dance. Elegant dance movements, often based on the formalised etiquette of the tea ceremony *(chanoyu)*, imbued Kabuki with a flair that has often been admired by western choreographers such as Robert Wilson, Ariane Mnouchkine and Maurice Béjart, to name just a few. Whilst western dance and ballet have always

endeavoured to defy the forces of gravity through the dancer's leaps and jumps, in traditional Japanese dance the performance is directed towards the earth. As a result, the entire set of gestures appears more subtle, more subdued. Leaps are only rarely included. By contrast, traditional Japanese dance incorporates a great deal of stomping. In order to make the sound of the stomping even more audible, hollow planks called *shosa* are placed on the stage, and dance plays performed on these planks are called *shosagoto*. *Shosagoto* are ballet-like dance pieces accompanied by various forms of solo or ensemble chanting, drums and the *shamisen*.

Dance is never abstract. It always depicts a story or a specific emotion such as admiration of nature, love, grief and revenge. The kind of dance called *michiyuki* (literally, 'walking on one's way') is particularly impressive, and it often depicts the final, tragic journey of two lovers as they make their way to commit double suicide! Their belief is that if they cannot be together in this world then death will reunite them in the next, and en route to their deaths they describe the journey they have undertaken.

Genres and themes

During the first fifty odd years of Kabuki's history as a dramatic art, themes were almost exclusively based on pre-Edo stories of noblemen, monks and samurai such as the tales revolving around the popular historical figures of Minamoto Yoshitsune (1159-89) and his loyal retainer Musashibō Benkei. Such dramas were called *jidaimono* ('period plays'), and in order to avoid censorship many dealt with contemporary political matters which were set in a fictional past.

The puppet theatre and Kabuki playwright Chikamatsu Monzaemon (1653-1724) made a valuable contribution to world theatre when, in 1701, he created the first *sewamono*. These were domestic plays in which the heroes are not samurai, but characters from the lower-ranking classes (farmers and *chōnin*).[10] Chikamatsu can be seen as the creator of the 'bourgeois tragedy', long before characters of commoners appeared on the stage in the English novelty plays.

Another play genre became popular at the beginning of the 19th century. Although Kabuki had always been considered the main entertainment of commoners, tickets had become so expensive that only the affluent could afford a visit to one of the licensed theatres. These visitors were no longer in touch with the lower-ranking classes. Heinous acts like theft, rape and even murder,

often enacted with realistic elements, represented the 'exotic' to this audience, and as such the first half of the 19th century witnessed the introduction of the aesthetic of evil into Kabuki.

Since Japan's move towards 'modernisation' following the Meiji restoration of 1868, Kabuki has been used (or rather misused) as an educational tool. Kabuki actors such as Ichikawa Ennosuke III (b. 1939) have attempted to modernise Kabuki and emphasise the drama and the show parts *(keren)* rather than subdued acting. Some critics applaud this move, whilst others regret the 'falsification' of old acting styles. Nevertheless, traditional plays remain the main stock of dramas.

Kabuki actors

Actors are the centre of Kabuki theatre. In the past Kabuki playwrights would create or modify plays in order to exploit the qualities and talents of a particular actor. Chikamatsu Monzaemon was the first writer mentioned by theatre owners on theatre placards and programmes, and in the past as is still done today audiences visit Kabuki not because of a specific drama but to see their favourite actor. All other stage crafts such as the gorgeous props and costumes, the mechanical stage 'tricks' such as the revolving stage and music are used to enhance an actor's appearance.

Actors are organised into families, and every name is associated with a specific 'flavour' of acting. Accordingly, the name is the most valuable property, and it is handed down from generation to generation, usually to the eldest son. If there are no sons, a pupil is adopted who is then instated as rightful heir to the family name. If there are more sons than names in the family, new names and family branches are created. Some names, like that of the aforementioned Sakata Tōjūrō, have remained idle for several centuries. There are, therefore, no formalised schools: boys are trained by their fathers and relatives beginning at ages three to seven.[11]

The portrayal of Kabuki actors in prints

Prints of Kabuki actors and images of the theatre world constituted a significant genre in Ukiyo-e, with some schools specialising in the field. Prints depicting actors in almost every scene of a play were sold as memorabilia to fans, and the great number of surviving works of this kind are yet further proof of the importance and popularity of actors. These prints are additionally a

valuable source of information regarding acting style and techniques.

All Kabuki dramas and acts provide moments when the actor's motion suddenly freezes and he assumes an expressive pose *(mie)* that lasts for a couple of seconds. The actors squint with one eye in order to create a 'Mona Lisa effect' whereby every member of the audience is left with the impression that the pose was produced specifically for them. It is this *mie* pose that is normally captured in a Ukiyo-e print. Actors understood the positive effect that woodblock prints might have on their career, fame and income, so it is not surprising that they insisted on a favourable representation, especially in scenes showcasing particular bravura.

Kabuki today and tomorrow

Kabuki has been and will remain the most popular form of Japanese theatre, perhaps not because of its historical merit but because of the star status of its actors. Today many Kabuki actors also appear in other genres such as musicals and even Shakespearean dramas. In the 1960s a great number of people, Japanese as well as foreign experts, were worried about the future of the art. Perhaps it has been the appreciation of Kabuki by the West which reminded Japan that it should preserve one of the most fascinating genres of world theatre.

Notes

1. See Thomas Leims, 'The importance of materials contained in western libraries for the research of early Kabuki' in *International symposium on the conservation of cultural property - Kabuki:-changes and prospects* (Tokyo: Tokyo National Research Institute for Cultural Properties, 1998), 83-103, especially 83.

2. As early as 1900 troupes of Japanese actors were touring Europe and North America. They were primarily amateurs and cannot be counted amongst professional Kabuki actors, although they incorporated some of the acting techniques characteristic of Kabuki.

3. Admittedly, today the aesthetic line between 'music' and 'speech' is less categorical than in the 19th century. Indeed, Kabuki actors' 'speech' is highly stylised and rhythmical. In contemporary music theory such a 'ductus' could well be subsumed under 'song', but music is not the primary focus in Kabuki.

4. In order to re-enforce his rulership Tokugawa Ieyasu established a rigid four-class social system: it was headed by the warrior class (samurai), then farmers, followed by artisans and artists, with merchants at the bottom. Confucianist ideology frowned upon those professions which did not earn a living by 'creating' but rather through buying and selling, particularly by making interest gains. With the relative peace that characterised the era, the merchants had a financial edge over the samurai even though they possessed no political power.

5. Japanese dance distinguishes between *mai*, the more formal round dance prevalent in Nō drama, and the more energetic *odori*, which forms the basis of Kabuki. In contrast to western ballet, neither of these two genres attempts to 'escape' gravity. Rather, both forms of dance are directed to the centre of the earth.

6. Based on recent research Okuni must have incorporated western, i.e. occidental elements into her dance. During the period in question, Jesuits, mainly from the Iberian peninsula, worked in Japan. They used Christian music, dance and performances in order to spread the gospel. See Thomas Leims, *Die Entstehung des Kabuki. Transkulturation Europa–Japan im 16. und 17. Jahrhundert* (Leiden, Cologne and Copenhaven: Brill Publishers, 1990).

7. It is obvious that a predominantly 'male' society created its own picture of femininity which belongs more to the realm of fantasy than realism. The prevalence of androgyny in Buddhism, in particular Buddhist art, may have helped in forming such an idealisation and image of 'beauty'.

8. The Tokugawa shogunate employed a similar method to Louis XIV, who kept close watch on those members of the nobility who he felt might pose a threat to his rulership. In Japan's case, local lords were required to leave their wives and families in Edo and to live a luxurious lifestyle that would deprive them of the financial means to start a coup.

9. Thus Kabuki facial make-up differs completely from that of the Beijing (Peking) opera *(jingju)*. The Chinese mask mainly depicts animals such as tigers and bats whose zoomorphic characteristics dominate the outlook of the role.

10. Admittedly, there were earlier attempts, but Chikamatsu can be credited with the first full-fledged *sewamono*.

11. Since 1974, the National Theatre of Japan has offered courses for young actors who are not related to established Kabuki families. Although the courses are quite rigid, only a few graduates have successfully entered the Kabuki world.

Festivals and celebrations
in Japanese life

Linda Fujie

Assiduousness, discipline and even workaholism are characteristics often associated with the Japanese, but in actual fact festivities play an extremely important part in their lives, and occasions for these fill their calendar. Solemn ceremonies carried out in Shinto shrines and Buddhist temples ensure the safe, fortuitous course of everyday life and are representative of the more formal aspect of festivities. But festivities are also raucous occasions for the Japanese to 'let off steam' in the face of pressures encountered in their day-to-day professional and private lives.

Festivals:
religious, social and cultural elements

The word commonly used today in Japan for 'festival' is *matsuri*, which in its broadest definition can refer to anything of a festive nature, from department-store sales to religious activities. In its narrower religious sense, the *matsuri* is a complex of events generally held annually at a Shinto shrine or Buddhist temple. Particularly within a Shinto context, *matsuri* include the important occasions surrounding acts of purification; the summoning of the shrine *kami*, the honouring of it through rituals and sometimes through public celebration; and the sending back of the *kami* to the realm where it normally dwells.[1] Whilst the exact content of each *matsuri* varies with location and type of shrine, traditionally these key components remain constant. Many small local shrines in Japan - estimated by some to number 500,000 - contain *ujigami*, the guardian spirits that protect neighbourhood residents.[2] Inhabitants renew their relationship with the *ujigami* during annual festivals and appeal for their continued protective powers. In some cases, historical events are also honoured as seen in the famous Gion Festival held in Kyoto every July which commemorates the end of a deadly epidemic that occurred there in 869 and appeals for the continued good health of the city's residents.

Today, Japan's major festivals are conspicuous not only as traditional forms of religious expression but also as significant stimuli to the country's tourism industry. Millions of visitors from other parts of Japan and from abroad flock to famous *matsuri* to observe the sometimes dignified, sometimes rollicking, street parades. But there are also thousands of local festivals that take place every year which are scarcely noted outside the jurisdiction of a particular shrine. At these small-scale events participants are at times just as interested in the social aspect of communing with neighbours as in the religious aspect of communing with spirits, especially in communities with many newcomers. Indeed, the various activities of the *matsuri* such as the parade of *mikoshi* (elaborate portable replicas of Shinto shrines placed on long wooden poles that all told can weigh a ton or more) or children in festive costumes do much to promote social interaction and community identity. Interestingly, it has also been pointed out by sociologists that the social distinctions that are emphasised during the ritual section of the festival are then equalised during the outdoor celebrations.[3] The social effect of the *matsuri* in a rural and urban context has been summed up as follows:

> As their [the shrine's] inhabitants come together to
> construct a float, to raise funds for repairing the
> pavilion housing the portable shrines, or to organize
> groups of dancers to perform throughout the city..., we see
> how an observance that is 'religious' at its core reaffirms
> social networks and promotes a sense of community in
> subtle yet tangible ways that more overt attempts of
> political or economic maneuvering do not.[4]

Related to the important social function of the *matsuri* is its traditional role as a source of entertainment for the population. In stark contrast to the routine of the daily workaday world, festivities can include music and dance, boisterous parades of parishioners in colourful costumes, merchants plying their wares, games and a considerable consumption of sake by all. Most eye-catching to the outside observer is the parade or procession (*gyōretsu*) of parishioners through the streets.

There is a great variety of parades, but most feature the aforementioned *mikoshi*. At the main shrine, the *kami* is 'transferred' by the priest to the *mikoshi* for its transport through the parish. This is then shouldered by dozens of parishioners dressed in traditional garb who rhythmically shout as they trot through the streets under the hot summer sun, tossing their heavy burden up in the air. The spiritual background of the *mikoshi* and other parade objects lies in the odyssey of the *kami* to bless those within its realm who are too old or sick to visit the shrine and to renew annually its protection of parishioners. At the end of the parade, the *kami* is 'transferred' by the priest back into the shrine, where it resides until the next *matsuri*.

Festive opportunities, and their accompanying function of distracting people from everyday concerns, date to ancient times. However, it was during the Tokugawa period (1600-1868) that they developed their current characteristic forms. Such occasions for diversion were extremely welcome in an age when urban merchants and farmers worked long hours without regular time off. The *hare no hi* ('festive days') served to rejuvenate the people mentally and physically.

An understanding of the social conditions of the Tokugawa period helps to shed light on the evolution of the *matsuri*. The social system that characterised Tokugawa Japan had been introduced during the earlier Momoyama period (1568-1600). This was a hierarchical class system that ranked its members in descending order as samurai, farmer, artisan or merchant. Social mobility was strictly proscribed, but the question of rank became problematic during the 18th and 19th centuries with the growing wealth of merchants and the impoverishment of many samurai. Rank was displayed, for example, in the dress members of each class were permitted to wear. But whilst some wealthy merchants had the means to purchase the expensive silk embroidered kimono reserved for the samurai class, increasing numbers of samurai could no longer afford them. Such merchants used festivals as opportunities to show off their prosperity. The affluence of the group was displayed through expensive *mikoshi* and floats. Individuals spent extravagant sums on gifts and clothing lined with the most expensive silks so as to avoid a flagrant breach of the law.

Cultural and economic life in cities was heavily influenced by artisans and merchants, who were collectively known as *chōnin* ('townspeople'). During the Tokugawa period, this group largely determined how *matsuri* were publicly celebrated in urban centres, and

this in turn has had a significant impact on modern *matsuri*. Though local festivals previously exhibited highly diverse profiles, today elements of the Edo (pre-Meiji name for Tokyo) festival appear in many urban and rural *matsuri*. This includes, for example, the *mikoshi* and the rambunctious manner in which it is paraded through the streets.

Folk performing arts and festivals

A wide range of folk performing arts *(minzoku geinō)* offer music and theatre to the *kami* during a *matsuri*; they additionally stimulate the lively mood and provide background music to the festivities. They are remarkable in their diversity: one author estimates that in contemporary Japan 'upward of twenty thousand folk performing arts [are] currently being presented'.[5] Of these, the various classical *kagura* dances are an especially important entertainment for the gods. Diverse folk forms of the established theatrical genres of Nō, Kabuki and Bunraku are also presented on shrine and temple stages, suggesting in some cases the popular roots of those classical forms.[6] The major types of folk performing arts that highlight Japanese festivals are:[7]

1. *Kagura*. Dance and mime forms welcoming and honouring the *kami* (see also essay by Onno Mensink).
2. *Dengaku*. Dance and drama forms relating to rice cultivation and harvest.
3. *Furyū*. Dance, theatre and music performed in costumes and/or masks which are linked to the worship of the *kami* and Buddhist invocations for the repose of souls.
4. *Shishimai*. Dance and music in which one or more dancers wear lion masks and perform in the streets or on stage (see below).
5. *Shukufukugei*. Festive arts, mainly vocal and instrumental music, celebrating and honouring the *kami*.
6. Puppet theatre of various kinds, often including text honouring the *kami*.
7. *Kyōgen*. Folk theatre usually of a mocking or foolish nature.
8. *Minyō*. Folk singing.
9. *Katarimono*. Narrative forms reciting congratulatory or festive words.
10. Numerous genres of local music, dance and drama performed in specific regions.

Performances of dance and drama usually take place on an outdoor stage within a shrine or temple precinct. The

performers are almost always amateurs, some inheriting the privilege of playing certain roles or characters. During the Tokugawa period, dancers, actors and musicians of the festive arts were urban artisans or merchants and rural peasants. However, today the dwindling number of amateurs learning these arts hail from a variety of professional backgrounds.

Musical performances can take place within a shrine compound, as part of a street parade or at certain rest stops along the parade route. Most musicians of festival music, called *matsuri-bayashi* ('festival ensemble') in some regions, have been and are still non-professionals. But some Tokyo musicians, who also perform dramatic skits and the lion dance, represent long-standing professional lineages. They play and act not only at numerous traditional festivals but also for store openings, banquets and similar festive occasions.

When festival musicians take part in a parade through the shrine parish, they usually sit in a cart or float. Sometimes these vehicles are simple wooden structures, just large enough to accommodate an ensemble of four or five musicians playing flute, drum and perhaps a *shamisen* or gong. This contrasts with the tall wooden floats of Kyoto's Gion festival, which are draped with sumptuous tapestries and are of significant historical value. The music played on the floats at this festival and others reflects the course of the parade. Melodies are categorised according to the slow, cautious beginning, the frenzied climax of the street parade and even for stops at traffic intersections!

Characteristic of a specific locale, festival music is considered essential for reminding its residents of the special day and for creating the proper celebratory atmosphere. Since many large urban neighbourhoods no longer have their own *matsuri-bayashi* groups or the money to hire them, strategic places along the route of the parade are now equipped with loudspeakers to amplify recordings of famous festival music groups. This highlights the indispensability of festival music as an element of the *matsuri*.

The illustration of festivities in Ukiyo-e

Ukiyo-e prints and books chronicle the diverse culture of the *chōnin* class. They are a valuable source in the illustration of festive occasions or celebratory entertainment, and the four types depicted in the work of the present exhibition include:

1. *Shishimai* ('lion dance', see ills. 67-70). Dances using lion, deer, boar and dragon costumes are common within Japanese folk performing arts, but those involving 'lions' are the most widespread. They are found in numerous variations from Hokkaido in the north to Okinawa in the south.[8] The Japanese lion dance was imported from China around 550 AD, probably first as a kind of acrobatic dance called *gigaku*. Documents record that in 612 a Korean immigrant from the Kudara kingdom was teaching young boys *gigaku* in the town of Sakurai. The 8th-century Shōsōin repository at the temple of Tōdaiji in Nara houses nine carved lion heads and fifteen masks of young lions, the former being almost identical to the heads used in contemporary *shishimai*.[9]

The significance of the lion in East Asian cultures (a creature not native to either China or Japan) lies in its role as 'king of the animal kingdom'. As such, it is believed to be capable of driving away evil and discontent from the physical world. Folk performances of the lion often present it as a ferocious beast that knows no fear. But the lion can also be depicted as a winsome creature as seen in the Tokyo *dai kagura* where it toys with its food before devouring it or twitches its ears whilst in deep sleep. The Tokyo lion also visits houses in the old town on New Year's Day in order to drive out any vestiges of bad luck from the previous year and to welcome in the new.

Dancers of *shishimai* perform in differing combinations, depending on the region. The most common form is the performance of the lion by individual dancers. They appear at the start of the festivities, and through their dance they purify and exorcise evil from the festival area. Such dancers usually don a large wooden lion head that is held with both hands. In some cases three lions perform as a group, including a young and an old lion, and one lioness.[10] In others two performers make up a lion, and together they perform acrobatic stunts. In areas of northeastern Japan, like Iwate prefecture, groups of four to eight lions perform together.[11]

2. *Sannō matsuri* ('Sannō festival', see ill. 72). Along with the Kanda and Asakusa festivals, the *Sannō matsuri* is one of the three great Tokyo *matsuri*. This festival has taken place in mid-June every other year, alternating with the Kanda *matsuri*, since 1681. One reason for this unusual system of alternation was linked to government attempts to curb the ostentatious display of wealth that traditionally accompanied the Sannō festival. Unlike the Kanda and Asakusa festivals, which were held in Edo's *shitamachi* or the old 'downtown' area of the merchants

and artisans, the Sannō took place in the *yamate* or the 'uptown' residential district for samurai and aristocrats. The Sannō festival centred around the Hie shrine, which was built in 1478 and housed the tutelary *kami* responsible for the well-being of Edoites in general and the shogun and his family in particular.[12] This shrine, therefore, had a special relationship with the Edo elite, and during the Tokugawa period the elaborate festivals at the Hie shrine were viewed as occasions to show off the social status and wealth of its parishioners.

The elaborateness of the *Sannō matsuri* led to competition with the participants of the Kanda festival, including many wealthy merchants. One anecdote recounts that Sannō festival participants fell into financial ruin by borrowing huge sums of money for use on the *matsuri*, whilst some Kanda residents, not to be surpassed, sold off their daughters to raise funds for the event.[13]

The Tokugawa-period Sannō parade included hundreds of tall floats *(dashi)* and *mikoshi*. Unfortunately, many of these were destroyed during the Allied bombing of Tokyo during WW II, and since then the proliferation of telephone wires in the city centre has made such a parade difficult in any case. At present the Sannō festival parade proceeds through areas that comprise Tokyo's most important business and government districts, including Yūrakucho, Ginza, Kasumigaseki, Otemachi, Akasaka and Yotsuya.[14] The relative dearth of night-time residents in these districts today is evinced in the meagre participation of *ujiko* parishioners - a stark contrast to the Tokugawa period when samurai and aristocrats would have proudly rode the tall floats through the streets.

3. *Hanabi* ('fireworks', see ills. 64-5). The rise of the *chōnin* during the Tokugawa era spawned numerous festivities that were organised by them. One such festivity is the mid-summer setting-off of fireworks. Whilst firework displays are today held throughout Japan, the *hanabi* most frequently captured by artists is the *Ryōgoku kawabiraki* (opening of the river at the bridge, Ryōgokubashi) which takes place on the banks of Tokyo's river, the Sumidagawa. Originally this spectacle occurred around 1 June to mark the beginning of the sweetfish season, but today it takes place in late July.[15] It is not surprising that the *Ryōgoku kawabiraki*, with its dazzling fireworks and spectators dressed in colourful cotton kimonos, has been a favourite subject for artists from the Tokugawa period to the present day.

4. *Hanami* ('cherry-blossom viewing', see ills. 66-7). The most important event marking spring in Japan is the blossoming of the cherry tree *(sakura)*: the word *sakura-doki* ('cherry-blossom time') was once even synonymous with 'spring'. In Japan there are about sixteen principle species of cherry and numerous varieties therein. These range from single- to double-petalled flowers in a broad spectrum of colours and shapes. Japan's extensive range in latitude has resulted in a great divergence in the cherry-blossom season: it begins in January in Okinawa, falling towards late March in Kyushu, early April in Tokyo and the end of May in northern Hokkaido. The relatively short life span of the cherry blossom suggests a Buddhist symbol of life's impermanence. But rather than viewing cherry blossoms in a such a contemplative manner, many Japanese see the season as an opportunity for boisterous *hanami* or 'cherry-blossom viewing' parties. It is usual in large cities for people from all walks of life to stake out a few square metres of park ground under flowering trees early in the morning so that open-air picnic parties can begin in late afternoon. Much food and sake is consumed, so that loud singing and even dancing soon follow.

In earlier times cherry-blossom viewing was a more sedate affair undertaken by Kyoto aristocracy, established as an annual event during the reign of Emperor Saga (r. 809-23). However, it was the Tokugawa *chōnin* who adopted the custom of *hanami* and shaped it into an important time for relaxation, to enjoy the company of others and perhaps also to reflect on the fleeting nature of the physical world.

Notes

1. Makita Shigeru, *Kami to matsuri to Nihonjin* (Kami, festivals and the Japanese) (Tokyo: Kodansha, 1972), 80-1.

2. Michael Ashkenazi, *Matsuri: festivals of a Japanese town* (Honolulu: University of Hawaii Press, 1993), 18.

3. Sonoda Minoru, 'The traditional festival in urban society', *Kokugakuin daigaku Nihon bunka kenkyūjo kiyō* xxxv (1975), 23.

4. John K. Nelson, *A year in the life of a Shinto shrine* (Seattle and London: University of Washington Press, 1996), 133.

5. Barbara E. Thornbury, *The folk performing arts: traditional culture in contemporary Japan* (Albany, NY: State University of New York Press, 1997), xvii.

6. For example, as noted in Misumi Haruo, *Matsuri to kamigami no sekai* (The world of festivals and the gods) (Tokyo: NHK Books, 1979).

7. Nishitsunoi Masahiro, *Minzoku geinō nyūmon* (Introduction to folk performing arts) (Tokyo: Bunken shuppan, 1979), 68–9.

8. *Ibid.*, 61.

9. *Ibid.*, 190.

10. Kurabayashi Shoji, *Nihon no matsuri. Kokoro to katachi* (Festivals of Japan. Spirit and shape) (Tokyo: Shufu no tomosha, 1979), 48.

11. Nishitsunoi (1979), 209.

12. Ozawa Hiroyaki, *Edo mikoshi* (Portable shrines of Edo) (Tokyo: Kodansha, 1981), 52.

13. Nakamura Tadashi, *Minzoku Tokyo no matsuri* (Folklore: festivals of Tokyo) (Tokyo: Yōshobo, 1980), 152.

14. Ozawa (1981), 52.

15. Helen Bauer and Sherwin Carlquist, *Japanese festivals* (Rutland, VT and Tokyo: Charles E. Tuttle Co., 1965), 18.

The women
of the pleasure quarter

Margarita Winkel

Yoshiwara: Edo's licensed quarter

In 1603 Tokugawa Ieyasu (1542-1616) received imperial appointment as the head of feudal power and established his shogunal government in Edo (present-day Tokyo). Just a fishing hamlet one-hundred years earlier, Edo now witnessed unprecedented growth. The burgeoning of the city's predominantly male population resulted in an increase in the areas of prostitution, and in the second decade of the 17th century several brothel owners, led by Shōji Jinemon (d. 1644), petitioned for legal recognition.[1] They argued that the establishment of a licensed quarter would benefit the government by enabling further control over the identity of visitors, the amount of time they spent in houses of pleasure and the widespread practice of kidnapping children for prostitution. Their efforts soon bore fruit. In the eleventh month of 1618 they began operation of Edo's first and only licensed quarter on a plot of land measuring approximately 218 x 218 m and situated on what was then the outskirts of the city. The quarter was named 'Yoshiwara' (reed [yoshi] field [wara]) as it occupied a vast riverfront area overgrown with reeds. In 1626 the character for 'reed' was replaced by a much more auspicious character meaning 'good fortune', also pronounced yoshi.

Edo continued to expand, and in 1656 the government reclaimed the land belonging to the Yoshiwara and offered the brothel owners a new location north of the city. Although the new site was close to the popular temple, the Asakusadera, it was still difficult to reach, and brothel proprietors feared the move would spell the end of their livelihood. To compensate them the government increased the allotted area by 50% percent and allowed them to run during night-time hours. Moreover, the government promised to take measures against 'bathhouses' which operated as illegal brothels in various parts of the capital and seriously competed with Yoshiwara establishments.

Whilst business initially slackened following the move, it was not long before this 'New Yoshiwara' (Shin

Yoshiwara) regained its former popularity. From the mid-18th to mid-19th centuries it became the centre of Edo's avant-garde popular culture. Together with the Kabuki theatre, the Shin Yoshiwara embodied the ukiyo, the 'floating' world of transient, earthly pleasures. The relationship between the Yoshiwara and Kabuki was intimate as the affairs of the pleasure quarter - most notably the at times very sensational deaths of high-ranking courtesans - were an important source of inspiration for Kabuki playwrights. Kabuki actors and Yoshiwara courtesans were frequent subjects in the prints and paintings of the Ukiyo-e school, which also peaked in popularity and sophistication during this era.

Both Ukiyo-e and Kabuki tended towards a romanticisation of life in the pleasure quarter, but writers of popular novels and comic poetry tackled this topic from a more humorous perspective. In the second half of the 18th century, the Shin Yoshiwara became the main subject of a type of novel called sharebon. Sharebon were witty, often licentious, tales that poked fun at life in the pleasure quarters, especially the love affairs of gallants and prostitutes. Written by connoisseurs like the celebrated author and print designer Santō Kyōden (1761-1816), they introduced the reader to the difficult and ever-changing code of behaviour within the district. By then the sensitivity to current fashions had become an important feature of Yoshiwara life.

The Yoshiwara continued operation until 1958, but from the 1840s its cultural significance had already begun to wane. Increased competition from illegal prostitutes, the impact of natural disasters, worsening economic conditions and harsh sumptuary edicts, along with the Yoshiwara's inability to adapt to change, all contributed to the district's decline in prosperity.

The plan and population
of the New Yoshiwara

The area of the New Yoshiwara measured 326 X 218 m; it was surrounded by walls and a moat. A gatekeeper at the entrance, the Ōmon (large gate), kept watch over

incoming and outgoing traffic. Anyone entering could be asked for personal identification, and prostitutes working in the district were forbidden to leave without written permission from their employers. Within the Yoshiwara enclosure three parallel streets, the Edo-chō, Kyō-machi and Sumi-chō, intersected the central avenue or Nakanochō, and these formed the basic plan of the quarter (see ill. on p. 48).

The Yoshiwara could be reached by road on foot, horseback or palanquin or by boat, and the entrance was located at the end of a winding road lined with teahouses (chaya). Some of these teahouses were known by the sobriquet amigasa-jaya ('woven-hat teahouses') in that beehived-shaped amigasa were available for hire there. These woven hats, which effectively concealed the head and face, were used by men - mainly samurai - who wished to remain incognito whilst visiting the Yoshiwara. Ukiyo-e prints and book illustrations of Yoshiwara scenes often depict figures whose faces are hidden under these unusual hats.

The plan of the quarter underwent change during the Tokugawa period (1600-1868) with brothels experiencing periods of prosperity and decline. Descriptions and maps of the late 17th and first half of the 18th centuries indicate that the Yoshiwara contained about 270 brothels.[2] There were also houses of assignation (ageya), teahouses and shops catering to prostitutes and clients.

Fires and the forced reallocation of illegal prostitutes sometimes had a profound effect on the quarter's plan. In a period when buildings were predominantly made of wood and paper, fires were frequent and greatly feared. In an area like the Yoshiwara, characterised by cramped living and working conditions, the effects of fire could be devastating. During the Tokugawa period alone the Yoshiwara burnt to the ground sixteen times; this resulted in the death of many prostitutes in that they were all but imprisoned in brothel buildings.

The Edo government made several attempts to close down illegal brothels, which were at first disguised as 'bathhouses' and later as 'teahouses'. Women who were caught at illegal prostitution were given two choices: they could renounce a life of prostitution in which case they were often sent to the countryside where depopulation caused by poverty and famine created a great demand for brides, or they could relocate to the New Yoshiwara where they were obliged to work for three years without pay. Following several raids in the 1660s, two streets were added to the quarter to accommodate new prostitutes. Since the majority of

these women were 'teahouse' prostitutes from the Fushimi and Sakai districts, the new avenues were called Fushimi-chō and Sakai-machi.

The documentation of prostitutes and their young assistants (future prostitutes) in brothel guides suggests that in around 1642 there were about 1000 prostitutes working in 125 brothels. By the late 1780s, the permanent population of prostitutes was estimated to be approximately 2500 individuals. The total population would have additionally comprised brothel and shop owners, clerks, entertainers and assistants. The Kansei reforms of 1789 caused a new wave of illegal prostitutes to enter the Yoshiwara, and the number of residents topped 4000. In the early decades of the 19th century the population exceeded 5000. Round-ups of illegal prostitutes during the Tenpō reforms of the early 1840s resulted in another rise in the Yoshiwara population; it is thought to have reached 6000 by 1844. A census conducted in 1846 indicates that a total of 7917 prostitutes were living in the quarter that year, the highest population density recorded for the Yoshiwara in its history.[3] A severe earthquake in 1855 killed many prostitutes, and this is reflected in the 1857 population figure of 4000.

J.E. De Becker, who was in Japan during the Meiji period (1868-1912), bases his number of 2900 to 3000 prostitutes operating in the Yoshiwara in 1897 on what he describes as the 'comparatively reliable' statistics of official medical examinations. He also records that on average these women received between 415 and 460 customers annually.[4] De Becker's study reveals that the Yoshiwara population had fallen to a number on par with the 1780s.

The enormous increase of Yoshiwara prostitutes in the late 18th and early 19th centuries made a shortage of space a perennial problem in the quarter. This was exacerbated by the fact that, despite a growing population, the New Yoshiwara was never allowed to extend beyond its original borders. The desperate need to find solutions for the cramped conditions is seen in the changes in the district's surrounding moat. Originally about 9.6 m wide, land reclamation had reduced it to only 3.6 m by the beginning of the Meiji period.

The hierarchy of brothels and prostitutes

Yoshiwara brothels were initially classified according to the highest rank of courtesan resident in an establishment. By the end of the 18th century, the form

of the wooden lattice windows fronting brothels became the deciding factor in their categorisation. These windows played an important role in that it was behind these that all prostitutes, except the highest class of courtesans, sat on display. Top-class establishments with the highest-ranking prostitutes comprised the *sō-magaki* ('complete lattice') or *ōmagaki* ('large lattice') brothels. The wooden lattices of these houses ran vertically from floor to ceiling and were about 20 cm wide. The next level were the *han-magaki* ('half-lattice') or *majiri-magaki* ('mixed lattice') establishments, where the upper or lower quarter of the lattice front was left open. These were followed by the *sōhan-magaki* ('complete half-lattice') where the partition covered only the lower half of the front and where prostitutes were clearly on view to potential clients and passers-by. The lowest-ranking brothels were found in the narrow backstreets and along the moat. If these had a latticed front, the bars would only be about 9 cm wide. At the cheapest houses of pleasure the bars ran horizontally instead of vertically.

When the old Yoshiwara began its operation, courtesans of the highest class were the *tayū*, and the cheapest prostitutes were the *hashi* or *tsubone*. A popular *tayū* would enhance the status of her brothel. *Hashi* or *tsubone* were not as fortunate: they were forced to ply their trade in small brothels located in backstreets and in the long tenement houses situated along the quarter's surrounding moat. A new rank called *sancha* (literally, 'powdered tea') was created following the arrest and transportation of 'teahouse' prostitutes to the New Yoshiwara between 1665 and 1668. Their arrival eventually upset the original hierarchy as their fees were lower than those of the *tayū*. It has to be remembered that in addition to the fees levied by the brothels, the customer also had to pay fees to the *ageya* that arranged appointments with *tayū*. Yoshiwara *tayū* eventually priced themselves out of existence, and with the retirement of the renown *tayū* Hanamurasaki of the Tamaya in 1761, this class of courtesan ceased to exist.

The major changes in ranking that occurred in the 1760s involved the division of the *sancha* into three new categories, the *yobidashi*, *chūsan* and *tsukemawashi*, which collectively represented the new upper-class courtesans called *oiran*. The highest of these, the *yobidashi* (literally, 'call out'), met clients by appointment only. Custom dictated that they had to be approached through special teahouses situated on Yoshiwara's central avenue, the Nakanochō.

Following the *oiran* in rank, and later included

among them, were the *zashikimochi* ('apartment owners'). Like all high-class courtesans, the *zashikimochi* had more than one room for their personal use which they rented from the owner of the brothel to which they belonged. The next rank were the *heyamochi* ('room owner') who had only one room; they were followed by the *mawashi-jorō* ('rotating prostitutes'). *Mawashi-jorō* did not have private rooms but lived together in one large space. They created private areas for themselves and their customers through the use of movable screens. The lowest classes of prostitutes could not be found in the better brothels along Yoshiwara's main roads, rather they operated in the aforementioned brothels in the small backstreets and along the moat. They were known by various names such as *kashi* ('moat-side'), *kiri* ('short-time') or *tsubone*.

All high-class courtesans were waited upon by young female assistants whose education and upkeep were their responsibility. The number of attendants varied with rank: the higher a courtesan's rank the more private rooms, and therefore attendants, she was able to accommodate. These attendants were of two types, *kamuro* and *shinzō*, and a high-ranking courtesan would have at least two *kamuro* and two *shinzō* at her service.

Girls destined to become *kamuro* were brought to the Yoshiwara around the age of seven and were assigned to a 'big sister' courtesan. Their task was to help and escort the elder courtesan, and to learn 'the tricks of the Yoshiwara trade'. Educated in the arts and music, they also acquired such skills as verbal persuasion, the writing of love letters and the faking of tears to create the 'romantic' world sought after by their customers. *Kamuro* are portrayed in Ukiyo-e prints and paintings as charming little girls in matching kimono who accompany a 'big sister' courtesan. Their hairstyles were simple and adorned with colourful floral ornaments. In contrast to courtesans and *shinzō*, *kamuro* tied their *obi* at the back; tassels worn on their sleeves further enhanced their playful image.

A *kamuro* exhibiting exceptional promise was temporarily withdrawn from her 'big sister' courtesan around the age of eleven or twelve. She was further educated by the brothel owner and his wife in the arts and other skills so as to enable her debut as a high-ranking courtesan, usually at the age of thirteen or fourteen. Her 'coming-out' ceremony was sponsored by her former 'big sister' courtesan, and whilst it carried great prestige for the older courtesan it also represented an enormous financial burden. *Kamuro* who lacked the outstanding qualities needed to become a high-class

courtesan would become *shinzō*. Their future position depended on their beauty, conversational skills, abilities at entertaining, proper decorum and intelligence. There were several types of *shinzō*: *furisode-shinzō*, *tomesode-shinzō* and *banto-shinzō*.

Furisode-shinzō or *furishin* ('long-sleeved *shinzō*') are recognisable in Ukiyo-e prints by the elegant long-sleeved kimono associated with girlhood and an *obi* tied in front in the style of courtesans. *Shinzō* were not supposed to have sexual relations with clients, but they were expected to attend to and entertain a client until the arrival of the senior courtesan. A *furishin* was best off if she could secure a patron to cover her main expenses. If successful in this pursuit, she became a *tomesode-shinzō* or *tomesode* ('short-sleeved *shinzō*') and wore a short-sleeved kimono like full-fledged courtesans. If her patron additionally bought her a set of luxurious bedding, she became a *heyamochi* ('room owner'). Moreover, if she was popular and could guarantee the backing of several patrons, she could be promoted to the aforementioned *zashikimochi*. In this case she was entrusted with the care of one or two *kamuro*.

If a girl could not expect a future as an expensive courtesan, she might aspire to become a *banto-shinzō* or *banshin* ('supervising *shinzō*'). She would then work as the personal assistant to a high-ranking courtesan. Whether a *banshin* received customers or not depended upon the rank and the financial standing of the courtesan who engaged her. If the proprietor of the brothel liked her, he could ask her to work as a *yarite*, a female supervisor and teacher in the service of a brothel. Becoming a *yarite* was also an alternative for a courtesan who had finished her service and, for whatever reason, could not hope for a life outside the pleasure quarter. *Shinzō* who were unsuccessful in obtaining any of these positions faced the ignominy of working as a low-class prostitute.

A young girl purchased by a brothel owner remained in his debt until her 'obligations' were paid off. Although kidnapping was a widespread problem, especially in rural areas, girls were often bought directly from poor families. In a moral or social sense, therefore, they were not condemned by society in that they not only obeyed their parents' will by allowing themselves to be sold but also helped to relieve their parents' impoverishment. Ideally, it took at least ten years, sometimes more, for girls to finish their service and regain their freedom. A patron could secure the early release of a prostitute by paying the brothel owner a

large sum. Although high-ranking courtesans could earn substantial amounts of money, the expenses for her own upkeep and that of her junior assistants were considerable. She had to rent one or more rooms and furnish them appropriately, buy expensive clothes and be generous towards those who assisted her, including geisha and teahouse employees. A popular courtesan was a gold-mine to a brothel owner. Brothel owners were known to be clever and unscrupulous in inventing ways to place a courtesan deeper in debt, thereby increasing their own profit but at the same time subjecting her to an endless spiral of indentured servitude. Needless to say, the situation for cheap prostitutes, who worked in appalling conditions, was far worse. Disease was rife among prostitutes, and owners were unwilling to spend much money on medical care, especially for ordinary prostitutes whose services brought little financial return. The problems of illness and the effects of poor care coupled with the frequent occurrence of devastating fires and earthquakes meant that the lives of many prostitutes ended well before their service was over.

Geisha

Different from the image generally held in the West, geisha were not prostitutes. They were male or female professional entertainers, and Yoshiwara geisha did not cater to men's sexual fantasies. Whilst most early geisha were male, the number of female geisha in the Yoshiwara rose quickly during the final decades of the 18th century. In 1770 there were thirty-one male to sixteen female geisha. Five years later, women outnumbered men for the first time, and in 1800 there were forty-five male and 143 female geisha working in the Yoshiwara.[5] This increase in numbers prompted the establishment of an agency in 1779 which controlled the activities of geisha and arranged appointments for them.

Geisha are invariably associated with the *shamisen*. Imported from the Ryūkyū islands during the 16th century, this stringed instrument became the standard accompaniment to popular songs in Japan. At first it was only high-ranking courtesans who sang and played the *shamisen*. However, with the widespread popularity of the instrument its playing became less exclusive, and by the late 18th century high-ranking courtesans increasingly left this task and singing to their own *shinzō* or to geisha.

Fig. 19.
New Yoshiwara.

The Yoshiwara in prints and books

The close ties between the Yoshiwara and prints or popular books is embodied in the activities of perhaps the best-known seller/publisher of books and prints dealing with the Yoshiwara, Tsutaya Jūsaburō (1750-97). Born and raised in the Yoshiwara, Tsutaya opened a bookshop at the entrance to the quarter in 1773, where he sold maps of the district. These maps were regularly updated, providing information on the location and status of each brothel as well as listing the names and ranks of their courtesans and sometimes their assistants.[6] In 1774, Tsutaya launched his career as a publisher with the production of 'courtesan critiques' (*yūjo hyōbanki*). As guidebooks that contained more detailed, but also more subjective, information than the earlier maps, these courtesan critiques included an evaluation of the accomplishments of individual courtesans. Tsutaya, also known as Tsutajū, soon became the leading producer of the witty *sharebon* mentioned earlier, and in the 1790s he was the foremost publisher of prints of actors (*yakusha-e*) and beauties (*bijinga*).

Geisha and prostitutes are easily distinguished in the prints (and illustrated books) published by men like Tsutaya and others. Geisha were dressed in an under-kimono and only one kimono which was covered by a

black over-kimono when outdoors; they went barefoot or wore low *geta*. Like *kamuro*, geisha tied their *obi* at the back. As seen in many prints of the period, Yoshiwara geisha often donned monochromatic kimono decorated with crests. Geisha can also be identified by their *shamisen* or by the black-lacquered *shamisen* case that is usually carried by a male servant walking behind her.

By contrast, courtesans imitated the female court dress of the Heian period (794-1185) in wearing several layers of kimono. Although styles of coiffure and kimono changed over time, as evinced in prints, some features remained constant. Unlike *kamuro*, courtesans tied their *obi* at the front. These were often done in complicated knots whose styles were subject to prevailing fashions. They wore toed socks (*tabi*) and when outdoors high *geta*. On outings courtesans were usually accompanied by their *shinzō* or *kamuro* and a male servant holding an umbrella. The appearance of elegantly dressed *yobidashi* courtesans, escorted by their young assistants and male attendants as they paraded along the Nakanochō in a procession called *oiran dōchū*, was one of the celebrated events of the Yoshiwara and a popular subject in Ukiyo-e. Prints also portrayed courtesans and their retinue during important Yoshiwara annual festivals or special occasions such as cherry-blossom viewing in spring. Ukiyo-e artists would additionally capture a popular courtesan in solitary

activities - absorbed in reading or writing a letter, looking in a mirror, dressing, reading a book or even playing with a cat. Other prints, known as *ōkubi-e* ('large head'), were portraits. Their subjects were not anonymous beauties but actual women whose names as well as those of their assistants and their brothels were often explicitly stated on the print. These women would have been well known to any visitor familiar with the Yoshiwara, and their popularity was counted upon to increase print sales. Such prints, therefore, served an important purpose: they were inexpensive souvenirs for those unable to afford the company of the Yoshiwara's beguiling beauties.

Notes

1. The most important source of information on the origin of the Yoshiwara is the *Ihon dōbō goen* ('Brothel episodes'), which was written in 1720 by Shōji Katsutomi, the sixth-generation descendant of Shōji Jinemon. According to Katsutomi, Jinemon spearheaded the establishment of a licensed brothel quarter in Edo. The existence of licensed brothels and pleasure quarters was not new to Japan: the first licensed brothel district had been formed in Kyoto as early as 1589.

2. These figures are adopted from Nishiyama Matsunosuke, 'Yoshiwara', vol. 14 of *Kokushi daijiten* (Tokyo: Yoshikawa Kōbunkan, 1993), 439. The author does not indicate the names of the maps and guides used for his calculations.

3. *Ibid.*, and Cecilia Segawa Seigle, *Yoshiwara: the glittering world of the Japanese courtesan* (Honolulu: University of Hawaii Press, 1993), 34.

4. J.E. De Becker, *Yoshiwara: the nightless city* (New York: Frederick Publications, 1960), 166.

5. Seigle (1993), 236-37. This author relied on Seigle's information for the description of brothels and prostitute ranking.

6. The sketch of the Yoshiwara included here is based on a map included in Mizuno Minoru (ed.), *Yonemanjū no hajimari/Shikake bunko/Mukashigatari inazumabyoshi*, vol. 85 of *Shin Nihon koten bungaku taikei* (Tokyo: Iwanami shoten, 1990), 376.

Suggestions for further reading

Dalby, Liza Crihfield. *Geisha*. Berkeley, CA: University of California Press, 1983.

Jenkins, Donald. *The floating world revisited*. Portland, OR: Portland Art Museum, 1993.

Jones, Sumie (ed.). *Imaging/reading Eros: proceedings for the conference 'Sexuality and Edo culture, 1750-1850'*. Bloomington, ID: The East Asian Studies Centre, Indiana University, 1996.

Kornicki, Peter. *The book in Japan. A cultural history from the beginnings to the nineteenth century*. Leiden, Boston and Cologne: Brill, 1998.

Nishiyama Matsunosuke, *Edo culture. Daily life and diversions in urban Japan, 1600-1868*. Trans. and ed. by Gerald Groemer. Honolulu: University of Hawai'i Press, 1997.

Swinton, Elizabeth de Sabato. *The women of the pleasure quarter: Japanese paintings and prints of the floating world*. New York: Hudson Hills Press, 1995.

Notes to the catalogue

Signatures on prints can be followed by the characters *ga* and *hitsu* which literally translates as 'picture by' or 'drawn by' *(ga)* and 'from the brush of' *(hitsu)*. These terms carry the general meaning of 'designed by'. Signatures are also sometimes followed by the characters like *utsusu*, 'copied by' or *monjin*, 'student of' the preceding name. Names can be preceded by the phrases *motome ni ōjite* or *ōju*, both meaning 'on request' and indicating a special commission. In addition, certain characters are commonly seen following names in the text of seals such as *no in*, which is read 'seal of'. The signatures of engravers can be preceded by the character *'hori'*, meaning carver, or followed by the character *tō*, translated as 'the knife of'. Names or parts thereof appearing on prints which are illegible or unknown have been indicated by dots ('...') and a (?) where the reading or name is questioned.

Unless otherwise stated, all measurements are given in millimetres, height preceding width. When indicated, months appear in roman numerals. Please note that the grouping of the entries below differs slightly from that of the exhibition. The last eleven prints appearing in the exhibition in the section called 'Figures from history and legend' have been included under the heading 'Musical instruments' (cat. nos. 38-49) in the catalogue.

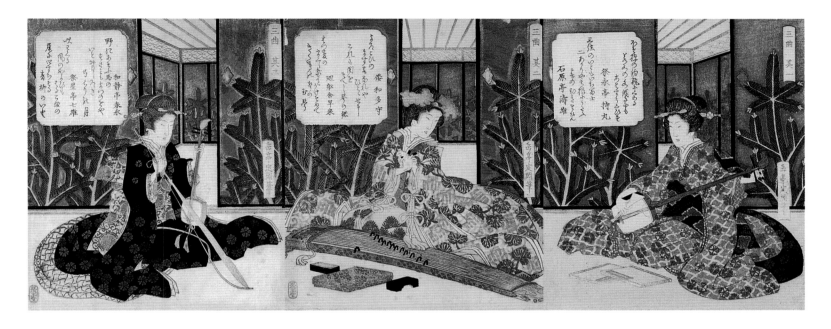

1. Yashima Gakutei (1786?-1868)

'The three musical instruments' *(Sankyoku)*, 1822
Signed *Gakutei Sadaoka hitsu*
Printed by Shugyokudō (centre and left sheets)
Privately issued by the poets
Woodblock, *shikishiban surimono* triptych, 209/210 x
182/186 (each)

> Rijksmuseum, Amsterdam 1958:382 (right sheet);
> Gemeentemuseum Den Haag PRM-0000-2376 (centre sheet);
> Gemeentemuseum Den Haag PRM-0000-2377 (left sheet)

A traditional musical ensemble exemplified by women
seated in a large room with a view into another room
through the partly opened sliding panels. They are
performing on (right to left), a *shamisen*, *koto* and the
four-stringed *kokyū*, which is played with a bow. Two
songbooks are before the woman to the right whilst two
lacquered boxes - the larger for storing *koto* bridges, the
smaller for finger plectra - are set before the central
figure. The sliding panels behind them are illustrated
with a painting of young pine trees, a reference to the
New Year.

Some of the poems contain allusions to the Year of
the Horse (1822). This allusion is immediately
understandable in the *kokyū* bow, but also in that all the
instruments employ long strings reminiscent of a
horse's tail. Each print is inscribed with two *kyōka*
poems included within a rectangular cartouche. They
were written by members of the various poetry clubs
that commissioned this *surimono* triptych.

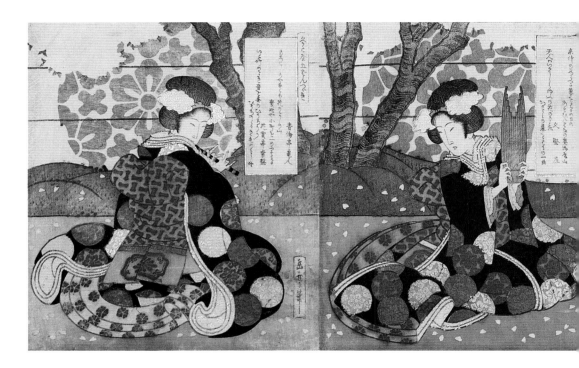

2. Yashima Gakutei (1786?-1868)
'A set of five prints for the Hisakataya poetry club'
(Hisakataya gobantsuzuki), late 1820s
Signed *Gakutei hitsu*
Privately issued by the Hisakataya poetry club
Woodblock, *shikishiban surimono* pentaptych, 214/219 x
185/188 (each)

Rijksmuseum voor Volkenkunde, Leiden 1353-327-331

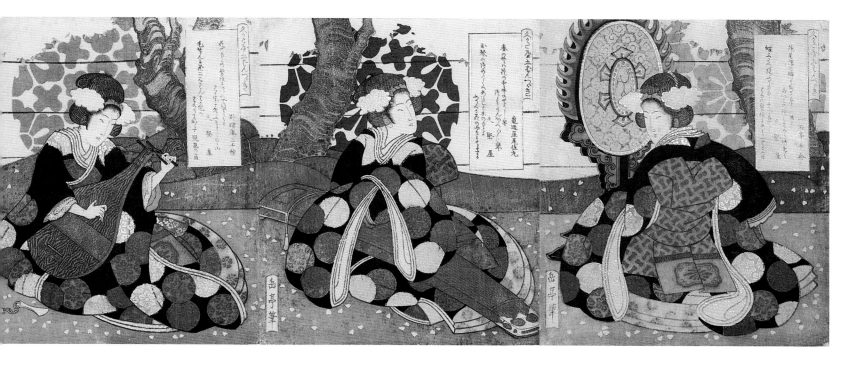

A traditional musical ensemble represented by women seated on red matting under flowering cherries; a large curtain is hung behind them. They are playing (from right to left) a large drum *(tsuridaiko)*, zither *(koto)*, lute *(biwa)*, mouth organ *(shō)* and flute *(yokobue)*.

The Hisakataya commissioned this *surimono* pentaptych. Each print is inscribed with two *kyōka* poems within a rectangular cartouche which were written by members of the Hisakataya poetry club. They include: Issekitei Senkin and Hisakataya (Misora); Kamenoya Osamaru and Hisakataya (Misora); Gashaan Sanchitane and Hisakataya (Misora); Suihōtei Komatsu and Hisakataya (Misora); Shōkaitei Kamendo and Hanabitei Tsunewada.

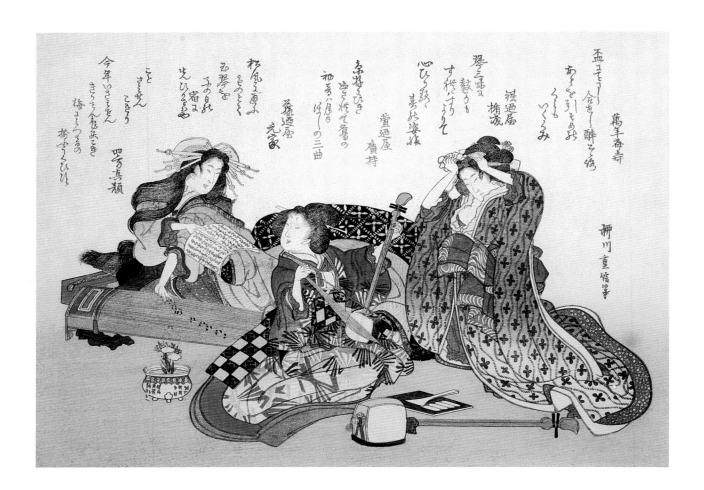

3. Yanagawa Shigenobu (1787-1832)

Signed *Yanagawa Shigenobu hitsu*

Woodblock, *surimono*, 206 x 285

Gemeentemuseum Den Haag PRM-1984-0002

A traditional musical ensemble illustrated by women who are playing (from right to left) a *shamisen*, the four-stringed *kokyū* with bow and *koto*. The woman to the right is adjusting her hairdo; her *shamisen* rests on the floor in front of her and her plectrum lies upon a songbook. To the left is an adonis *(fukujusō)* in a porcelain pot, a traditional New Year's plant.

This is a Meiji-period (1868-1912) copy after a *surimono* originally issued privately by the Yomogawa poetry club around 1825.

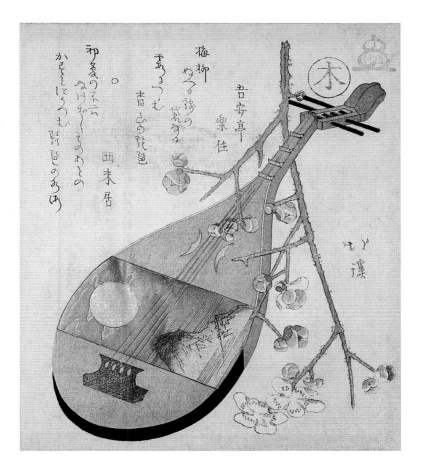

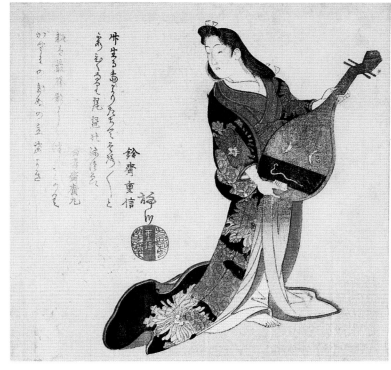

4. Totoya Hokkei (1780-1850)
From the series *The five elements
(Gogyō)*, early 1820s
Signed *Hokkei*
Privately issued by an
unidentified poetry club
Woodblock, *shikishiban surimono*,
210 x 181

Gemeentemuseum Den Haag
PRM-0000-2321

A still-life of a lute *(biwa)* and a
spray of plum blossoms as an
illustration of the basic element
'wood' *(ki)*. The section of the

instrument where the strings are
commonly played with an ivory
or wooden plectrum is protected
with a piece of leather or textile.
Here it is decorated with a scene
of a full moon over a mountain
range.

The two poems above are by
Goantei Rakuzumi and
Sairaikyo (Mibutsu, a judge of
the Gogawa poetry club).

**5. Yanagawa Shigenobu
(1787-1832)**
Signed *Yanagawa* with seal
Shigenobu
Privately issued by the poets,
1821
Woodblock, *shikishiban surimono*,
182 x 185

Gemeentemuseum Den Haag
PRM-0000-2331

A woman is dressed in a style
associated with a much earlier
classical era, her hair hanging
long and loose over her neck. She

is holding a lute *(biwa)*. A decoration
in the shape of a snake, an allusion
to the Year of the Snake (1821),
ornaments the leather protecting
the instrument where it is played.
The date of 1821 is further
confirmed in the numerals for
the long and short months for
this particular year, which are
included in the seal of the artist.

The work is inscribed with
two *kyōka* poems, the first by
Shigenobu himself (signed
Reisai Shigenobu) and the
second by Nichijusai Hiromaru.

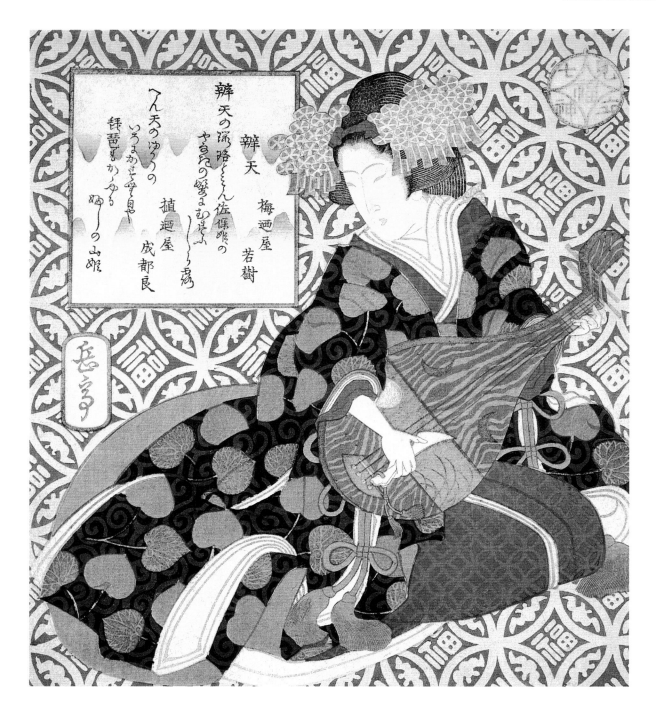

6. Yashima Gakutei (1786?-1868)
From the series *A mitate of the Seven gods of good fortune*
(Mitate shichifukujin), late 1820s
Signed *Gakutei*
Privately issued by the Shippō poetry club
Woodblock, *shikishiban surimono*, 208 x 185

Gemeentemuseum Den Haag PRM-0000-2303

A seated women is dressed in a kimono decorated with mallow *(aoi)* leaves, her hair decorated with large metal ornamental hairpins. She is playing a lute *(biwa)*. The image of the moon over the Musashino plains, recognisable by the pampas grass, ornaments the leather protecting the instrument where it is played. The woman represents the goddess Benten, one of the popular Seven gods of good fortune *(shichifukujin)*, who often appears with her attribute, the *biwa*. The ground is decorated with a repetitive pattern of partly superimposed circles *(shippō)* with the word 'luck' *(fuku)* in the centre and bats, also auspicious symbols, on the four sides.

Two *kyōka* poems by Umenoya Wakagi and Shokunoya Natora appear above.

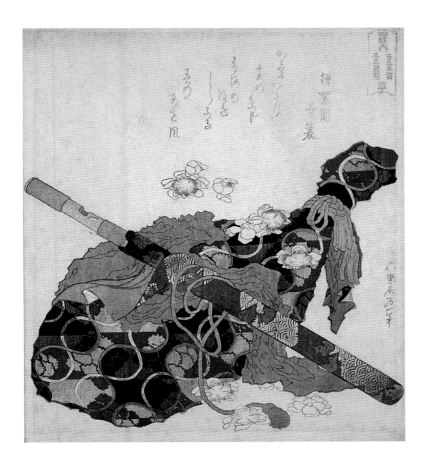

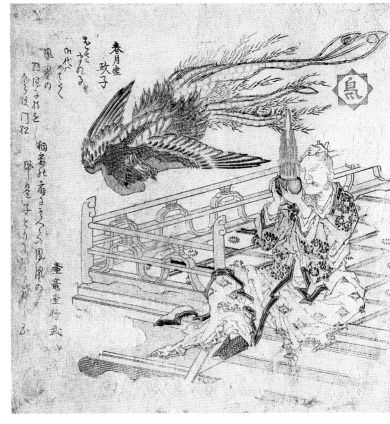

7. Katsushika Hokusai (1760-1849)

'The Aoba flute and the Aoyama lute' (*Aobafue Aoyamabiwa*) from the series *The four clans* (*Shisei no uchi*), 1822

Signed *Fusenkyo Iitsu hitsu*

Privately issued by an unidentified poetry club

Woodblock, *shikishiban surimono*, 213 x 186

Rijksmuseum voor Volkenkunde, Leiden 360-2345t

This *surimono* illustrates a still-life of a lute (*biwa*) and flute (*yokobue*). Both are depicted in their richly decorated brocade wrappers with red silken cords and tassels. Some plum blossoms are strewn over the instruments. These musical instruments represent the family treasures of the Taira clan as is indicated in the title of the print, 'The Aoba flute and the Aoyama lute'.

There is a *kyōka* poem above.

8. Totoya Hokkei (1780-1850)

'Bird' (*Tori*), from an untitled series on the theme of 'flowers, birds, wind and moon' (*kachō fūgetsu*), early 1820s

Signed *Hokkei*

Privately issued by an unidentified poetry club

Woodblock, *shikishiban surimono*, 207 x 184

Gemeentemuseum Den Haag PRM-0000-2324

Shōshi was a famous flute player from the Chinese Qin dynasty (255-209 BC) who is said to have played such divine music that phoenixes flew down from heaven to listen to his music. Here Shōshi is playing a *sheng*, a Chinese mouth organ. This print represents the 'Bird' subject from a series of four on the classical theme, possibly of Chinese origin, of flowers, birds, wind and moon (*kachō fūgetsu*).

There are two *kyōka* poems by Shungetsudō Masako and Koryūdō Yukitake above.

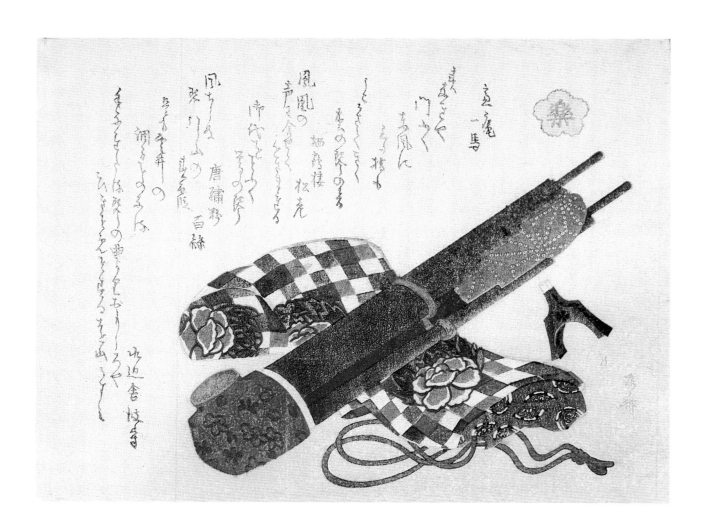

9. Ryūryūkyo Shinsai (1764?-1825?)

'Music' *(Gaku)* from an untitled series on 'the six
accomplishments' *(rikugei)*, early 1800s

Signed *Shinsai*

Privately issued by an unidentified poetry club

Woodblock, *surimono*, 147 x 188

Gemeentemuseum Den Haag

PRM-1985-0003

A still-life of a mouth organ *(shō)* - which consists of a
number of bamboo pipes with a lacquered wind chest -
resting on its cloth wrapper on the left and a *koto* bridge
to the right. This print represents 'Music' from a series
of six prints; the title is inscribed in a plum blossom-
shaped cartouche.

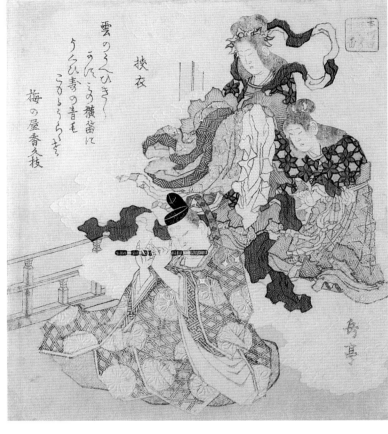

10. Totoya Hokkei (1780-1850)
Signed *Aoigaoka Hokkei*
Privately issued by the poet,
mid-1820s
Woodblock, *shikishiban surimono*,
209 x 185

 Gemeentemuseum Den Haag

 PRM-0000-2320

A Japanese nobleman in court
attire with cap sits on a terrace
under a window and plays the
flute (*yokobue*) whilst the sun is
setting.

 A *kyōka* poem by Gorōdai
Toshiyori is to the left.

11. Yashima Gakutei (1786?-1868)
From the series *Ten stories for the Honchōren (Honchōren monogatari jūban)*, mid-1820s
Signed *Gakutei*
Privately issued by the Honchō
poetry club
Woodblock, *shikishiban surimono*,
206 x 180

 Gemeentemuseum Den Haag

 PRM-0000-2333

Accompanied by one of her
maidens, Seiōbō, the Daoist Royal
mother of the western
hemisphere, appears in a cloud
at the sound of the flute
(*yokobue*) played by a Japanese
nobleman. The nobleman is
Sagoromo no daishō, a
womaniser and protagonist of
the *Sagoromo monogatari* (Tale of
Sagoromo, 1069-77?), a story
attributed to Daini, the daughter
of the authoress Murasaki
Shikibu (c. 978-c. 1014).

 A *kyōka* poem by Umenoya
Kakue is seen to the left.

門松は梅のうるおひ
ふたろくてあそせ物より
竜のちる風

鈍々亭

ちゝ姫の
妾の糸も
ひととすみる
浦のすま亭
ひくまるきしれ

金紋舎
幾久丸

12. Ryūryūkyo Shinsai (1764?-1825?)
From an untitled group of still-lifes, c. 1821-22
Signed *Shinsai*
Privately issued by the Taikogawa poetry club
Woodblock, *shikishiban surimono*, 211 x 184

Rijksmuseum voor Volkenkunde, Leiden 360-2345c

This *surimono* is a still-life of a lacquered writing-box on a piece of purple cloth, some books and a single-stringed zither *(ichigenkin)*. A spray of plum blossoms, a reference to the New Year, is seen behind.

Two *kyōka* poems appear above, the first by Kinbunsha Ikumaru and the second by Dondontei Wataru, the leader of the Taiko poetry club. The club's emblem, a drum *(taiko)*, is sealed top right.

13. Ryūryūkyo Shinsai (1764?-1825?)
From the series *Tales of Genji (Genji monogatari)*, c. 1820
Signed *Shinsai*
Privately issued by the Taikogawa poetry club
Woodblock, *shikishiban surimono*, 208 x 188

Gemeentemuseum Den Haag PRM-0000-2328

14. Yashima Gakutei (1786?-1868)
From an unidentified series, 1820
Signed *Gakutei*
Privately issued by the poets
Woodblock, *shikishiban surimono*, 198 x 170

Gemeentemuseum Den Haag PRM-0000-2307

A still-life of a seven-stringed *koto* resting on a *sugoroku* (type of backgammon) board with the game stones in a bag on the board. A court cap and a horse whip are placed before the board; there are a few *koto* bridges next to the cap. These represent chapters 25 to 27 from Murasaki Shikibu's (c. 978 - c. 1014) classic, the *Genji monogatari* (Tales of Genji), which are entitled *Hotaru*, *Tokonatsu* and *Kagaribi*, respectively.

Three *kyōka* poems appear above, the first two written by Kankodō Osamaru and the third by Kinkōsha Gakumaru. The poetry club's emblem, a drum *(taiko)*, appears over the title cartouche.

Taishin Ō Fujin, the youngest daughter of Seiōbō, the Royal mother of the western hemisphere (see also ill. 11), charms a dragon by playing a single-stringed zither *(ichigenkin)*. Normally this Daoist deity is portrayed riding a white dragon.

This is a New Year's *surimono* for the Year of the Dragon, 1820.

Two *kyōka* poems appear above, the first by Fukunoya Uchinari and the second by his teacher Rokujuen (Yadoya Meshimori [1753-1830]).

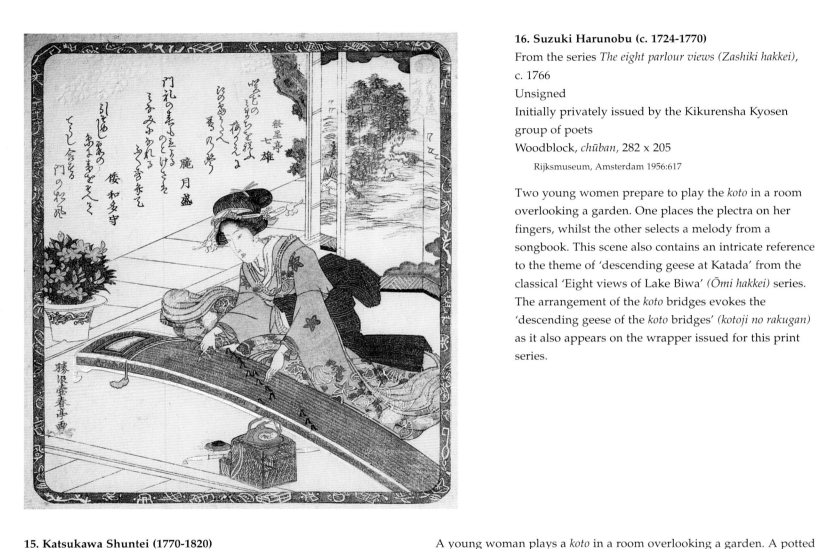

16. Suzuki Harunobu (c. 1724-1770)

From the series *The eight parlour views (Zashiki hakkei)*, c. 1766

Unsigned

Initially privately issued by the Kikurensha Kyosen group of poets

Woodblock, *chūban*, 282 x 205

Rijksmuseum, Amsterdam 1956:617

Two young women prepare to play the *koto* in a room overlooking a garden. One places the plectra on her fingers, whilst the other selects a melody from a songbook. This scene also contains an intricate reference to the theme of 'descending geese at Katada' from the classical 'Eight views of Lake Biwa' (*Ōmi hakkei*) series. The arrangement of the *koto* bridges evokes the 'descending geese of the *koto* bridges' (*kotoji no rakugan*) as it also appears on the wrapper issued for this print series.

15. Katsukawa Shuntei (1770-1820)

From the series *The Seven gods of good fortune for the Hanagasa poetry club (Hanagasaren shichifukujin)*, 1821 (Year of the Snake)

Signed *Shōkyūko Shuntei ga*, with *kakihan* (a written seal)

Privately issued by the Hanagasa poetry club

Woodblock, *shikishiban surimono*, 215 x 189

Gemeentemuseum Den Haag PRM-0000-2311

A young woman plays a *koto* in a room overlooking a garden. A potted plant is positioned on the verandah and a set of smoking utensils is seen in the foreground. The young woman alludes to the first tuning of the *koto* in the New Year, and like everything done first, this is also considered of special importance. The shell patterns on her kimono and the view of the island of Enoshima on the screen in the background refer to Benten, one of the Seven gods of good fortune (*shichifukujin*) who is worshipped at a shrine on Enoshima. Shells, Enoshima and Benten also usually refer to the Year of the Snake.

There are three *kyōka* poems above by Saiseitei Nanao, Oboro no Tsukimori and Yamato no Watamori. Watamori (1795-1849) was the leader of the Hanagasaren, a subdivision of the Taikogawa poetry club. The Hanagasaren emblem, a drum (*taiko*), appears over the series title.

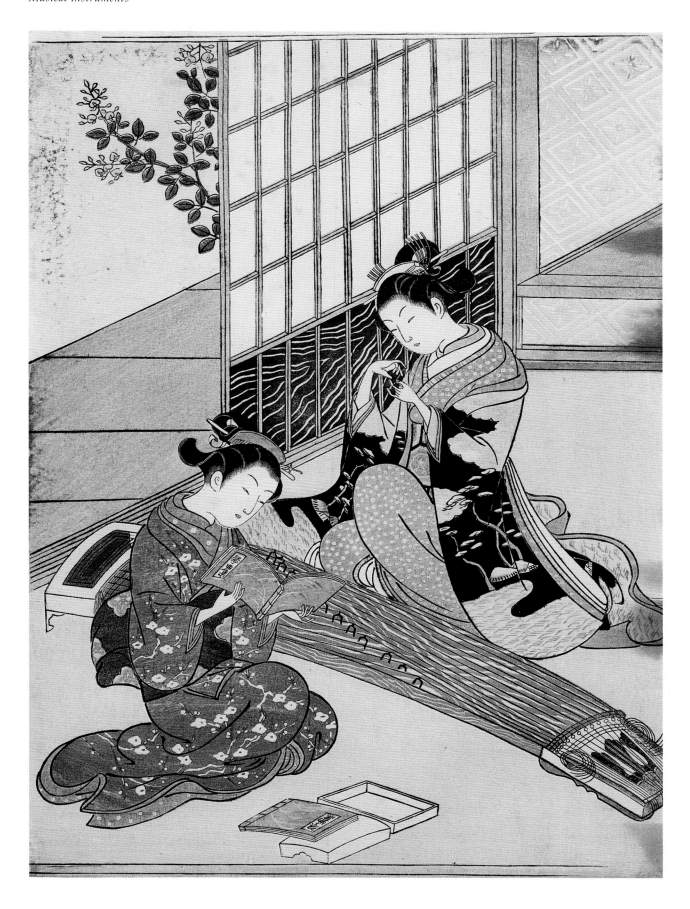

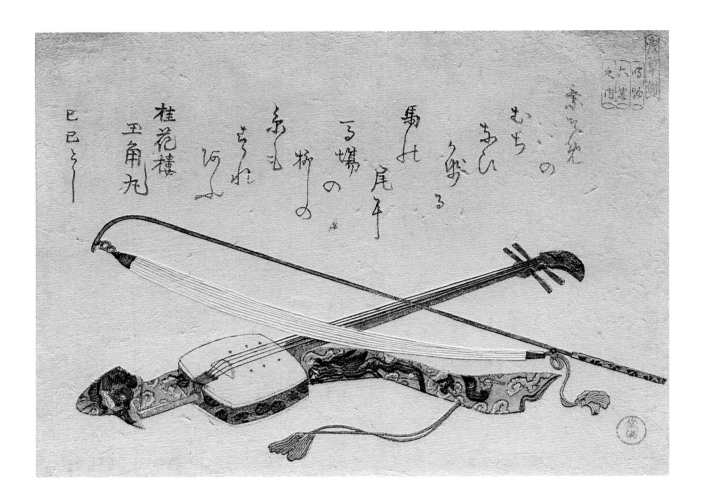

17. Kubota Shunman (1757-1820)

From the series *Six musical instruments (Narimono rokuban no uchi)*, 1809

Sealed *Shunman*

Privately issued by the Asakusagawa poetry club

Woodblock, *surimono*, 134 x 182

Gemeentemuseum Den Haag PRM-0000-2702

A still-life of a *kokyū*, a string instrument played with a bow, and its cloth wrapper.

A *kyōka* poem above is by Keikarō Gyokkadomaru, most likely the owner of the Kado Tamaya brothel in the Yoshiwara.

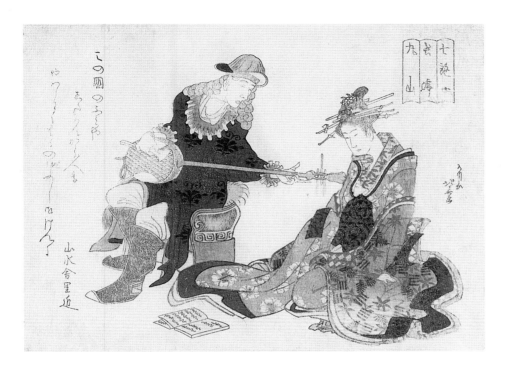

18. Katsushika Hokusai (1760-1849)
From the series *Seven courtesans (Nana yūjo)*, 1806
Signed *Katsushika Hokusai ga*
Privately issued by the poets
Woodblock, *surimono*, 132 x 179
Gemeentemuseum Den Haag PRM-1981-0001

A Dutchman plays a *shamisen* of a non-Japanese type for a courtesan of the Maruyama, the red-light district of Nagasaki. The location is also confirmed in the title of the print.

A *kyōka* poem by Sansuisha Satochika appears to the left.

19. Ryūryūkyo Shinsai (1764?-1825?)
Signed *Shinsai*
Privately issued by the poets, 1820
Woodblock, *shikishiban surimono*, 188 x 174
Gemeentemuseum Den Haag PRM-0000-2313

A still-life of a temple lantern and a *shamisen* on a piece of Indian cloth *(sarasa)*. A spray of camellia lies over the instrument. Visible behind is the instrument's wooden storage box which is labelled *jahasen*, probably an alternative name for the instrument. The decoration of a dragon on the lantern alludes to the Year of the Dragon, 1820.

There are three *kyōka* poems above by Saizanrō, Kakuseirō Takamaru and Kasugatei Nagahito.

20. Totoya Hokkei (1780-1850)

Signed *Aoigaoka Hokkei*

Privately issued by the poet, 1825

Woodblock, *shikishiban surimono*, 216 x 182

Rijksmuseum voor Volkenkunde, Leiden 1223-3

A white rooster on a large drum overgrown with ivy is illustrated against a gold ground. This representation is regarded as an emblem of peace following the old Chinese custom of keeping a drum outside the palace.

The drum was beaten to sound the alarm in the event of danger and to order the assembly of troops. When the country enjoyed peace, fowl perched on these drums.

Although uncommon in Edo *surimono*, a haiku by Zuidō Akegarasu is included above. This work is a calendar print, the numerals for the long months (1, 3, 5, 7, 10 and 12) inscribed on the drum, and *surimono* for the New Year of the Cock, 1825.

21. Ryūryūkyo Shinsai (1764?-1825?)
Signed *Shinsai* (sealed bottom right corner)
Privately issued by the poet, 1825
Woodblock, *shikishiban surimono*, 207 x 185

Rijksmuseum voor Volkenkunde, Leiden 5204-2

A family of rooster, hen and chick nestles near a large drum on a stand. This piece refers to the same tradition depicted in illustration 20. It was probably produced by the designer for the New Year of the Cock, 1825.

A *kyōka* poem by Nijutei Suenaga is included above.

22. Utagawa Kunisada (1786-1865)
From the series *Famous restaurants of today*
(Tōji kōmei kaiteizukushi), early 1820s
Signed *Gototei Kunisada ga*
Published by Yamaguchiya Tōbei
Woodblock, *ōban*, 385 x 262

Rijksmuseum voor Volkenkunde, Leiden 1-4470-x10

A woman is depicted with two hand-drums
(kotsuzumi and *ōtsuzumi)* and a drum of the
shimedaiko type on its stand before her. A
view of the Tagawaya restaurant, in front of
the Daininji temple, is seen in a cartouche top
left.

**23. Attributed to Utagawa Kunisada
(1786-1865)**

From the series *Beauties and the fifty-three
stations of the Tōkaidō (Bijin awase gojūsantsugi)*,
late 1820s
Unsigned
Privately issued
Woodblock, *surimono*, 184 x 121

Gemeentemuseum Den Haag PRM-0000-2336

A woman illustrated with two hand-drums
(kotsuzumi and ōtsuzumi) and a drum of the
shimedaiko-type on its stand in front of her.
The cartouche top left illustrates a landscape
view of Kitagawa, which cannot be identified
with any station along the Tōkaidō. The
Tōkaidō was the main highway connecting
the cities of Edo and Kyoto. The composition
repeats the design in illustration 22 in almost
every detail.

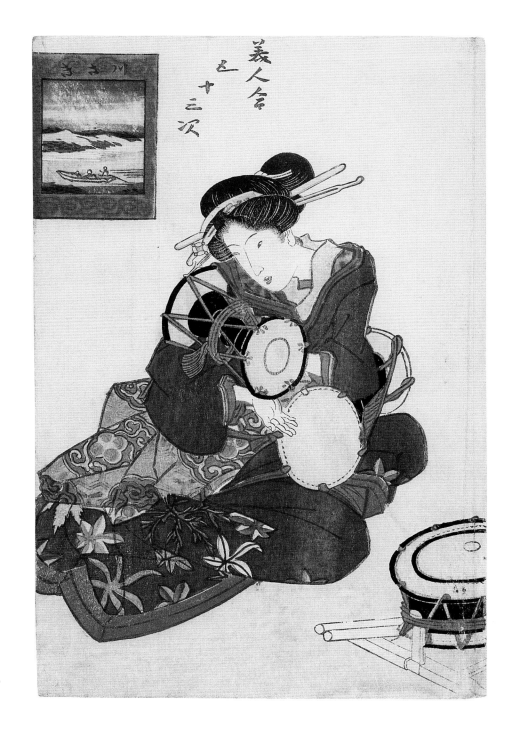

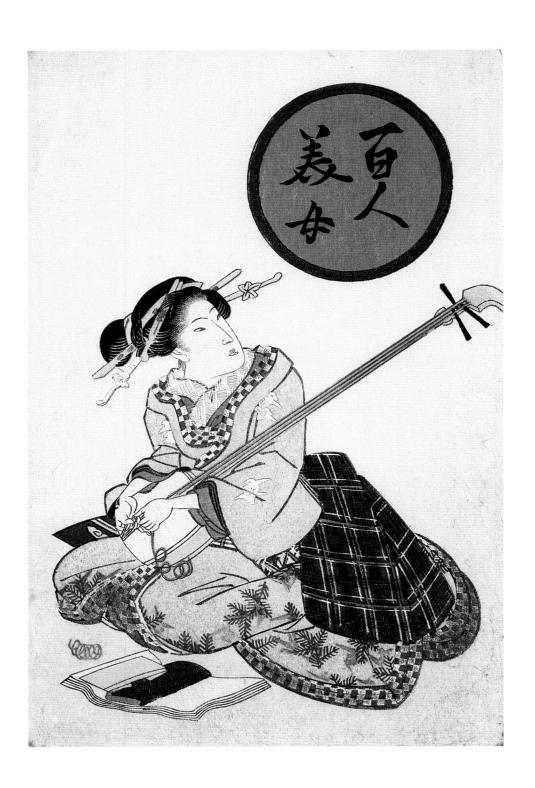

24. Attributed to Utagawa Kunisada (1786-1865)
From the series *One-hundred beautiful women (Hyakunin bijo)*, late 1820s
Unsigned
Privately issued
Woodblock, *surimono*, 191 x 126
Gemeentemuseum Den Haag PRM-1985-0002.2

A geisha prepares to play the *shamisen*, stretching the strings of the instrument. A rolled-up string is set before her.

25. Attributed to Utagawa Kunisada
(1786-1865)

From the series *One-hundred beautiful women*
(Hyakunin bijo), late 1820s
Unsigned
Privately issued
Woodblock, *surimono*, 188 x 126

Gemeentemuseum Den Haag PRM-1985-0002.1

A geisha is shown playing the *shamisen*.

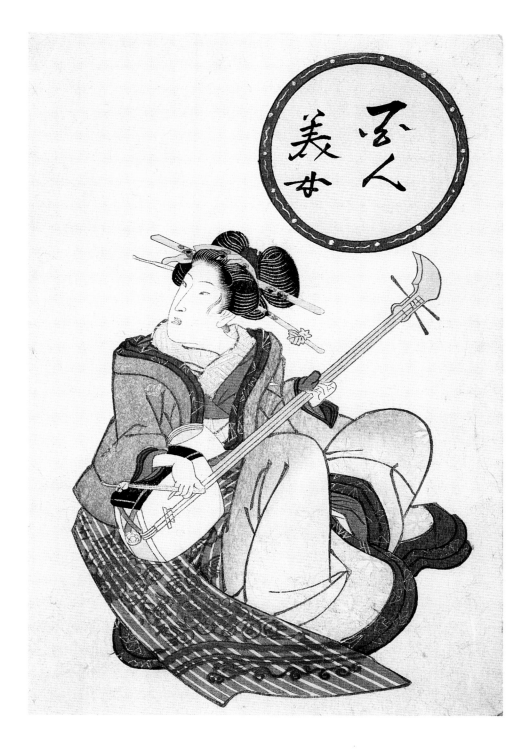

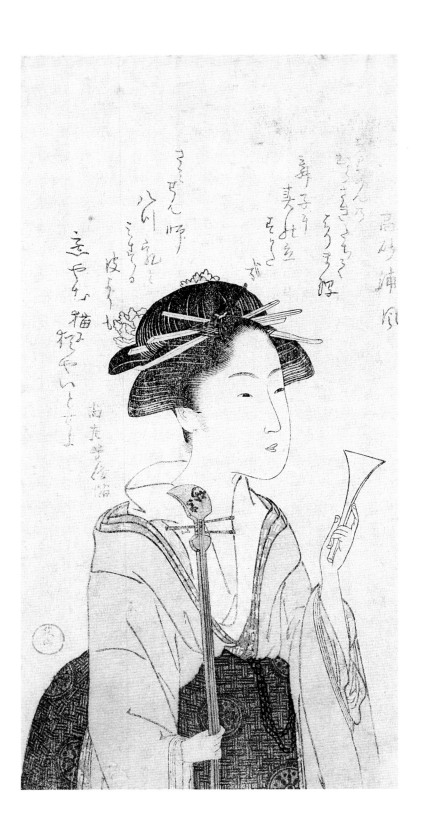

26. Kubota Shunman (1757-1820)

Sealed *Shunman*

Privately issued, probably by the poetess, late 1790s

Woodblock, *surimono*, 210 x 106

Gemeentemuseum Den Haag PRM-1983-0006

A half-length portrait of a geisha holding a *shamisen*, the ivory plectrum used to play the instrument in one hand.

Two *kyōka* poems appear above. The first is by Takazuna Urakaze, possibly the geisha portrayed in this print since this name is also inscribed on the instrument. The second is signed Shōsadō Shunman, the pen-name of the designer of this print.

27. Katsushika Hokusai (1760-1849)

'The three-stringed colt' *(Sangenkoma)* from the series *A series of horses (Umazukushi)*, 1822 (Year of the Horse)

Signed *Fusenkyo Iitsu hitsu*

Privately issued by the Yomogawa poetry club

Woodblock, *shikishiban surimono*, 206 x 183

Rijksmuseum, Amsterdam 1958:285

This *surimono* is a still-life of a dismantled *shamisen;* the neck rests on a pile of songbooks and is wrapped in a cloth decorated with a stylised crane motif. This motif is the emblem of the Yomogawa poetry club, which was responsible for the print's production. In the title of the print, 'The three-stringed colt' *(Sangenkoma)*, the three-stringed *(sangen) shamisen* is likened to a hobby-horse, and this comparison is confirmed by the first poem. The bridge over which the strings are stretched is called *koma*, a homophone for 'colt' or 'pony'.

Three *kyōka* poems appear above, the first two by Jakushōtei Midori and the third by Shūchōdō Monoyama (1762-1840?).

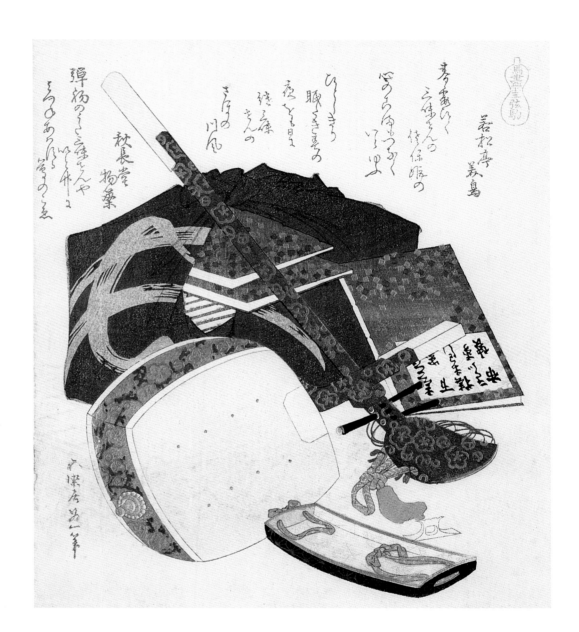

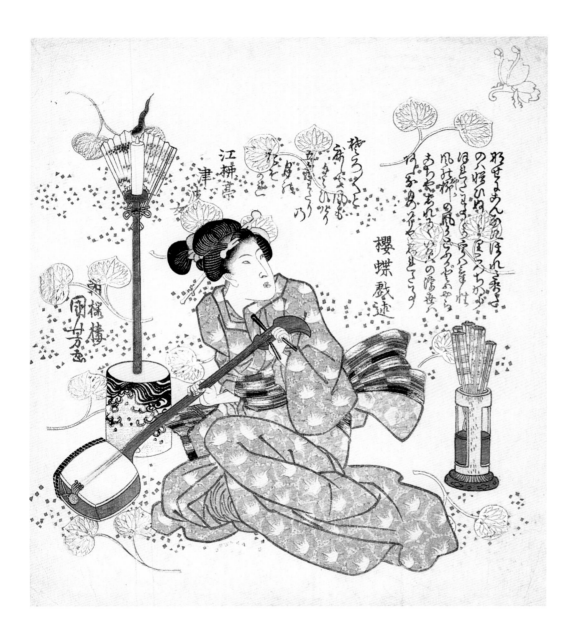

28. Utagawa Kuniyoshi (1797-1861)
Signed *Chōōrō Kuniyoshi ga*
Privately issued, probably by an unidentified
poetry club, late 1820s
Woodblock, *shikishiban surimono* (centre sheet
of a triptych), 202 x 178

Gemeentemuseum Den Haag PRM-0000-2371

Set against a background of mallow *(aoi)*
leaves printed in silver, an actor is depicted
in the role of a geisha tuning her *shamisen*. A
candle in a large stand is at her side and
behind her are folded fans in a wooden pot.

A text by Ōchō and a *kyōka* poem by
Kōryūtei Tsubame appears above. This print
was probably issued by a poetry club whose
emblem was that of the butterfly appearing
in the top right.

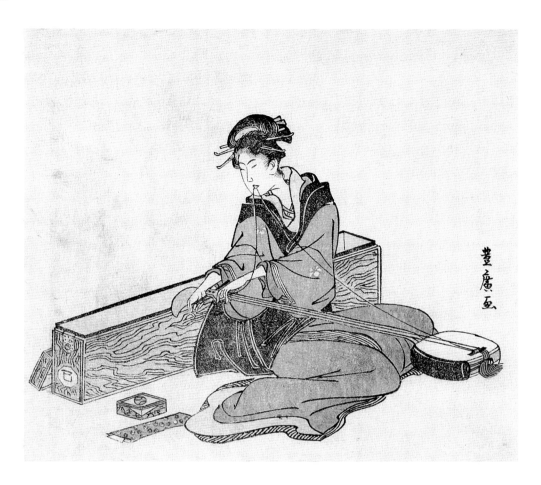

29. Utagawa Toyohiro (1773-1828)

Signed *Toyohiro ga*

Privately issued as a calendar print *(egoyomi)*, 1797

Woodblock, *surimono*, 119 x 131

Gemeentemuseum Den Haag PRM-0000-2326

A geisha prepares to play the *shamisen*, stretching the strings of the instrument. The numerals for the short months of the lunar year 1797 are inscribed on the small box containing the strings; the zodiacal sign of the Snake appears on the *shamisen* case.

30. Yashima Gakutei (1786?-1868)

Signed *Gakutei*

Sealed *Sadaoka*

Privately issued by the poets, early 1820s

Woodblock, *shikishiban surimono*, 208 x 183

Gemeentemuseum Den Haag PRM-0000-2304

A geisha stretches the strings of her *shamisen* in preparation for playing whilst a cat reacts angrily when it sees its reflection in the lacquered instrument case.

Two *kyōka* poems appear above, the first by Kōtei Kitaru and the second by Sone Nao...(?). The poets probably belonged to the club whose emblem - the character 'Naka' - appears on the woman's kimono.

Later in his career, Gakutei dealt with the theme of a cat watching its reflection, this time as mirrored in a lacquered mirror and toilet case. This later work was also a *shikishiban surimono*, but was produced by Tani Seikō in Osaka.

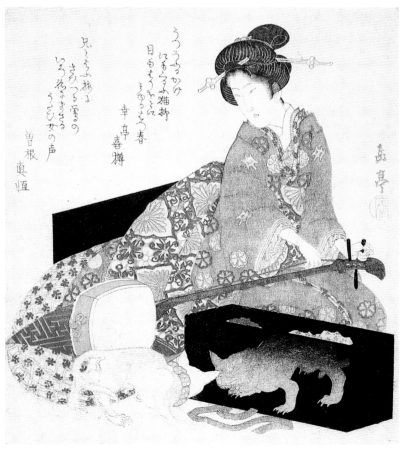

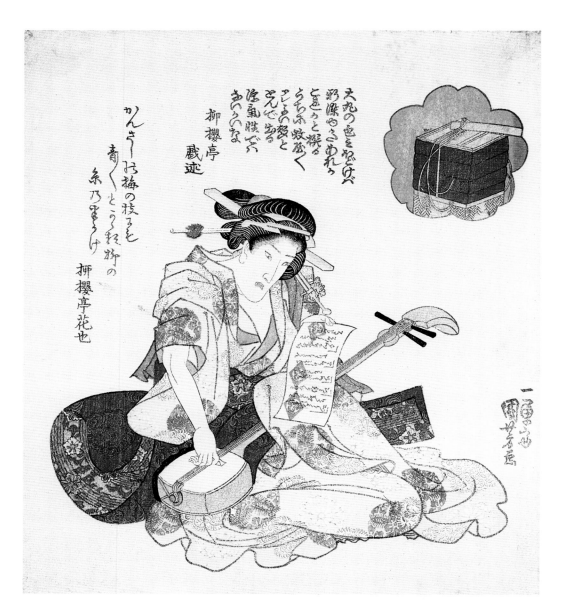

31. Utagawa Kuniyoshi (1797-1861)
From an untitled series with variously
shaped insets, late 1820s
Signed *Ichiyūsai Kuniyoshi ga*
Privately issued
Woodblock, *shikishiban surimono*, 212 x 187

Gemeentemuseum Den Haag PRM-0000-2372

A geisha interrupts her *shamisen* playing to
look at the text which she holds in one hand.
Stacked boxes are seen in a blossom-shaped
inset top right.

A humorous text and a *kyōka* poem by
Ryūōtei (Edo no) Hananari appears above.

32. Anonymous

Unsigned

Privately issued by the poets, 1820s

Woodblock, *shikishiban surimono*, 197 x 180

Gemeentemuseum Den Haag PRM-0000-2349

A standing geisha, her *shamisen* resting on the black-lacquered case behind her.

Two *kyōka* poems to the right and to the left by Kōkan no Michinari and Kurizono, respectively.

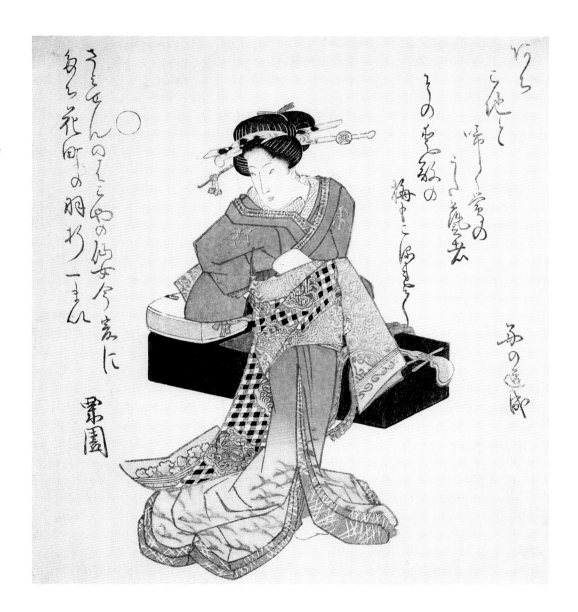

33. Utagawa Kunisada (1786-1865)

From the series *Five modern women in an orchestra (Ima no fujin goninbayashi)*, c. 1851-52

Signed *Toyokuni ga* within *Toshidama* ring

Censors' seals of Kinugasa and Murata

Published by Tsujiokaya Bunsuke

Woodblock, fanprint *(uchiwa-e)* 227 x 297

Gemeentemuseum Den Haag PRM-2000-0001

A bust portrait of a woman beating a drum *(shimedaiko)*, set against the backdrop of a striped curtain with flowering plum above. It is difficult to say whether this print - and the following four from the same set (cat. nos. 34-37) - was intended to be made into a fan or to serve as a collector's item.

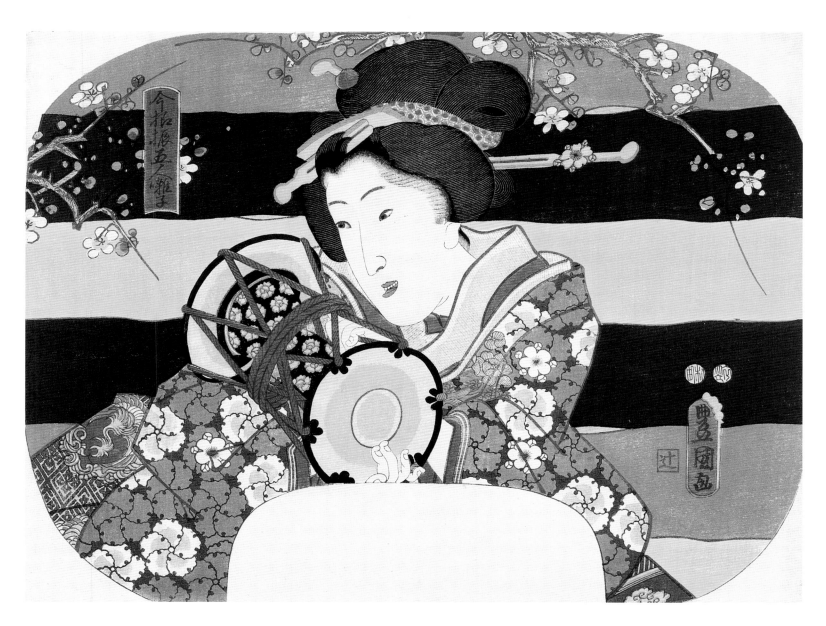

34. Utagawa Kunisada (1786-1865)
From the series *Five modern women in an orchestra (Ima no fujin goninbayashi)*, c. 1851-52
Signed *Toyokuni ga* within *Toshidama* ring
Censors' seals of Kinugasa and Murata
Published by Tsujiokaya Bunsuke
Woodblock, fanprint *(uchiwa-e)* 227 x 297
Gemeentemuseum Den Haag PRM-2000-0004

A bust portrait of a woman beating a small drum *(kotsuzumi)*, set against the backdrop of a striped curtain with flowering plum above.

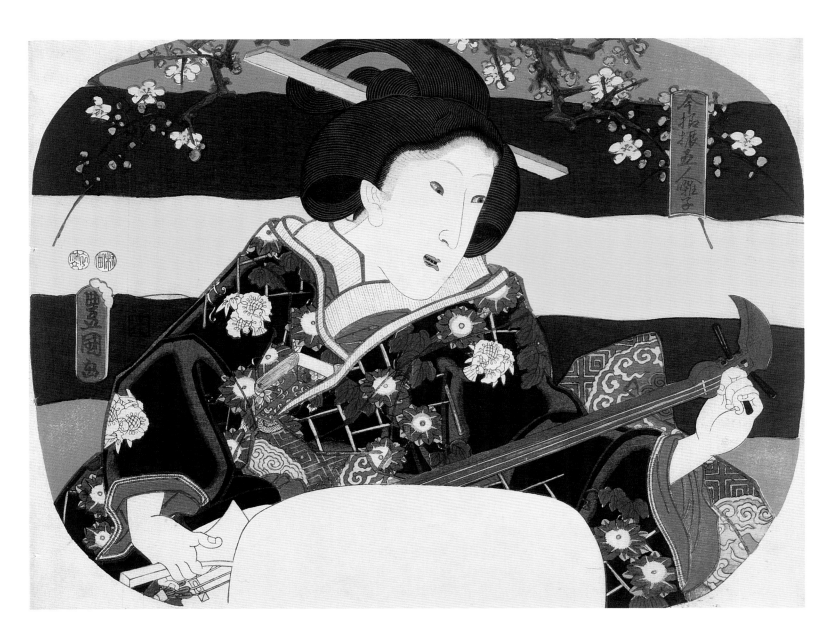

35. Utagawa Kunisada (1786-1865)

From the series *Five modern women in an orchestra (Ima no fujin goninbayashi)*, c. 1851-52

Signed *Toyokuni ga* within *Toshidama* ring

Censors' seals of Kinugasa and Murata

Published by Tsujiokaya Bunsuke

Woodblock, fanprint *(uchiwa-e)*, 227 x 297

Gemeentemuseum Den Haag PRM-2000-0002

A bust portrait of a woman dressed in a kimono decorated with morning glories, set against the backdrop of a striped curtain with flowering plum above. She is tuning a *shamisen*.

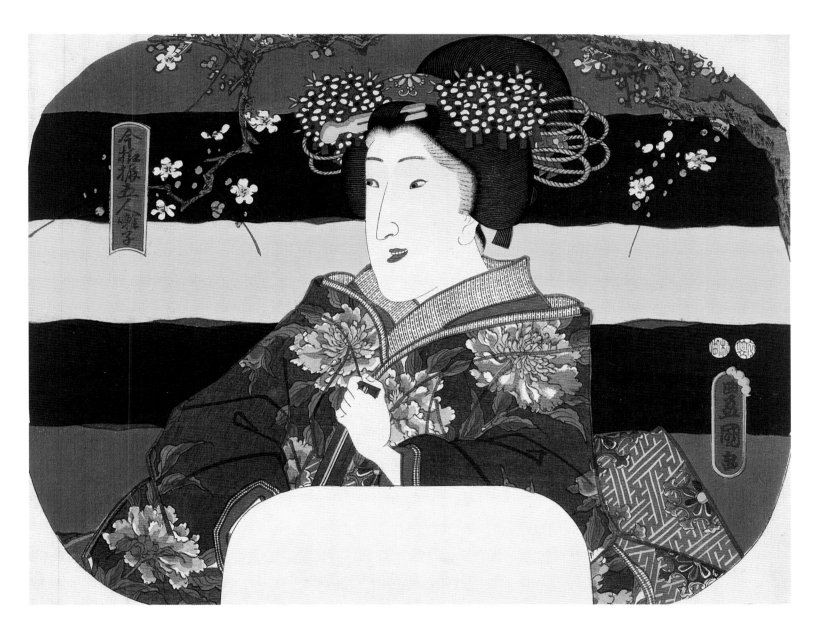

36. Utagawa Kunisada (1786-1865)
From the series *Five modern women in an orchestra (Ima no fujin goninbayashi)*, c. 1851-52
Signed *Toyokuni ga* within *Toshidama* ring
Censors' seals of Kinugasa and Murata
Published by Tsujiokaya Bunsuke
Woodblock, fanprint *(uchiwa-e)*, 227 x 297

Gemeentemuseum Den Haag PRM-2000-0003

A bust portrait of a woman dressed in a kimono decorated with peonies, set against the backdrop of a striped curtain with flowering plum above. She is holding a closed fan.

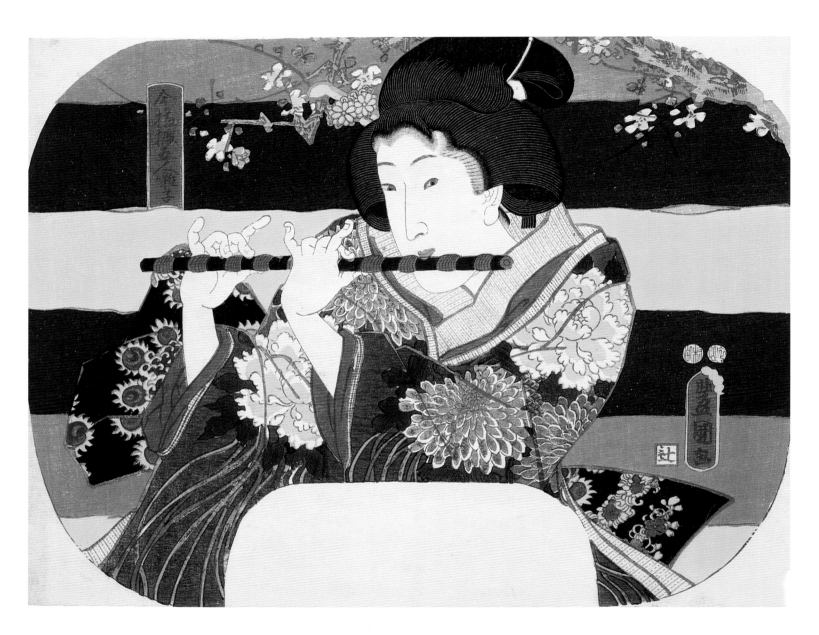

37. Utagawa Kunisada (1786-1865)

From the series *Five modern women in an orchestra (Ima no fujin goninbayashi)*, c. 1851-52

Signed *Toyokuni ga* within *Toshidama* ring

Censors' seals of Kinugasa and Murata

Published by Tsujiokaya Bunsuke

Woodblock, fanprint *(uchiwa-e)*, 227 x 297

Gemeentemuseum Den Haag PRM-2000-0005

A bust portrait of a woman dressed in a kimono decorated with chrysanthemums and peonies, set against the backdrop of a striped curtain with flowering plum above. She is playing a flute *(yokobue)*.

38. Tsukioka Yoshitoshi (1839-92)

'The moon at Shizugadake - Hideyoshi'
(*Shizugadake no tsuki - Hideyoshi*)

from the series *One-hundred aspects of the moon*
(*Tsuki no hyakushi*), 1888 (originally issued
25/X/1888)

Signed *Yoshitoshi* with seal *Taiso*

Blocks cut by Enkatsu Noguchi (sealed
Enkatsu tō)

Published by Akiyama Buemon

Woodblock, *ōban*, 360 x 245

 Gemeentemuseum Den Haag PRM-1988-0002

The military leader Toyotomi Hideyoshi
(1536-98) blows a conch shell (*horagai*) by
moonlight at Mount Shizugadake.

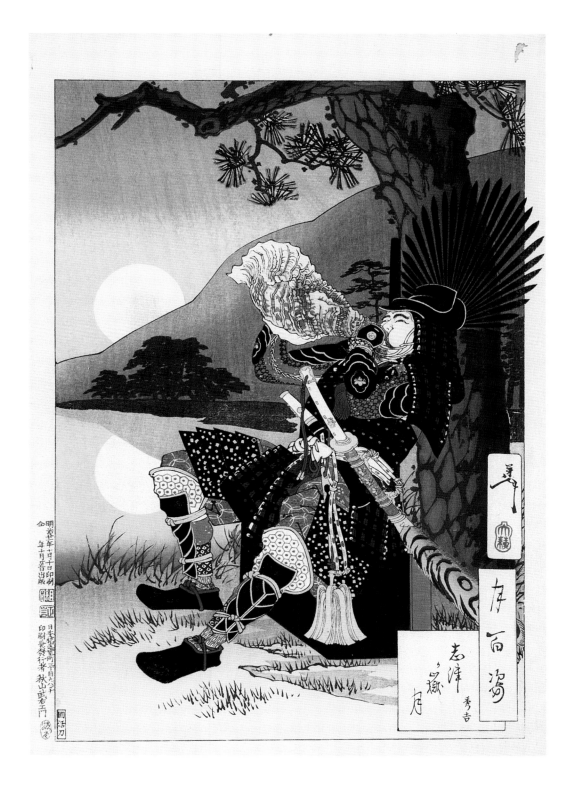

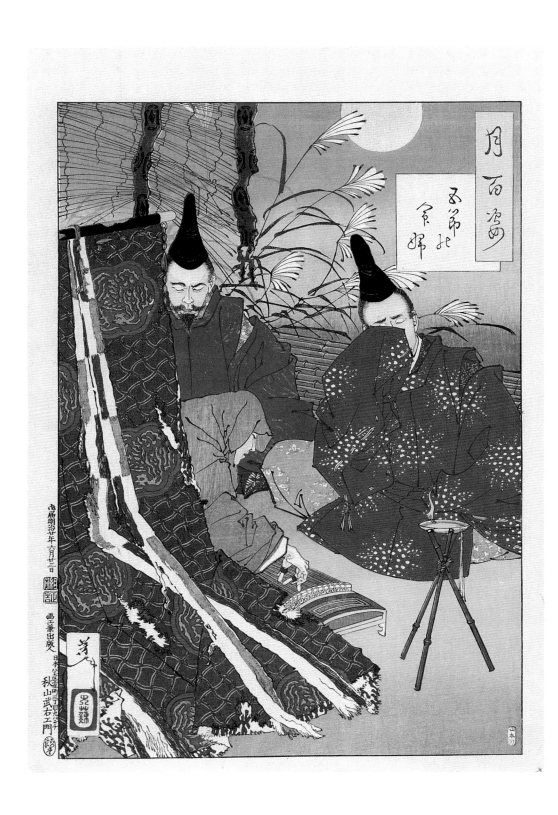

39. Tsukioka Yoshitoshi (1839-92)
'Lady Gosechi' *(Gosechi no myōbu)* from the
series *One-hundred aspects of the moon (Tsuki
no hyakushi)*, 23/VI/1887
Signed *Yoshitoshi* with seal *Taiso*
Blocks cut by Yamamoto Shinji (sealed
Yamamoto tō)
Published by Akiyama Buemon
Woodblock, *ōban*, 370 x 252

Gemeentemuseum Den Haag PRM-1986-0004

The Lady Gosechi, partially hidden by a
curtain, plays the *koto* by moonlight whilst
two men listen.

40. Tsukioka Yoshitoshi (1839-92)

'The moon at Ashigarayama - Yoshimitsu'
(Ashigarayama no tsuki - Yoshimitsu)
from the series *One-hundred aspects of the moon*
(Tsuki no hyakushi), 1889 (originally issued
10/X/1889)
Signed *Yoshitoshi* with seal *Yoshitoshi*
Blocks cut by Enkatsu Noguchi (sealed
Enkatsu tō)
Published by Akiyama Buemon
Woodblock, *ōban*, 360 x 245

Gemeentemuseum Den Haag PRM-1988-0003

Minamoto no Yoshimitsu (d. 1127) plays a
mouth organ *(shō)* at Mount Ashigara.

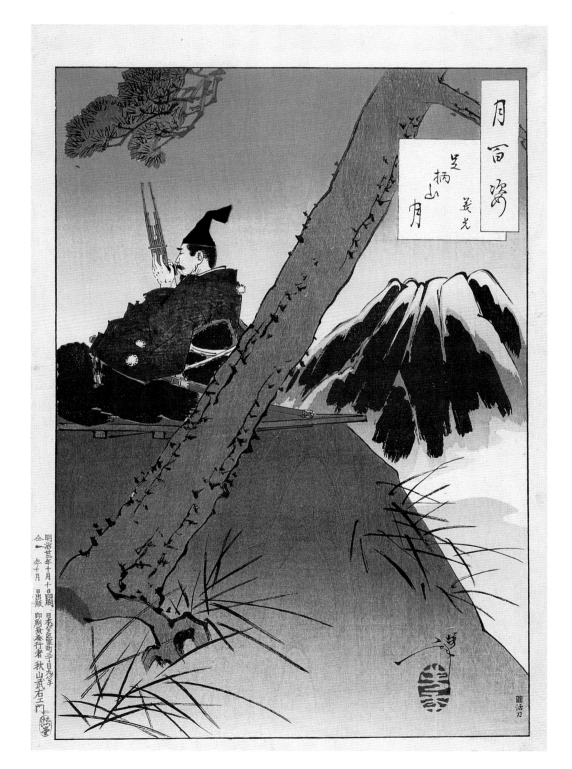

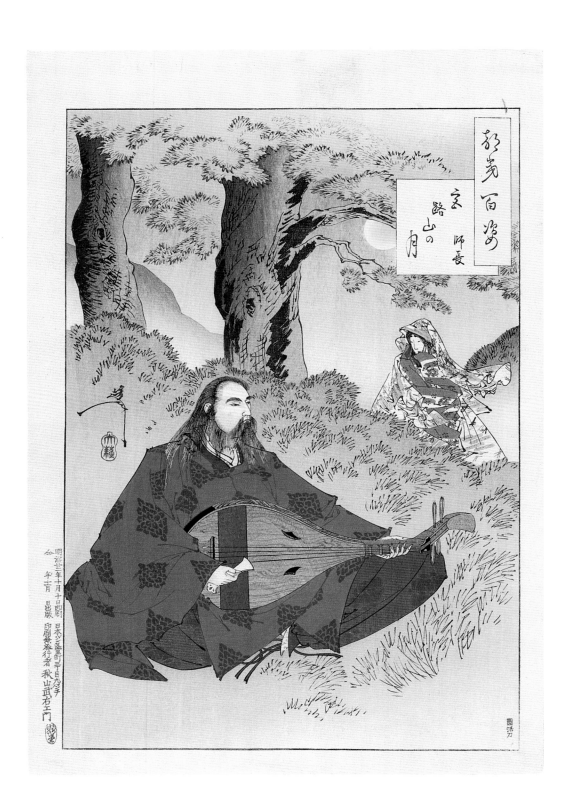

41. Tsukioka Yoshitoshi (1839-92)
'The moon at Mount Maroyama - Moronaga'
(*Maroyama no tsuki - Moronaga*) from the
series *One-hundred aspects of the moon (Tsuki
no hyakushi)*, XI/1889
Signed *Yoshitoshi* with seal *Taiso*
Blocks cut by Enkatsu Noguchi (sealed
Enkatsu tō)
Published by Akiyama Buemon
Woodblock, *ōban*, 371 x 254
Gemeentemuseum Den Haag PRM-1986-0003

Fujiwara no Moronaga (1137-92) plays the
lute *(biwa)* by moonlight at Mount
Maroyama.

42. Tsukioka Yoshitoshi (1839-92)

'The moon's four strings - Semimaru'
(Tsuki no yotsu no o - Semimaru)
from the series *One-hundred aspects of the moon*
(Tsuki no hyakushi), VIII/1891
Signed *Yoshitoshi* with seal *Yoshitoshi*
Blocks cut by Yamawaki Yoshihisa (sealed
Yoshihisa tō)
Published by Akiyama Buemon
Woodblock, *ōban*, 360 x 245

Gemeentemuseum Den Haag PRM-1988-0005

Semimaru, the retired servant of Prince
Atsuzane shinnō (896-966), plays the lute
(biwa), seated on the verandah of his hut.

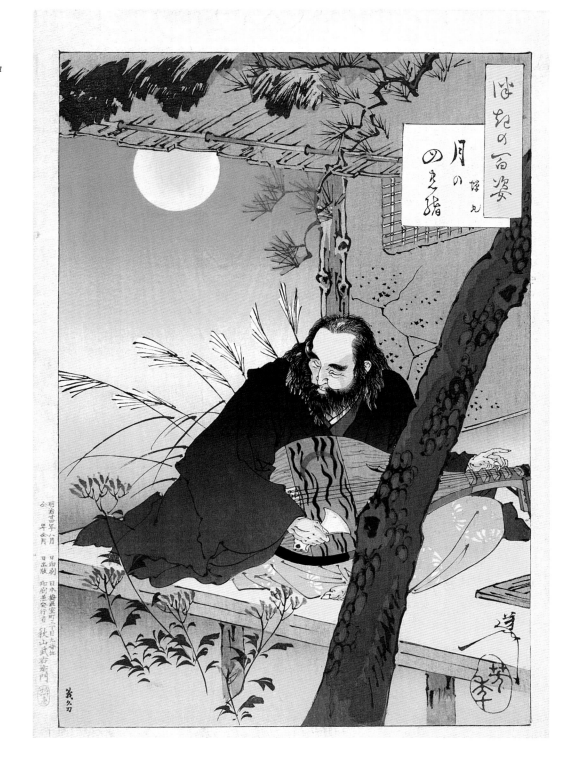

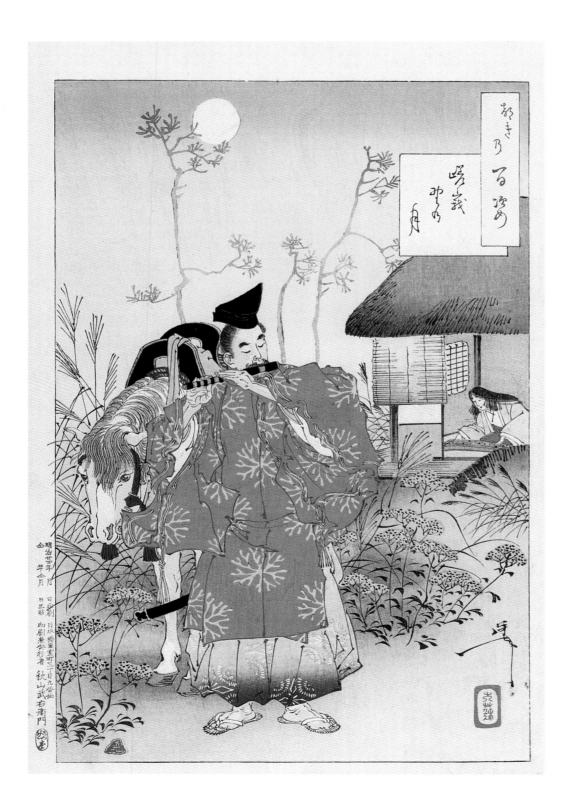

43. Tsukioka Yoshitoshi (1839-92)
'The moon at Saga moor' *(Sagano no tsuki)*
from the series *One-hundred aspects of the moon*
(Tsuki no hyakushi), I/1891 (originally issued
1/I/1891)
Signed *Yoshitoshi* with seal *Taiso*
Blocks cut by Negishi Naoyama (sealed
Naoyama tō)
Published by Akiyama Buemon
Woodblock, *ōban*, 360 x 245
> Gemeentemuseum Den Haag PRM-1988-0004

Nakakuni serenades the Lady Kogō no
Tsubone on a flute *(yokobue)* by moonlight in
Saga. She plays the *koto*.

44. Tsukioka Yoshitoshi (1839-92)

'The moon at Suzaku gate - Hakuga Sammi'
(*Suzakumon no tsuki - Hakuga Sammi*) from the
series *One-hundred aspects of the moon (Tsuki
no hyakushi*), 1/II/1886
Signed *Yoshitoshi* with seal *Yoshitoshi no in*
Blocks cut by Yamamoto Shinji (sealed
Yamamoto tō)
Published by Akiyama Buemon
Woodblock, *ōban*, 360 x 245

Gemeentemuseum Den Haag PRM-1988-0001

Hakuga Sammi and a stranger play a flute
(*yokobue*) at the gate, Suzakumon, in Kyoto.

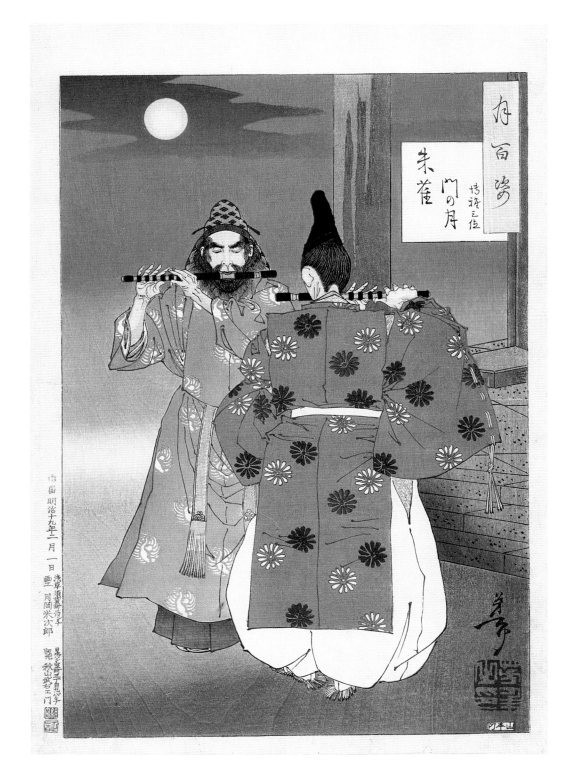

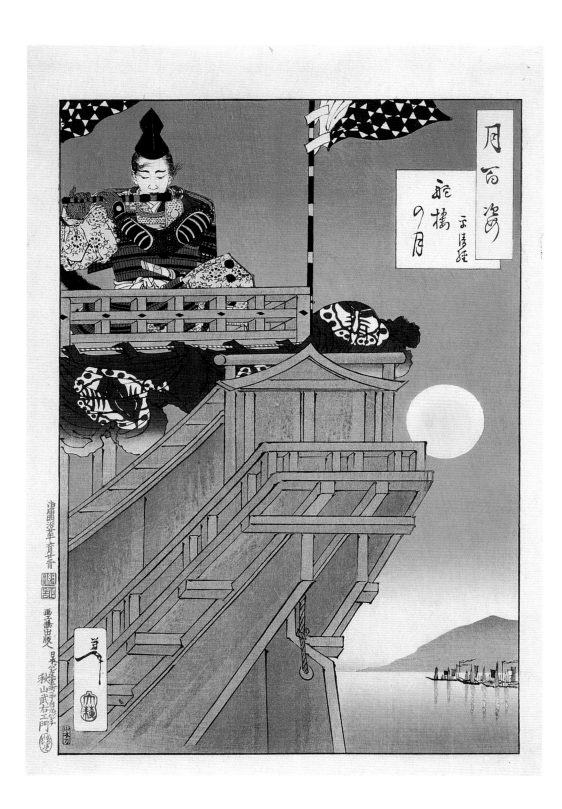

45. Tsukioka Yoshitoshi (1839-92)
'The moon and the helm of a boat - Taira no Kiyotsune' *(Darō no tsuki - Taira no Kiyotsune)* from the series *One-hundred aspects of the moon (Tsuki no hyakushi)*, 23/VI/1887
Signed *Yoshitoshi* with seal *Taiso*
Blocks cut by Yamamoto Shinji (sealed *Yamamoto tō*)
Published by Akiyama Buemon
Woodblock, *ōban*, 361 x 247
 Gemeentemuseum Den Haag PRM-1986-0005

Taira no Kiyotsune (c. 1165-99) plays the flute *(yokobue)* by moonlight on a ship's bridge.

46. Tsukioka Yoshitoshi (1839-92)

'Ariko' *(Ariko)* from the series *One-hundred aspects of the moon (Tsuki no hyakushi),* 6/IX/1886

Signed *Yoshitoshi* with seal *Taiso*

Blocks cut by Yamamoto Shinji (sealed *Yamamoto tō*)

Published by Akiyama Buemon

Woodblock, *ōban*, 370 x 250

Collection Josephine Asselbergs-Siebers

Fujiwara no Ariko is seated in a boat, weeping over her lute *(biwa)*, a poem by this court lady in the cartouche top right.

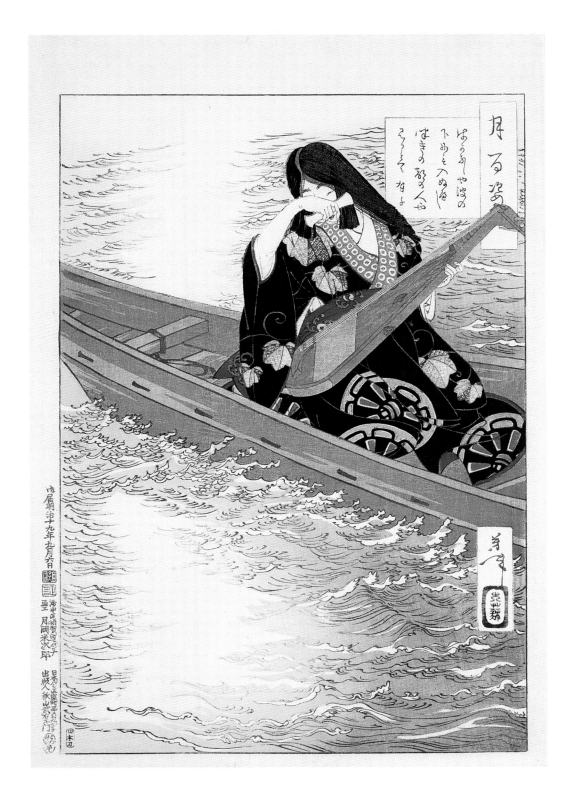

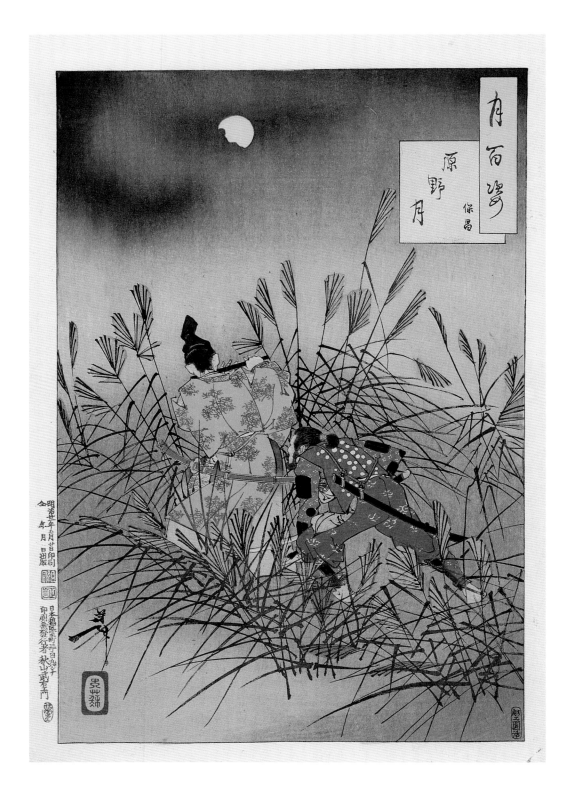

47. Tsukioka Yoshitoshi (1839-92)
'The moon in the grassy plains - Yasumasa'
(Harano no tsuki - Yasumasa) from the series
One-hundred aspects of the moon (Tsuki no
hyakushi), 1888 (originally issued 20/V/1888)
Signed *Yoshitoshi* with seal *Taiso*
Blocks cut by Enkatsu Noguchi (sealed
Enkatsu tō)
Published by Akiyama Buemon
Woodblock, *ōban*, 361 x 247

Gemeentemuseum Den Haag PRM-1992-0001

Fujiwara no Yasumasa (958-1036) plays the
flute *(yokobue)* by moonlight on a grassy
moor.

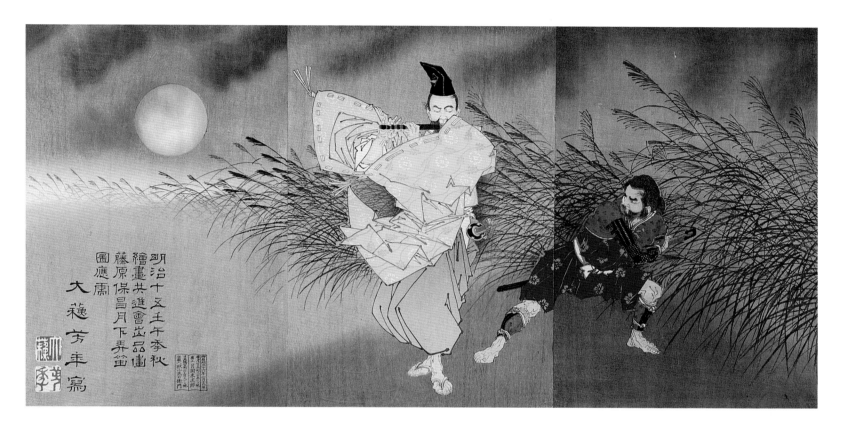

48. Tsukioka Yoshitoshi (1839-92)
'Fujiwara no Yasumasa playing the flute in moonlight'
(Fujiwara no Yasumasa gekka rōteki no zu)
Signed *Taiso Yoshitoshi utsusu* with seals *Taiso; Yoshitoshi*
Printed by Tsune *(Suri Tsune)*
Published by Akiyama Buemon, 12/II/1883
Woodblock, *ōban* triptych, 366/375 x 248/260 (each)
　　Collection Arendie and Henk Herwig

Fujiwara no Yasumasa (958-1036) plays the flute
(yokobue) by moonlight on a grassy moor, his brother
behind him.

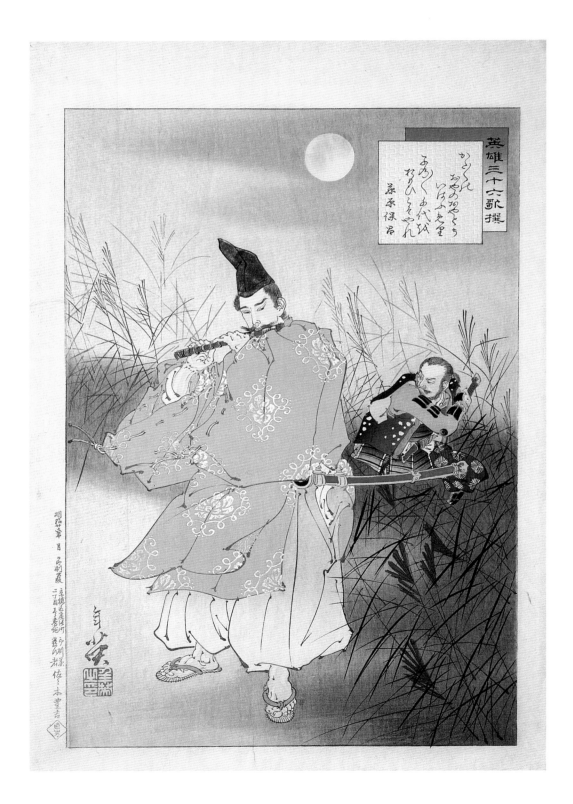

49. Utagawa Toshihide (1862-1926)

From the series *The thirty-six poets of bravery and valiance (Eiyū sanjūrokkasen)*, 1888 (originally issued 25/X/1888)
Signed *Toshihide* with seal *Toshihide no in*
Published by Sasaki Toyokichi
Woodblock, *ōban*, 367 x 252

Collection Josephine Asselbergs-Siebers

Fujiwara no Yasumasa (958-1036) plays the flute *(yokobue)*, his brother behind him.

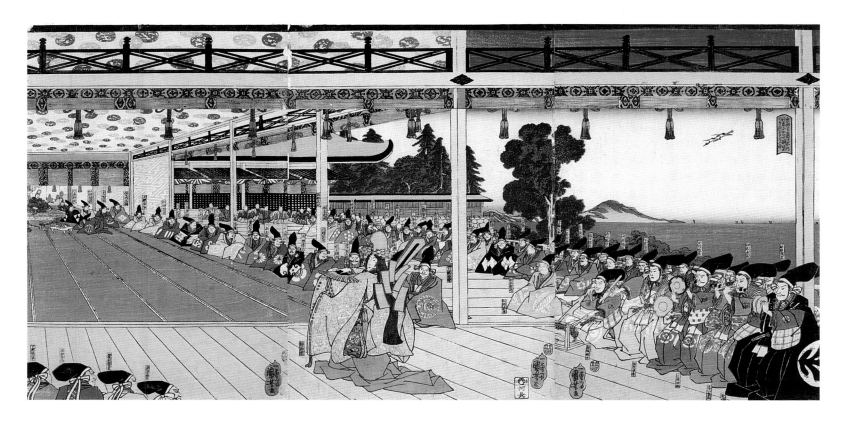

50. Utagawa Kuniyoshi (1797-1861)

'Lord Yoritomo watching Shizuka Gozen dance at Tsurugaoka' *(Yoritomo kō Tsurugaoka no shinzen ni oite Shizuka Gozen no mai wo miru no zu)*, c. 1844

Signed *Ichiyūsai Kuniyoshi ga*

Published by Kawaguchiya Chōzō

Censor's seal of Fukatsu Ihei

Woodblock, *ōban* triptych, 362/365 x 247/252 (each)

Rijksmuseum voor Volkenkunde, Leiden 1353-1046

Shizuka Gozen (1168-87), the concubine of Minamoto no Yoshitsune (1159-89), performs as a *shirabyōshi* dancer on a stage erected at the Tsurugaoka Hachiman shrine on 29 April 1186. At this time she was being held prisoner by Minamoto no Yoritomo (1147-99), and she undertook the dance at the request of Yoritomo's wife, Masako. She wears the high cap and holds the *gohei* staff characteristic of the *shirabyōshi* dance.

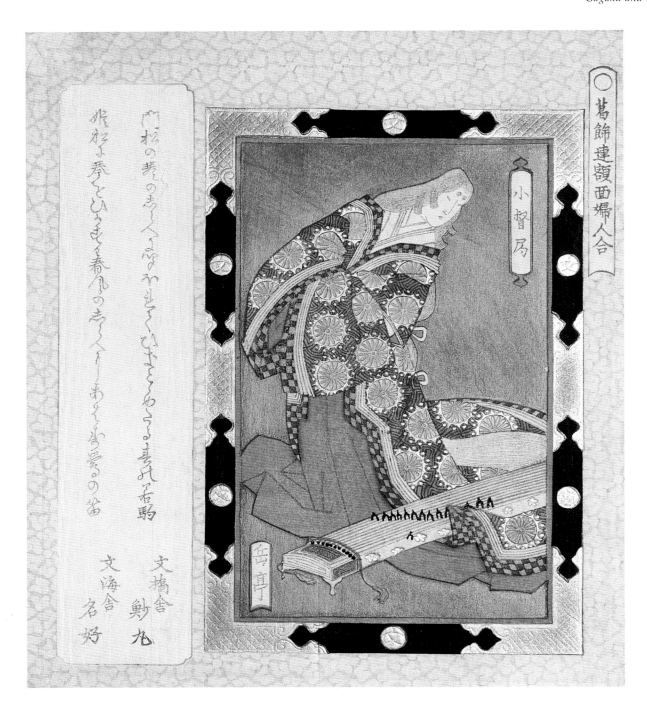

51. Yashima Gakutei (1786?-1868)

From the series *A series of ladies in framed pictures for the Katsushika poetry club (Katsushikaren gakumen fujin awase)*, c. 1823

Signed *Gakutei*

Privately issued by the Katsushika poetry club

Woodblock, *shikishiban surimono*, 208 x 182

Rijksmuseum voor Volkenkunde, Leiden 360-6887

The lady-in-waiting Kotoku stands by a *koto*, dressed in court robes. Her figure is set against a gold ground enclosed by a black-lacquered frame with silver fittings.

Two *kyōka* poems by Bunkyōsha ..(?)maru and Bunkaisha Nazuki appear in a rectangular cartouche to the left.

**52. Ishikawa Toyomasa
(act. c. 1770-80)**

'Drunkard' (*Shōjō*) from the
series *A series of eight dances
(Utai hachiban no uchi)*, c. 1775
Signed *Ishikawa Toyomasa ga*
Published anonymously
Woodblock, *chūban*, 254 x 129

Rijksmuseum, Amsterdam 1956:27

A party of boys makes music
with a drum *(kotsuzumi)* and a
flute *(fue)*, and performs a dance
around a large barrel filled with
sake. This is an allusion to the
legendary *shōjō*: people with
long red hair who lived on the
beach, constantly imbibing sake
which they scoop out with long
ladles from a large barrel like
that held by the boy in the
foreground. 'Shōjō' ('drunkard')
is also the title of the print.

**53. Ishikawa Toyomasa
(act. c. 1770-80)**

Momijigari from the series
*A series of eight dances (Utai
hachiban no uchi)*, c. 1775
Signed *Ishikawa Toyomasa ga*
Published anonymously
Woodblock, *chūban*, 257 x 188

Rijksmuseum voor Volkenkunde,
Leiden 4306-1

Three boys watch as two others
perform a dance regarding a
legendary incident in the life of
Watanabe no Tsuna, one of the
retainers of Minamoto no
Yorimitsu (948-1021). In 976,
Watanabe no Tsuna fought and
cut off the arm of demoness
Ibaraki at Kyoto's southern gate,
the Rashōmon. Ibaraki later
visited him in the guise of his
old nurse. She tricked him into
showing her his trophy at which
point she grasped the arm and
flew away. This print is titled
Momijigari, the name of the Nō
play written about the tale.

54. Katsushika Hokusai (1760-1849)

Signed *zen Hokusai Taito hitsu*

Printed by Ryūsai (seal appears within a circle)

Privately issued by the poets, mostly belonging to the
Yomogawa poetry club, 1820 (Year of the Dragon)

Woodblock, *shikishiban surimono*, 197 x 171

Rijksmuseum voor Volkenkunde, Leiden 1353-616

Two men in court robes and wearing headgear
decorated with dragons, small staffs in their hands,
perform a dance to large drums *(tsuridaiko)*. The drums
are suspended within ornamental frames; a curtain
hangs behind them.

Three *kyōka* poems by Kūmanya Maegaki Maeda,
Shibanoya Sanyō (d. c. 1836) and Haikai (Kyōkadō)
Utaba Magao (1753-1829) appear above and to the left.

55. Yashima Gakutei (1786?-1868)

Genji from the series *Ten stories for the Honchōren (Honchōren monogatari jūban)*, mid-
1820s

Signed *Gakutei*

Privately issued by the Honchō poetry club

Woodblock, *shikishiban surimono*, 201 x 179

Gemeentemuseum Den Haag PRM-0000-2309

Two men in court robes perform a dance to the accompaniment of a large drum
(tsuridaiko), which is suspended within an ornamental frame; a curtain hangs behind
them. Although the title of the print, 'Genji', makes clear the work's reference to an
episode from the *Genji monogatari* ('Tales of Genji' by Lady Murasaki Shikibu
(c. 978-c.1014), it is difficult to identify the corresponding chapter.

Three *kyōka* poems by Sodenoya Furukichi, ..(?)noya Masa..(?) and Chiyonoya
Matsusuzume appear to the left.

56. Teisai Hokuba (1771-1844)
From the series *A series of ten designs for the Hisakataya (Hisakataya jūban no uchi)*, early 1820s
Signed *Hokuba ga*
Privately issued by the Hisakataya poetry club
Woodblock, *shikishiban surimono*, 211 x 185

Rijksmuseum voor Volkenkunde, Leiden 1353-665

This *surimono* depicts a scene from the Nō play, *Adachigahara* (also known as *Kurozuka*). A travelling priest holds up a rosary for a demoness or witch of the *hannya* type, who holds a staff and carries a bundle of branches on her back.

Two *kyōka* poems appear above, the last one by Senmentei Orizumi.

57. Teisai Hokuba (1771-1844)
From the series *A series of ten designs for the Hisakataya (Hisakataya jūban no uchi)*, early 1820s
Signed *Hokuba ga*
Privately issued by the Hisakataya poetry club
Woodblock, *shikishiban surimono*, 211 x 185

Rijksmuseum voor Volkenkunde, Leiden 1353-665C

Like the previous example, this print illustrates a scene from a Nō play. A man kneels by a small drum on a stand whilst a dancer wearing a 'bird's helmet' (*torikabuto*) stands to the left.

Two *kyōka* poems by Shōmentei Tatsumaru and Ki no Wakame appear above.

58. Totoya Hokkei (1780-1850)

From the series *A series for the Hanazono poetry club (Hanazono bantsuzuki)*, early 1820s
Signed *Hokkei*
Privately issued by the Hanazono poetry club
Woodblock, *shikishiban surimono*, 210 x 184

Gemeentemuseum Den Haag PRM-0000-2325

A still-life of a drum *(kakko)* in its stand against which rests a bell tree *(suzu)* and staff of folded papers *(gohei)* as used in several ceremonial dances. A spray of plum blossoms identified with the 'plum of *kagura*' dance *(kagura ume)* is seen to the right in a separate cartouche.

A *kyōka* poem by Senryūtei (Karamaro [1788-1864]) from Sendai appears to the left.

59. Ryūryūkyo Shinsai (1764?-1825?)

From the series *Musical instruments (Gakki)*,
early 1800s
Signed *Ryūryūkyo Shinsai ga*
Privately issued by the poets
Woodblock, *surimono*, 133 x 183

Gemeentemuseum Den Haag PRM-0000-2314

A still-life of a drum *(kakko)* on its stand, an oboe-like instrument *(hichiriki)* next to it on a piece of cloth and a partly opened fan behind.

Two *kyōka* poems by Kuchishio Tarando and Kasuga Nagahito appear above.

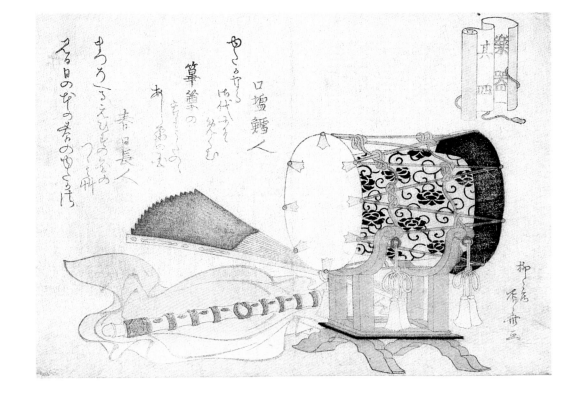

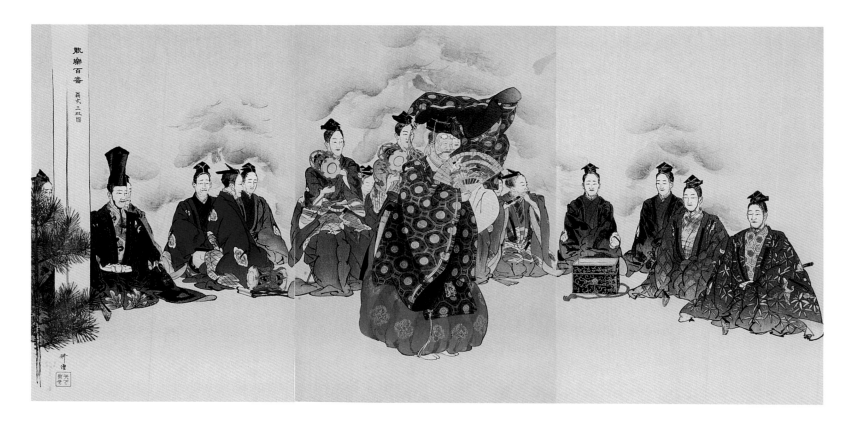

60. Tsukioka Kōgyo (1869-1927)

From the series *One-hundred Nō plays (Nōgaku hyakuban)*,
1920s

Signed *Kōgyo* with seal *Sadanoshita*(?)

Published by Matsuki Heikichi (Daikokuya)

Woodblock, *ōban* triptych, 378 x 255 (each)

Gemeentemuseum Den Haag PRM-1999-0003

A Nō dancer performs the *sanbasō* dance in the role of
the old man Okina. The performer wears the mask with
large white tufts for eyebrows and a movable chin that
is identified with this role; the choir and orchestra
(drums and flute) are seen in the background.

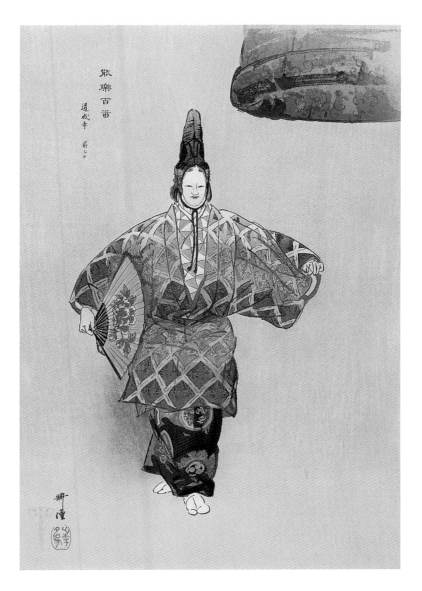

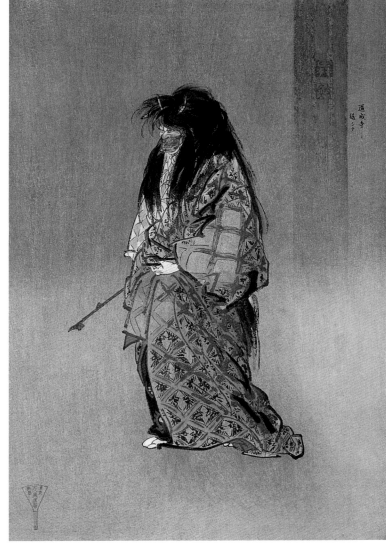

61. Tsukioka Kōgyo (1869-1927)
From the series *One-hundred Nō plays (Nōgaku hyakuban)*, 1925
Signed *Kōgyo* with seal *Sankō*(?)
Published by Matsuki Heikichi (Daikokuya)
Woodblock, *ōban*, 378 x 257

Collection Robert Schaap,

The Netherlands

A Nō dancer performs the role of the young princess, Kiyohime. As portrayed in the first part of the play *Nō Dōjōji*, Kiyohime is passionately in love with Anchin, a Buddhist monk of the temple, Dōjōji. A large temple bell (*denshō*) is partly visible in the top right.

62. Tsukioka Kōgyo (1869-1927)
From the series *One-hundred Nō plays (Nōgaku hyakuban)*, 1925
Seal unread
Published by Matsuki Heikichi (Daikokuya)
Woodblock, *ōban*, 378 x 256

Collection Robert Schaap,

The Netherlands

A Nō dancer appears in the role of Kiyohime from the second part of the play *Nō Dōjōji*. At this stage she has turned into an angry demoness because her love for the monk Anchin remains unrequited. She wears a *hannya* demon mask and carries a staff for beating the temple bell.

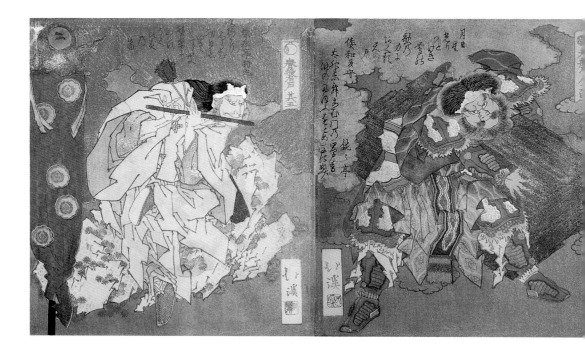

63. Totoya Hokkei (1780-1850)
'The Spring Cave' *(Haru no iwato)*, 1825 (Year of the Cock)
Signed *Hokkei* with seal *Hokkei*
Privately issued by the Taikogawa poetry club
Woodblock, *shikishiban surimono* pentaptych,
203/211 x 181/186 (each)

Rijksmuseum voor Volkenkunde, Leiden 1353-563a-1-5

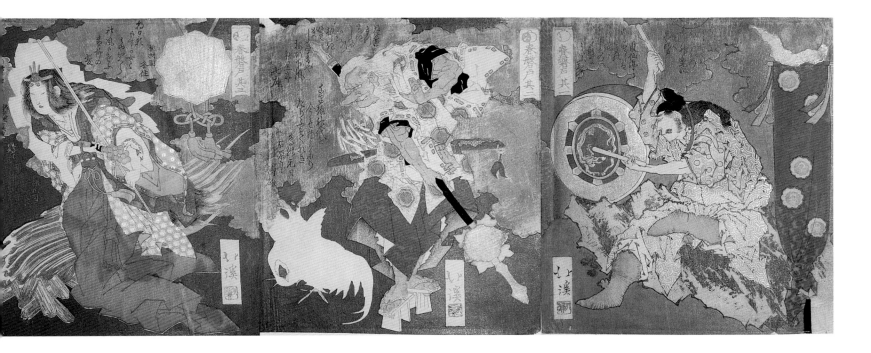

This *surimono* pentaptych illustrates the myth of the sun
goddess Amaterasu no Ōmikami when she concealed
herself in a cave, thus casting the world into darkness.
The gods gathered and tried to lure her from the cave
by beating drums and playing the flute, lighting a fire
and fastening a mirror to a nearby tree. When Ame no
Uzume no Mikoto danced so enthusiastically that her
clothes dropped off, the gods burst into laughter. Upon
hearing the revelry the sun goddess peeked out from
the cave. Upon seeing her reflection in the mirror,
Amaterasu opened the cave door a little more,
whereupon the strong Ama no Tajikarao rolled it away.
The sun goddess had little choice but to reappear and
restore lightness to the world.

Each print features one or more *kyōka* poems as
follows (right to left): first sheet: two poems; second
sheet: poems by Saiseitei Nanao and Sekigentei Namio;
third sheet: three poems; fourth sheet: poems by Yamato
Watamori (1795-1849) and Dondontei (Wataru II); and
fifth sheet: one poem.

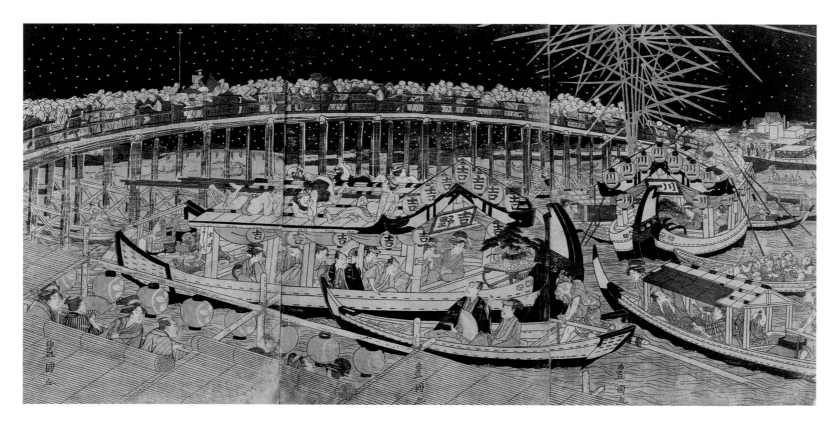

64. Utagawa Toyokuni (1769-1825)

Signed *Toyokuni ga*

Published anonymously, c. 1804

Woodblock, *ōban* triptych, 379/382 x 245/258 (each)

Rijksmuseum voor Volkenkunde, Leiden 1353-1541

A large crowd has gathered on the Ryōgokubashi, one of the major bridges over the Sumidagawa in Edo, on the evening of the 28th day of the fifth lunar month when fireworks marked the opening of the river for pleasure boats. This celebration, known as the *Ryōgokubashi kawabiraki* ('opening of the river at the Ryōgokubashi'), originated in 1733. It soon developed into one of Edo's major annual events. Those who could afford it, such as the Kabuki actors in the foreground of the print, viewed the fireworks from boats where drinks and food were served to the accompaniment of music.

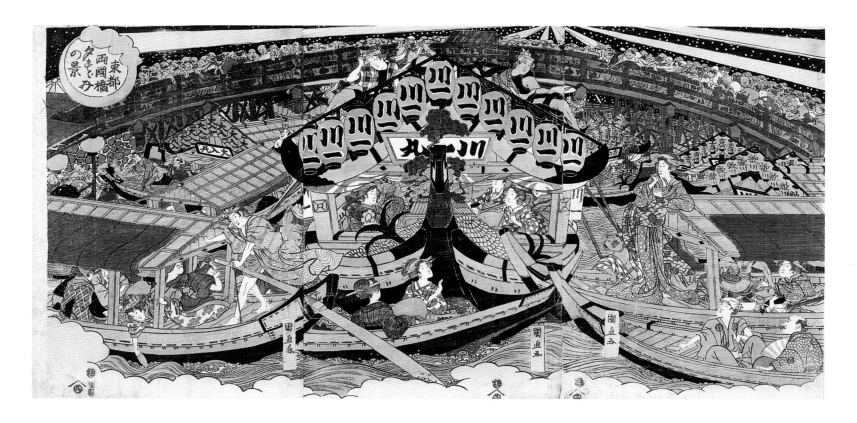

65. Utagawa Kuninao (1793-1854)

'View of enjoying the evening cool at the bridge, Ryōgokubashi, in the Eastern capital' *(Tōto Ryōgokubashi yūsuzumi no kei)*, c. 1811-12

Signed *Kuninao ga*

Kiwame censorship seal and censor's seal of Igaya Kanemon

Published by Nishimuraya Yohachi

Woodblock, *ōban* triptych, 376 x 769

Rijksmuseum voor Volkenkunde, Leiden 1353-1092

An orchestra entertains guests on a large pleasure boat on the river, Sumidagawa. The name 'Kawaichi' ('River's first') appears on the lanterns. This is only one of a large number of similar boats providing select guests with a good view of the fireworks over the bridge, Ryōgokubashi. A large crowd has gathered at the bridge to witness the festival marking the occasion of the river's opening on the 28th day of the fifth lunar month. The title of the print is contained within a cartouche which is shaped like the emblem of the Utagawa school of print designers.

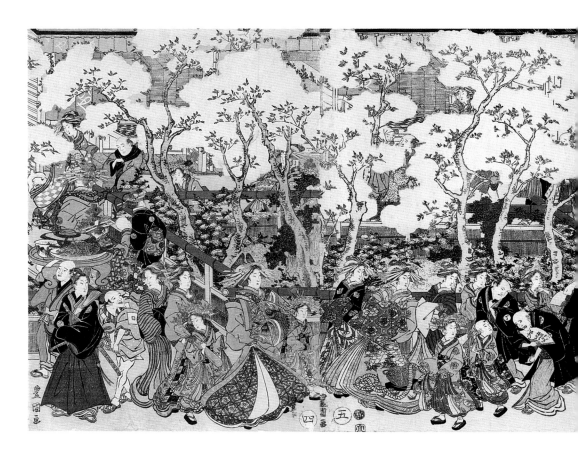

66. Utagawa Toyokuni (1769-1825)

'A view of flowering cherries in the New Yoshiwara: a pentaptych' *(Shin Yoshiwara sakura no keshiki - gobantsuzuki)*, 1811

Signed *Toyokuni ga*

Kiwame censorship seal and censor's seal of Ōsakaya Hidehachi

Published by Yamamotoya Kyūbei (on right sheet only)

Woodblock, *ōban* pentaptych, 368/369/ x 251/255 (each)

Rijksmuseum voor Volkenkunde, Leiden 1330-59

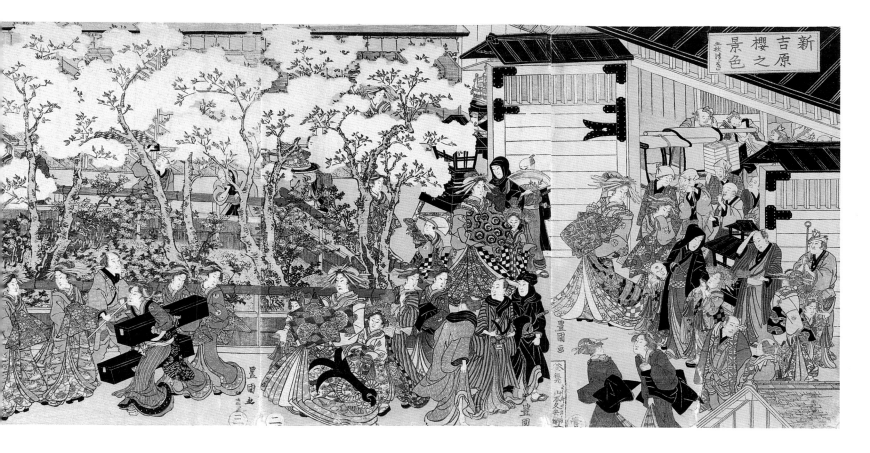

A large crowd assembles as courtesans and their
assistants (*shinzō*) parade through the main street of the
Yoshiwara pleasure quarter in Edo during the cherry-
blossom season.

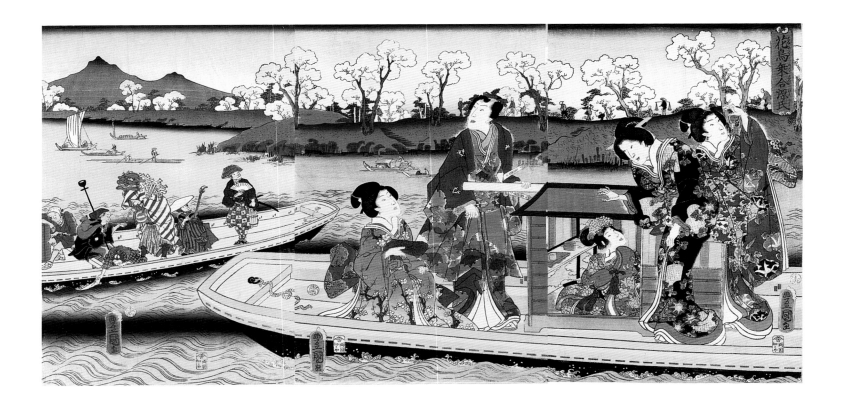

67. Utagawa Kunisada (1786-1865)
'Prince Genji riding together with flowers and birds'
(Hana ni tori noriai Genji), VIII/1859
Signed *Toyokuni ga*
Aratame censorship seal and date seal corresponding to
Year of the Goat 8 (VIII/1859)
Published by Kagaya Kichibei
Woodblock, *ōban* triptych, 370/374 x 252/255 (each)

Rijksmuseum voor Volkenkunde, Leiden 2488-58

A pleasure boat on the Edo river, the Sumidagawa, with
blossoming cherry trees on the far bank. A man wearing
the lion's mask used in the *shishimai* ('lion's dance') and
a seated monkey trainer with his long pole are visible
on the ferry to the left.

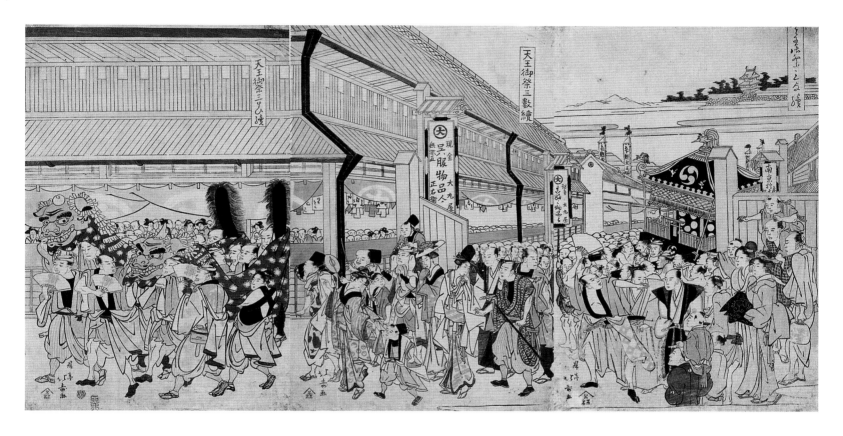

68. Shōtei Hokujū (act. early 19th century)

'A triptych of the Tennō festival' (*Tennō matsuri sanmaitsuzuki*), VI/1807

Signed *Shōtei Hokujū ga* (right and left sheets); *Hokujū* (centre sheet)

Kiwame censorship seal and date seal corresponding to Year of the Hare 6 (VI/1807)

Published by Moriya Jihei

Woodblock, *ōban* triptych, 378/380 x 253 (each)

Gemeentemuseum Den Haag PRM-1983-0001.3

This triptych illustrates a large procession through the streets of Edo. It is led by a group of men performing the *shishimai* ('lion's dance'), who are wearing two large lion masks to which a cloth is attached. The occasion for these celebrations is the *Tennō matsuri* ('Tennō festival'), an annual festival held from the 5th day until the evening of the 14th day of the sixth month. It commences at the Tennō temples at Kanda and Shinagawa. In this print the procession has clearly begun in Kanda in that the shogun's castle is visible in the background and has just crossed the Nakabashi and is now passing the Daimaruya drapery at Ōtenmachō. A festival float is being carried by a number of men. The title of the print appears on all three sheets of the triptych, not just on one as is customary.

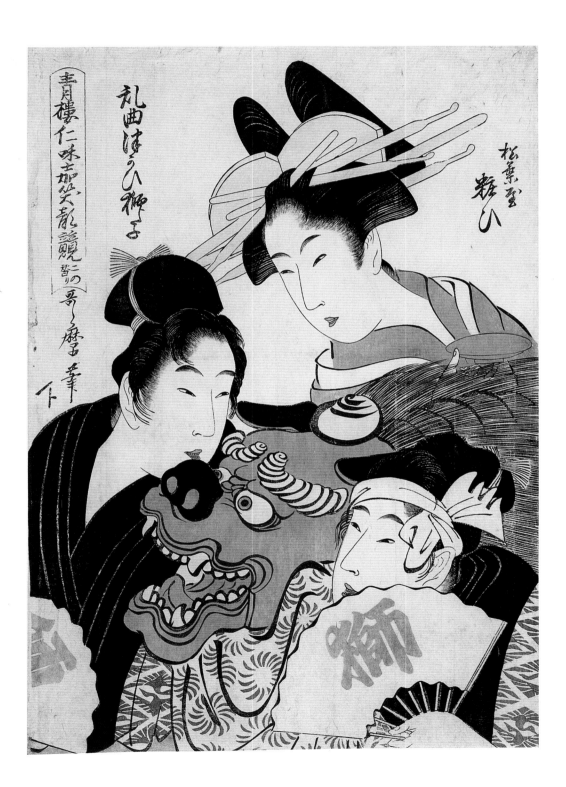

69. Kitagawa Utamaro (1753-1806)
'The *shishi* out of tune' *(Rankyoku tsukai shishi)*
from the series *Comparison of laughing faces at
the Niwaka festival in the licensed district (Seirō
niwaka egao kurabe)*, c. 1799
Signed *Utamaro hitsu*
Published by Yamaguchiya Chūsuke
Woodblock, *ōban*, 375 x 260

Rijksmuseum voor Volkenkunde, Leiden 1327-263

The courtesan Yosooi of the Matsubaya
watches two lion dancers with a large lion
mask between them. Both dancers hold
opened fans inscribed with the word *shishi*
('lion').

70. Katsukawa Shunsen (act. early 19th century)
From an untitled series of playing children, c. 1810s
Signed *Shunsen ga*
Published by Wakasaya Yoichi
Woodblock, *ōban*, 338 x 229

 Rijksmuseum voor Volkenkunde, Leiden 1327-142

Two young boys play the lion dance *(shishimai)*; one
holds a lion mask, the other beats a drum.

71. Kitao Masanobu (1761-1816)
From the *kyōka* album *Spring in all directions (Yomo no haru)*, 1795
Signed *Santō Kyōden utsusu*
Edited by Yomo Utagaki Magao
Published by Tsutaya Jūsaburō
Woodblock, bookplate, 168 x 301

 Rijksmuseum voor Volkenkunde, Leiden 1353-1860

A dancer with a fox mask scares a few women who are working in the kitchen of a
brothel in the pleasure quarter. Two men are outside; one plays a flute whilst another
strikes drums.

72. Torii Kiyonaga (1752-1815)
Signed *Kiyonaga ga*
Published by Takatsu, c. 1788
Woodblock, *ōban* triptych, 361/368 x 247 (each)

Rijksmuseum voor Volkenkunde, Leiden 1353-1818

The Sannō festival procession passes the Miyakezaka towards Hanzōmon, one of the gates of the shogunal castle. The castle walls are visible in the distance towards the centre and right. The procession is accompanied by musicians playing various instruments, and two large festival floats are being carried along in the crowd.

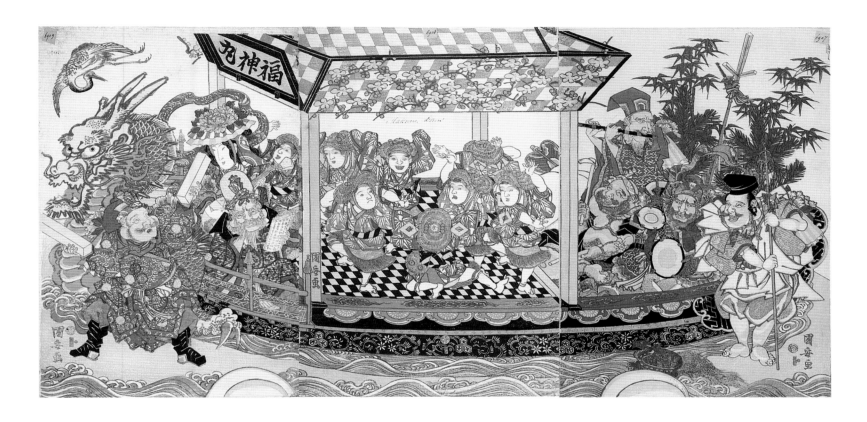

73. Utagawa Kuniyasu (1794-1832)

Signed *Kuniyasu ga*

Kiwame censorship seal

Published by Yamaguchiya Tōbei, early 1820s

Woodblock, *ōban* triptych, 386/392 x 265/268 (each)

Rijksmuseum voor Volkenkunde, Leiden 360-6907-6909

A number of children wearing hats perform the sparrow dance *(suzume odori)* in the same boat that brings the Seven gods of good fortune *(shichifukujin)* into harbour on New Year's morning. To the right the god Daikoku stands beside the boat. To the left the god Ebisu beats wooden blocks *(tsukegi)*. The remaining gods are assembled in the boat called *Fukujinmaru* (the boat of the Gods of good fortune) and play diverse instruments. A crane flies over the boat to the left. This print alludes to the custom of placing a picture of the treasure ship *(takarabune)*, as this boat is usually called, under one's pillow on New Year's eve so as to ensure auspicious dreams.

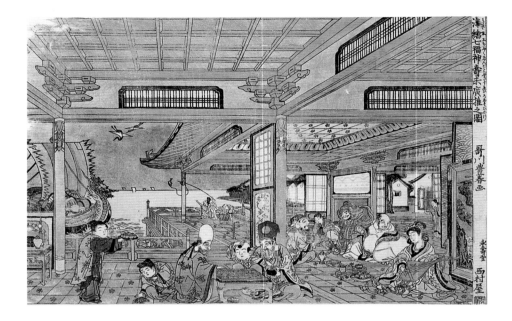

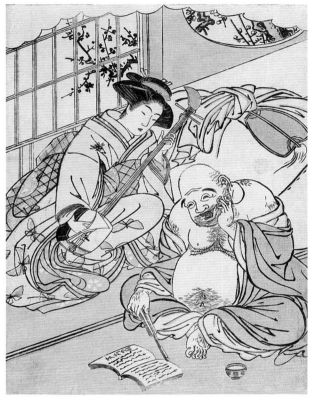

74. Utagawa Toyoharu (1735-1814)

'Perspective print of the Seven gods of good fortune spreading out like a fan' *(Ukie shichifukujin kotobuki suehiro asobi no zu)* from an untitled series of perspective prints *(uki-e)*, c. 1770s

Signed *Utagawa Toyoharu ga*

Published by Nishimuraya Yohachi

Woodblock, *ōban*, 246 x 373

Rijksmuseum voor Volkenkunde, Leiden 1353-1554

After the anchoring of the treasure ship *(takarabune)* - which brings the Seven gods of good fortune *(shichifukujin)* into harbour on New Year's morning - the gods seem to pass the time leisurely. The gods Jurōjin and Fukurokuju are engaged in a game of gō, whilst Benten is playing the lute *(biwa)*.

75. Attributed to Kitao Shigemasa (1739-1820)

Unsigned

Published anonymously, c. 1780s

Woodblock, *chūban*, 250 x 180

Gemeentemuseum Den Haag PRM-1985-0001

A geisha plays the *shamisen* for Hotei, one of the Seven gods of good fortune *(shichifukujin)*. He is recognisable by his rotund belly, thick earlobes and large sack of treasures. The god beats out the tune with a fan as he reads along from a songbook before him on the floor.

76. Ryūryūkyo Shinsai (1764?-1825?)
Signed *Shinsai*
Privately issued by the poets, early 1820s
Woodblock, *shikishiban surimono*, 203 x 184

Rijksmuseum voor Volkenkunde, Leiden 360-2345n

This still-life illustrates the attributes of the
Seven gods of good fortune *(shichifukujin)*.
These include the lute *(biwa)* for the goddess
of love and music, Benten; the cap and
'hammer of chaos' for the god of wealth (of
grains), Daikoku; the sea bream for the god of
daily food, Ebisu; the bag for the god of
happiness, Hotei; the scroll for the god of
academic success, Jurōjin; the helmet for the
god of war, Bishamonten; and the stag's
antler for the god of longevity, Fukurokujū.

Three *kyōka* poems by Denkadō
Michisuki, Nenreisha Harunori and Haikai
Utaba (Kyōkadō) Magao (1753-1829) appear
above.

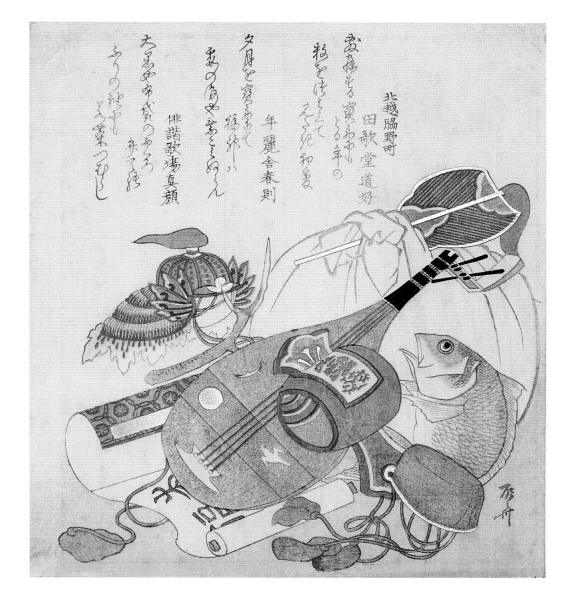

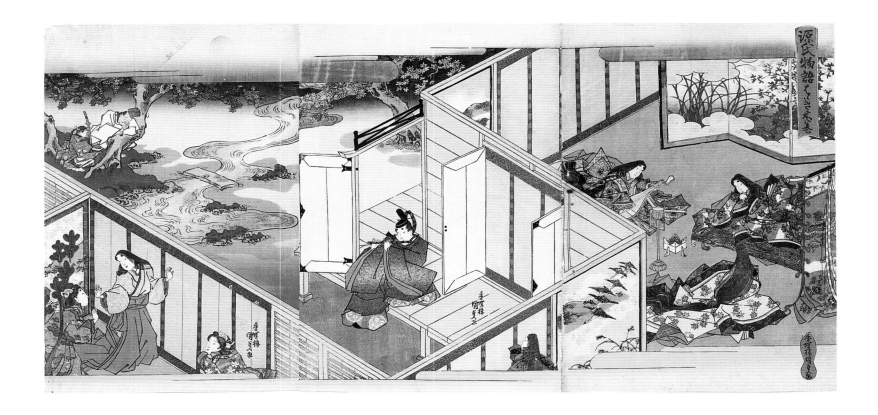

77. Utagawa Kunisada II (1823-80)

'The chapter of Hahakigi' (*Hahakigi no maki*) probably from the series *Tale of Genji (Genji monogatari)*, c. 1834-37
Signed *Kōchōrō Kunisada ga*
Published by Moriya Jihei (no seal on this print)
Woodblock, *ōban* triptych, 363/365 x 244/260 (each)

 Rijksmuseum voor Volkenkunde, Leiden 2488-41

A bird's-eye view into the rooms of a mansion and a garden. To the right court ladies are playing the *koto* and lute *(biwa)*, and a courtier plays along with his flute *(yokobue)* on the verandah outside. Court ladies to the left are enjoying the music.

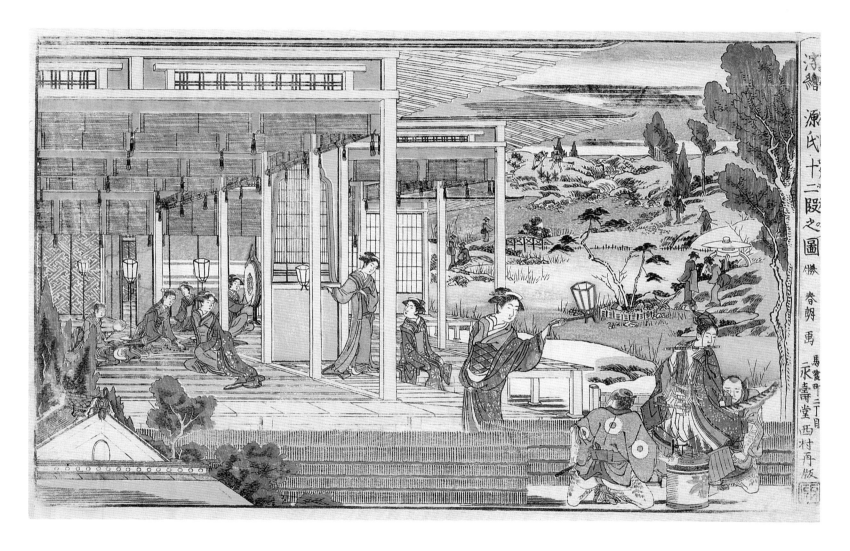

78. Katsushika Hokusai (1760-1849)

'Perspective print of Genji practising' *(Ukie Genji jūnidan no zu)* from an untitled series of seven known perspective prints *(uki-e)*, c. 1785

Signed *Katsu Shunrō ga*

Published by Nishimuraya Yohachi

Woodblock, *ōban*, 241 x 373

Rijksmuseum voor Volkenkunde, Leiden 1353-586

Outside a house, Minamoto no Yoshitsune (1159-89) serenades the beautiful young princess, Jorurihime, on a flute. Jorurihime plays the *koto*, accompanied by a large drum *(tsuridaiko)*. Upon hearing the flutist, she sends one of her maidservants, Reizei, with a lantern to discover his identity. Although Jorurihime's grandfather judged no one an appropriate suitor for her, Yoshitsune managed to gain access to the princess and to spend ten nights in her company. Like many of Hokusai's perspective prints *(uki-e)*, this composition was also based on an earlier design by Utagawa Toyoharu (1735-1814).

79. Kitagawa Utamaro (1753-1806)
'Brocade prints of beauties performing as
Jorurihime' *(Jūnidan hana no nishikie)* from the
series *Amusements at the Niwaka festival in the
licensed district in full bloom (Seirō niwaka zensei
asobi)*, c. 1800-4
Signed *Utamaro hitsu*
Publisher unidentified
Woodblock, *ōban*, 395 x 259

Gemeentemuseum Den Haag PRM-0000-2421

A performance of the Yoshiwara Niwaka
festival with a courtesan as the maidservant
Reizei. Reizei was sent into the garden by the
princess, Jorurihime, to look for the flutist
who accompanied her *koto* playing (see
previous illustration). Here Reizei stands by
the garden gate, a lantern in her hand.
Outside, Minamoto no Yoshitsune (1159-89)
stands and plays the flute whilst one of his
retainers kneels down behind him.
Yoshitsune's long-sleeved kimono is
decorated with the Minamoto family crest, a
gentian above bamboo leaves, and a pattern
of young pines by the entrance gate of a
shrine at the bottom.

80. Suzuki Harunobu (1724-70)
Signed *Suzuki Harunobu ga*
Issued anonymously, c. 1766-68
Woodblock, *hashira-e*, 636 x 116
Rijksmuseum voor Volkenkunde, Leiden 4204-1

A young man *(wakashū)* is dressed as an itinerant
begging monk *(komusō)*, a straw hat in his right hand
and a *shakuhachi* in his left. An alms bag made of black
cloth is over his shoulder. *Wakashū*, sometimes referred
to as 'young dandies', were also regarded as male
prostitutes. They often disguised themselves as
travelling monks, the large straw hats serving to conceal
their identity.

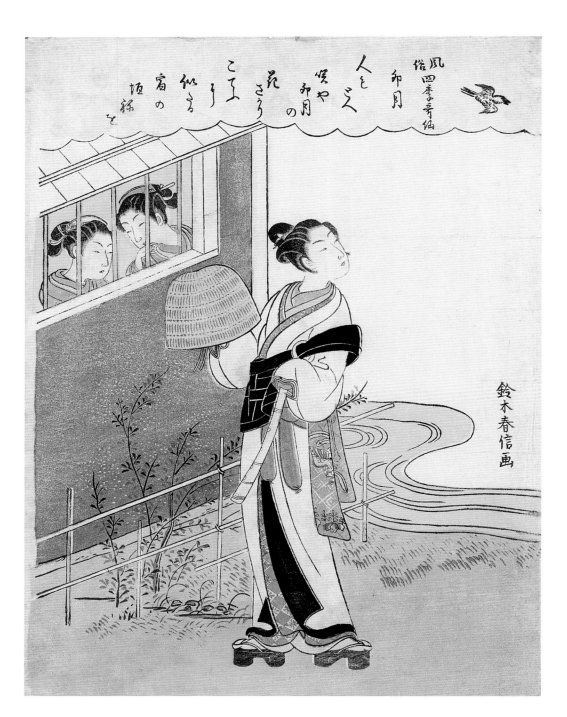

81. Suzuki Harunobu (1724-70)
'The fourth month' *(Uzuki)* from the series
Modern poems in the four seasons (Fūzoku shiki kasen), c. 1768
Signed *Suzuki Harunobu ga*
Published anonymously
Woodblock, *chūban*, 288 x 215

Rijksmuseum, Amsterdam 1956:614

Two young women look out of a latticed window in order to catch a glimpse of a young man dressed as an itinerant begging monk *(komusō)*. The man holds a straw hat in his right hand and seems to be gazing at the flying cuckoo over the stream on one side. He holds a *shakuhachi* in his left hand and his black cloth alms bag is over his shoulder.

The *kyōka* poem at the top of the print reads:

In May, people flock
to the house
where flowers bloom -
like butterflies
around the flower fence.

Hito mo toe
saku ya uzuki no
hana sakari
kochō ni nitaru
yado no kakine.

82. Utagawa Kunisada (1786-1865)

'Willows in the first mist' (*Hatsukasumi yanagi*) (right sheet) and 'Play of the strings' (*Ito asobi*) (left sheet), late 1820s

Signed *Kōchōrō Kunisada ga* with double *Toshidama* seal

Privately issued by the poets

Woodblock, *shikishiban surimono* diptych, 203/204 x 179 (each)

Gemeentemuseum Den Haag PRM-0000-2370; PRM-0000-2369

Two itinerant female musicians (*torioi*) are depicted wearing wide straw hats: Otama plays the *kokyū*, a stringed instrument played with a bow and Osugi plays the *shamisen*. A long text referring to their performances at local district festivals, and especially at the New Year, has been written by Ryūōtei (the poet Edo no Hananari) and appears above.

In addition, there is a *kyōka* poem by Edo no Hananari on the right sheet and a poem by Ryūkaen Zuigaki on the left.

83. Utagawa Kuniyoshi (1797-1861)
Signed *Ichiyūsai Kuniyoshi ga*
Kiwame censorship seal
Published by Kawaguchiya Shōzō, 1816
Woodblock, *ōban*, 374 x 253
Gemeentemuseum Den Haag PRM-1979-0001

The Kabuki actor Onoe Kikugorō III (1815-1847)* is portrayed in the role of the blind *mokkin* player Tokuichi, who in reality is Amagasa Tokubei. This character is from the play *Kasane ōgi* which was performed at the Nakamuraza in the eighth month of 1816 to commemorate the death of the actor Onoe Shōroku I (lived 1744-1815). During this performance, Kikugorō did seven quick changes of role on the stage which were, as the text at the top of the print testifies, a great success. The *mokkin*, a kind of xylophone with wooden bars, is richly decorated in a colourful pattern of possibly foreign origin, perhaps Chinese or even Southeast Asian.

*

Here and in the following, dates indicate the period actors performed under a specific name, rather than dates of birth and death.

84. Kitagawa Utamaro (1753-1806)

'Newly arrived in Edo - souvenirs from Ōtsu'
(*Edo shiire Ōtsu miyage*), c. 1800-4
Signed *Tosa Mitsunobu monjin; Matabei hitsu*
(for the demon); *Utamaro hitsu* (for the
woman)
Published by Ōmiya Gonkurō
Woodblock, *ōban*, 366 x 250

Rijksmuseum voor Volkenkunde, Leiden 1353-1667

A young woman is illustrated wearing a
large hat and holding a branch of wisteria.
Behind her is the large figure of a horned
demon *(oni)*, clad in a black kimono. He beats
a bell *(kane)* and holds an account book.
These two popular figures are taken from the
repertoire of *Ōtsu-e*, traditional folk paintings
from Ōtsu near Kyoto.

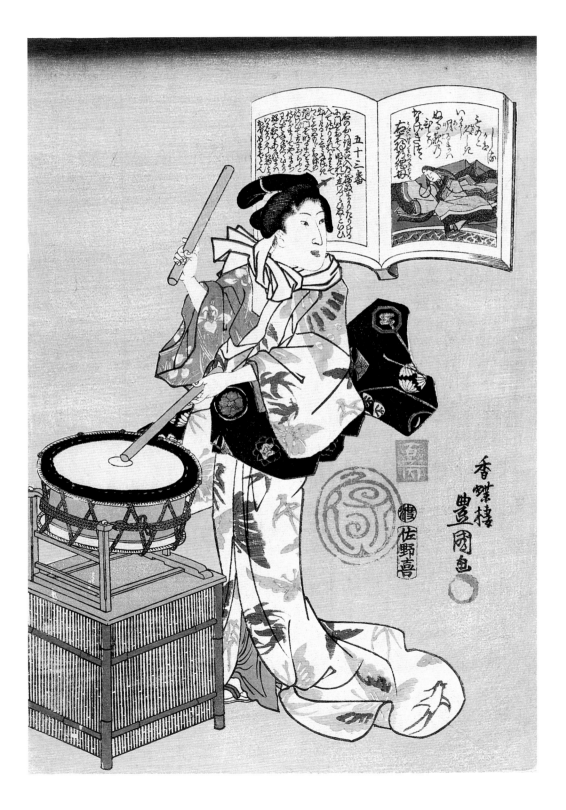

85. Utagawa Kunisada (1786-1865)

From an untitled series on the theme of the 'One-hundred poems by one-hundred poets' *(Hyakunin isshu)*, c. 1843-47

Signed *Kōchōrō Kunisada ga* with *Toshidama* seal

Censor's seal of Watanabe Shōemon

Published by Sanoya Kihei

Woodblock, *ōban*, 375 x 251

Gemeentemuseum Den Haag PRM-0000-2361

A woman is shown beating a drum *(shimedaiko)* on a raised stand. Her kimono is decorated with a repetitive pattern of butterflies and swallows. The top of the print shows an opened book featuring a portrait of the mother of Udaishō Michitsuna (937-95), one of the classical poets represented in the anthology *One-hundred poems by one-hundred poets (Hyakunin isshu)*, and the poem:

Sighing all alone
all the long wake of the night
till daybreak -
Can you grasp at all
how tedious that is?

Nagekitsutsu
hitori nuru yo no
akuru ma wa
ika ni hisashiki
mono to ka wa shiru.

The oval seal adjacent to the figure is unread and was stamped on the print by an earlier collector. The adjacent rectangular seal reads 'from [a series] of one hundred' *(hyaku no uchi)*.

86. Utagawa Kunisada (1786-1865)

From an untitled series on the theme of the 'One-hundred poems by one-hundred poets' (*Hyakunin isshu*), c. 1843-47

Signed *Kōchōrō Kunisada ga* with *Toshidama* seal

Censor's seal of Watanabe Shōemon

Published by Sanoya Kihei

Woodblock, *ōban*, 369 x 248

Gemeentemuseum Den Haag PRM-0000-2362

A woman is seen beating a small bronze bell (*kane*) suspended from a silk cord that she holds in her left hand. Like the woman in the previous illustration, her kimono is decorated with a repetitive pattern of butterflies and swallows. Similarly, the top of the print depicts an opened book, this time featuring a portrait of Fujiwara no Sanetaka ason (d. 998), one of the classical poets represented in the anthology *One-hundred poems by one-hundred poets (Hyakunin isshu)*, and the poem:

How can I tell her
that it is as it is?
She may never know
that my love for her
burns like moxa from Mount Ibuki.

Kaku to dani
e ya wa ibuki no
sashimogusa
sashino shiraji na
moyuru omoi wo.

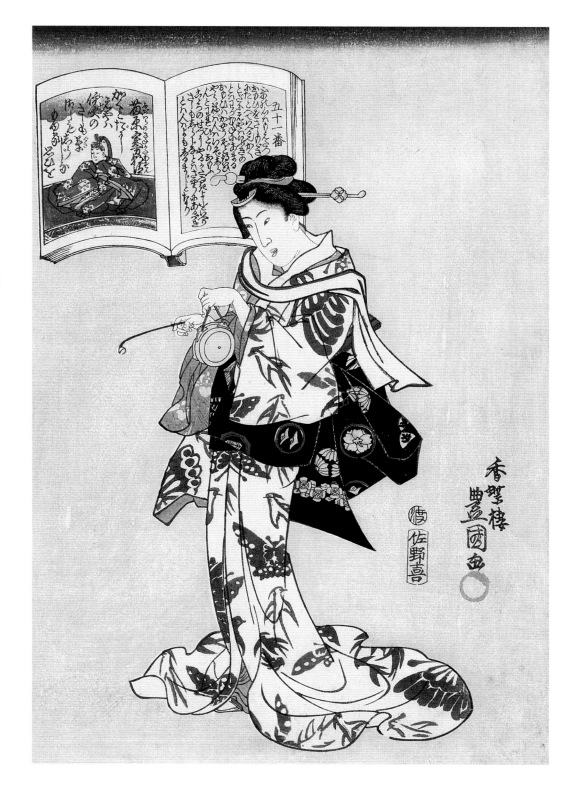

87. Katsukawa Shunkō (1743-1812)

Signed *Shunkō ga*

Published anonymously, c. 1780s

Woodblock, *hosoban*, 325 x 145

Rijksmuseum voor Volkenkunde, Leiden 1353-1121D

A portrait of the Kabuki actor Ichikawa Danjūrō V (1770-91) in the role of an itinerant haberdasher, a chest containing his wares on his back. A small drum hangs from his sash, which is apparently beaten to attract clients' attention when he makes rounds through town. His overkimono is richly decorated with a repetitive pattern of childrens' toys such as Daruma dolls, tops, mills that turn in the wind and small drums with tiny beads attached to strings which create sounds when turned.

88. Kubota Shunman (1753-1820)

Sealed *Shunman*

Privately issued by the Hanazono poetry club, c. 1810s

Woodblock, *shikishiban surimono*, 214 x 188

Rijksmuseum, Amsterdam W.810

A mechanical puppet manipulates two children *(karako)* whilst beating cymbals.

The print is inscribed with two poems by Bairintei Matsukage and Garyūen. Garyūen Umemaro (1792-1857) was the leader of the Hanazono poetry club that was responsible for the publication of this print.

89. Katsushika Hokusai (1760-1849)

Nissaka from an untitled series on the theme of the 'Fifty-three stations of the Tōkaidō' (*Tōkaidō gojūsan tsugi*), after 1804

Signed *Gakyōjin Hokusai ga*

Issued anonymously

Woodblock, *koban*, 125 x 182

 Gemeentemuseum Den Haag PRM-1984-0001

Two street performers make music on a mat at the side of the road at Nissaka. One is an elder man playing the drum whilst his, much younger, counterpart is dancing and beating a set of eight small bells attached to his sash by straps. The bells are set into motion and lifted up by the swinging of the body. Nissaka is a post station located along the highway, the Tōkaidō. The next station, Kakegawa, is indicated as being one mile and 29 *chō* away.

90. Utagawa Yoshiiku (1833-1904)
From the series *An alphabetical account of the Tōkaidō (Tōkaidō iroha nikki)*, VII/1861
Signed *Yoshiiku utsusu*
Published by Takadaya Takezō(?)
Woodblock, *ōban*, 372 x 250

Gemeentemuseum Den Haag PRM-1986-0002

A Kabuki actor as Ameuri Ujūmatsu in the role of a *shamisen* player tuning his instrument. A small drum hangs from a cord around his neck and a mechanical doll is before him on a table. The puppet is seated and beats a metal bell. There are two texts above the figure: the one to the right by Gengyō praises the actor and the other provides information on the performance, which apparently takes place at Kurofunechō in Edo.

91. Toyohara Kunichika (1835-1900)

From the series *Scenes of the twenty-four hours parodied (Mitate chūya nijūyoji no uchi)*, Meiji 24 (I/1891)

Signed *Toyohara Kunichika hitsu* with *Toshidama* seal

Blocks cut by Ōta Kosaburō(?) (sealed *chōkō Kosan*)

Published by Fukuda Kumajirō

Woodblock, *ōban*, 369 x 245

Gemeentemuseum Den Haag PRM-2000-0006

A woman, wearing a head scarf and a striped kimono, plays the *shamisen*. This print illustrates the Hour of the Horse or 12 noon (*Uma no koku jūniji*).

92. Utagawa Kuniyasu (1794-1832)

'A picture of camels' *(Rakuda no zu)*, VIII/1824

Signed *ōju Kuniyasu ga*

Kiwame censorship seal

Published by Moriya Jihei

Woodblock, *ōban* diptych, 389/392 x 261/265 (each)

Rijksmuseum voor Volkenkunde, Leiden 2666-70, 71

These two camels and their attendants were on display at Nishi Ryōgoku in Edo from the eighth month of 1824. They were first imported to Japan by the Dutch at Nagasaki where they were unloaded in the sixth month of 1821 and depicted in a number of *Nagasaki-e* ('Nagasaki pictures'). The camels' stay in Osaka, from the fourth month of 1823, has been recorded in various prints. Two musicians ride the animals, playing a flute and a triangle.

According to the long inscription above by Santō Kyōzan (1769-1858), the animals were imported from Arabia. In a later impression of the print, apparently issued after one of the two animals died, the text and the foreground attendants have been omitted.

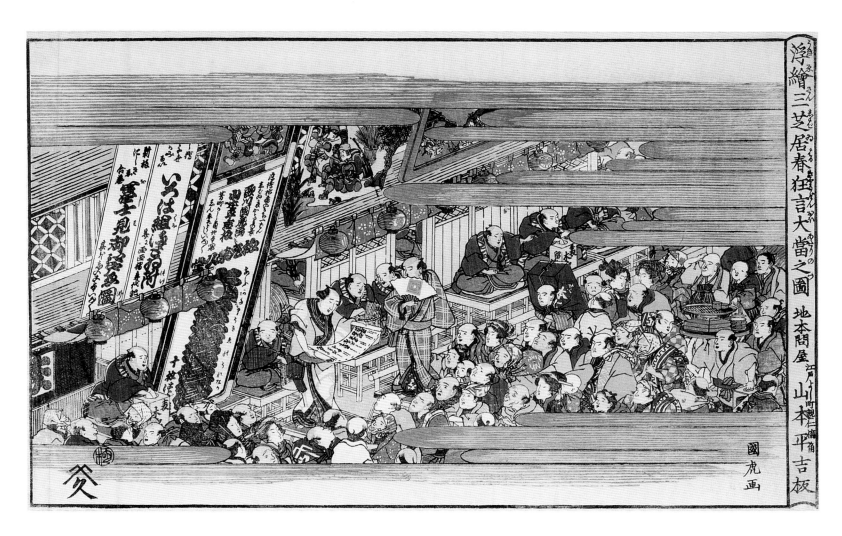

93. Utagawa Kunitora (act. early 19th century)

'Perspective print of the three theatres staging big hits at the "spring performances"' (*Ukie san shibai haru kyōgen ōatari no zu*) from an untitled series of perspective prints (*uki-e*), c. 1820s

Signed *Kunitora ga*

Kiwame censorship seal

Published by Yamamotoya Heikichi

Woodblock, *ōban*, 232 x 371

Rijksmuseum voor Volkenkunde, Leiden 1-4474-79

The theatre district in Edo crowded with people at the time of the 'spring performances' (*haru kyōgen*). The main theatres are to the left; their programmes are announced on the large panels hanging from their facades.

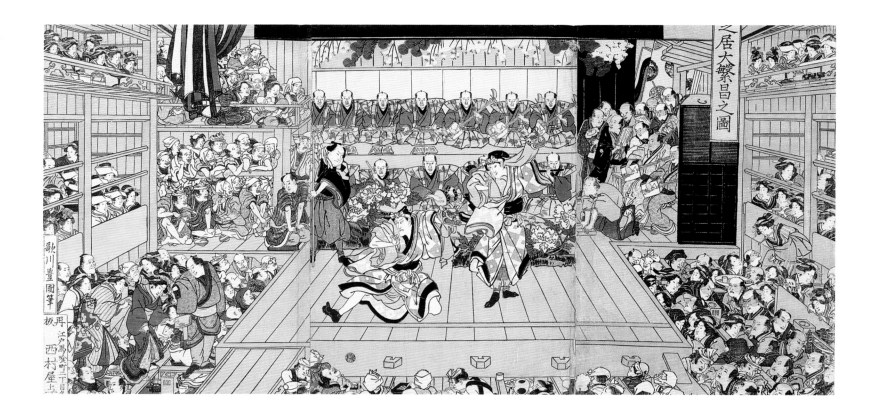

94. Utagawa Toyokuni (1769-1825)

'Great success at the theatre' *(Shibai ōhanjō no zu)*, early 1800s

Signed *Utagawa Toyokuni hitsu*

Kiwame censorship seal

Published by Nishimuraya Yohachi

Woodblock, *ōban* triptych, 355 x 744

Gemeentemuseum Den Haag PRM-0000-2449

This triptych depicts the interior of a Kabuki theatre in Edo. The audience is seated to the right and left, on both the theatre floor and in the balcony. The 'flower path' *(hanamichi)*, which the actors cross when they enter the stage, is seen on the left. Two actors are performing on the stage - Ichikawa Danjūrō VII (1800-32) to the left - with the choir and musicians behind them. The name of the publisher Nishimuraya Yohachi is preceded by the note 'reprint' *(saihan)* which suggests that this print was issued earlier in a slightly different version, possibly with a different performance illustrated in the centre sheet.

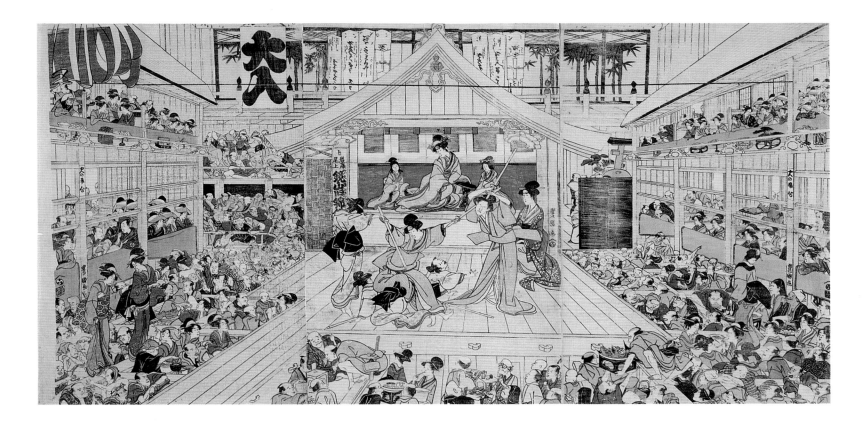

95. Utagawa Toyokuni (1769-1825)

Signed *Toyokuni ga*

Published by Nishimuraya Yohachi, late 1790s

Woodblock, *ōban* triptych, 374/375 x 240/252 (each)

Rijksmuseum voor Volkenkunde, Leiden 1327-230

The composition in this triptych is similar to the preceding example, but in this work the orchestra and choir are hidden behind bamboo blinds to the right. The centre sheet shows a lady and two attendants seated towards the back of the stage whilst five actors in female roles (*onnagata*) are engaged in a fight in the foreground. This print is known in various versions; only the centre sheet is different and represents various scenes from Kabuki performances. Toyokuni is also known to have designed a double triptych (published by Moriya Jihei) with the interior of the theatre shown in the upper triptych and the exterior of the theatre, the Nakamuraza, in the bottom triptych.

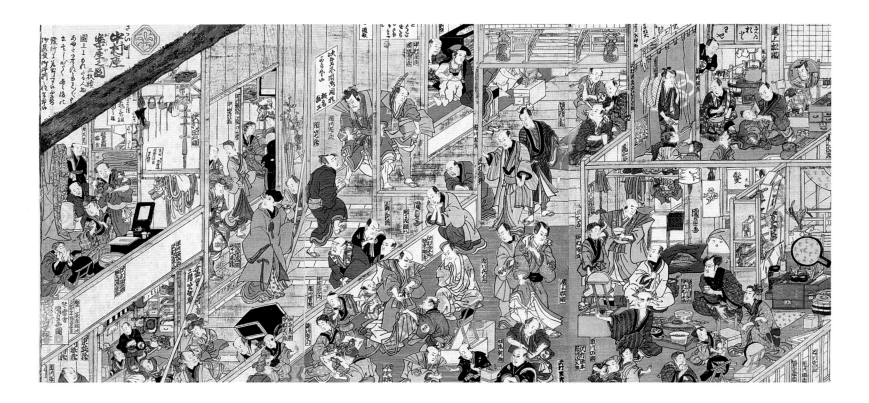

96. Utagawa Kunisada (1786-1865)

'Scene off-stage at the Nakamuraza at Sakaichō' (*Sakai-chō Nakamuraza gakuya no zu*), 1813

Signed *Kunisada ga* (right sheet); *Kinraisha Kunisada ga* (left sheet) with seal *Kunisada* (left sheet)

Published by Nishimuraya Yohachi

Woodblock, *ōban* triptych, 364 x 777

Rijksmuseum voor Volkenkunde, Leiden 1353-824

This triptych illustrates the interior of the Nakamuraza, one of the three major Kabuki theatres in Edo. Unlike the majority of such theatre interiors, this example does not permit us a view of the main hall. Rather, it gives us a glimpse of the various rooms where actors prepare for their performances, of their dressing-rooms and of bustling servants. Most of the actors are identified by name in small upright slips. The right-hand sheet shows the dressing-room of Onoe Matsusuke II (1809-1814) at the top, a party of actors, including Bandō Mitsugorō III (1799-1831) and Nakamura Shichisaburō IV (1785-?), enjoying a meal below. In the centre sheet, Ichikawa Ichizō (1812-1815) is waiting at the top of the stairs. At the top left, Sawamura Tanosuke II (1801-1817) is seen in his dressing-room, and at bottom left a view of the room where the orchestra's musical instruments are kept. Kunisada did a number of such prints of backstage scenes at Kabuki theatres: one of these even dates from as late as 1856.

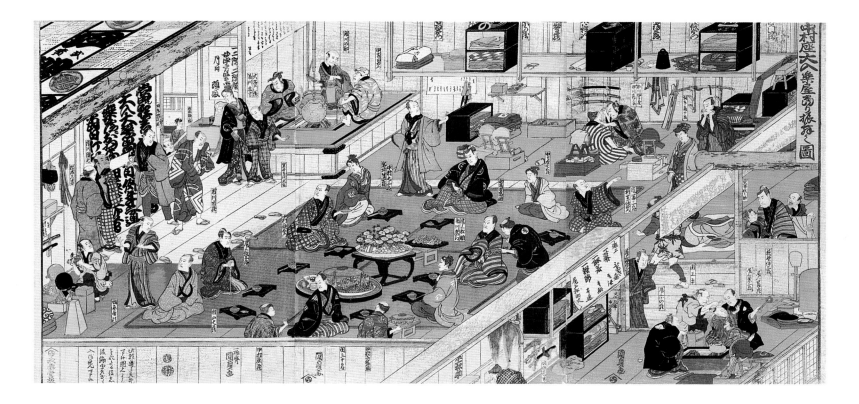

97. Utagawa Kunisada (1786-1865)

'A feast behind the scenes at the Nakamuraza on the occasion of a great success' *(Nakamuraza ōiri gakuya atari furumai no zu)*, 1812

Signed *Kunisada ga* (right and centre sheets); *Ichiyūsai Kunisada ga* (left sheet)

Kiwame censorship seal and censor's seal of Tsuruya Kinsuke

Published by Nishimuraya Yohachi

Woodblock, *ōban* triptych, 372 x 782

Rijksmuseum voor Volkenkunde, Leiden 1353-826

A similar, though more subdued, backstage scene at the Nakamuraza than the preceding image. Here a banquet is being served to a group of actors seated in a large room: (top left) Iwai Hanshirō V (1804-1832) dressed as a female impersonator *(onnagata)*; (to the left) Nakamura Utaemon III (1791-1835); (at bottom) Seki Sanjūrō II (1807-1839) in a black overkimono; (to the right) Onoe Matsusuke II (1809-1814) in a striped kimono; and (to the far left) Ichikawa Ichizō (1812-1815) in a blue summer kimono. The date 'first month of 1812' is inscribed on a panel to the right.

98. Utagawa Kunisada (1786-1865)
Signed *Kunisada ga* (right sheet);
Gototei Kunisada ga (left sheet)
Kiwame censorship seal
Published by Maruya Bunemon, late 1820s
Woodblock, *ōban* triptych, 375 x 684

Rijksmuseum voor Volkenkunde, Leiden 1353-829

A nightly encounter between three Kabuki actors: (to the right) Matsumoto Kōshirō V (1801-1838) carries a large trunk on his back and is beating Ichikawa Danjūrō VII (1800-1832), (centre) with a large stick. Bandō Mitsugorō III (1799-1831) stands to the left.

99. Utagawa Kuniyoshi (1797-1861)

From the series *A comparison of the temperaments of chivalrous men (Date otoko kishō kurabe)*, c. 1847-50

Signed *Ichiyūsai Kuniyoshi ga* with *kiri* seal
Censors' seals of Mera and Murata
Published by Iseya Ichibei
Woodblock, *ōban*, 365 x 254

Rijksmuseum voor Volkenkunde, Leiden 1353-955

The Kabuki actor Ichimura Uzaemon XII (1821-50) is seen in the role of Shōki Hanbei, a popular hero and *otokodate*, a chivalrous type who assisted the poor and oppressed. He wears a wildly ornamented kimono illustrating demon's heads with paulownia leaves and small bells arranged in a starfish pattern. His *shakuhachi*, which is tucked into his sash at the back, was commonly used as a weapon by *otokodate*. The scene is from an unidentified play, one which is not recorded in the eight-volume reference work *Kabuki nenpyō* ('Chronological table of Kabuki', published 1956-73).

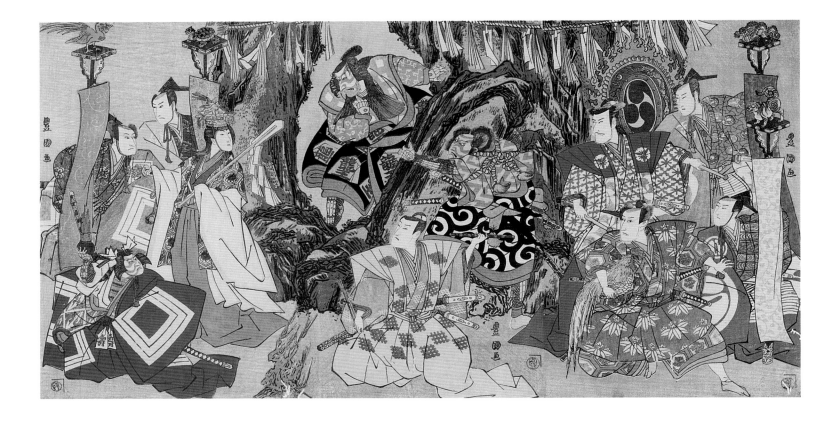

100. Utagawa Toyokuni (1769-1825)

Signed *Toyokuni ga*

Published by Tsuruya Kinsuke, c. 1799

Woodblock, *ōban* triptych, 378/379 x 249/251 (each)

Rijksmuseum voor Volkenkunde, Leiden 1327-230

A *tableau de la troupe* of the eleven most popular Kabuki actors of the day. They pose in an imaginary scene which represents the legendary opening of the cave where the sun goddess Amaterasu no Ōmikami has hidden herself. In this case, however, the cave opens not to reveal Amaterasu but an actor.

For another illustration of the same scene, see catalogue number 63.

101. Utagawa Toyokuni (1769-1825)
Dated 1799
Signed *Toyokuni ga*
Published by Tsuruya Kiemon
Woodblock, *ōban*, 384 x 259

Rijksmuseum voor Volkenkunde, Leiden 1353-1445

A double portrait of the actors Ichikawa
Danzō IV (1773-1808), as the famous warrior
Minamoto no Tametomo (1139-?), and Iwai
Kumesaburō I (1787-1804) as the court lady
Sakon. Sakon holds a flute *(yokobue)*, partly
wrapped in silk. They depict a scene from the
play *Tametomo yumiya no oyabune*, which was
performed at the Nakamuraza from XI/1799.

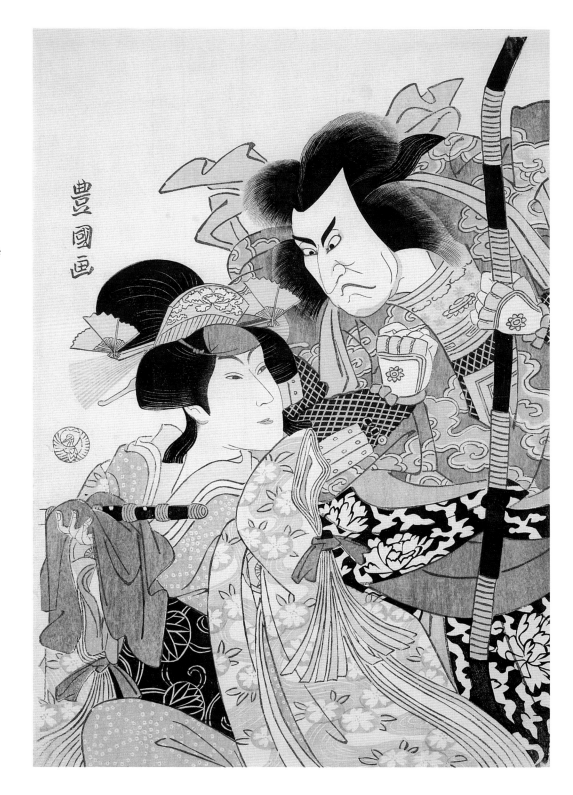

102. Attributed to Utagawa Toyokuni (1769-1825)
Unsigned
Privately issued, 1802
Woodblock, *chūban*, 188 x 258
Collection Matthi Forrer

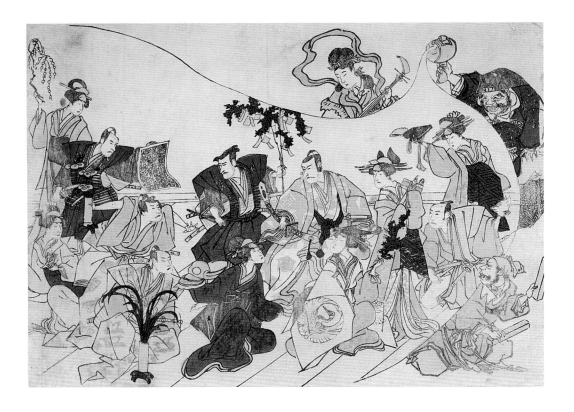

A *tableau de la troupe* of the most popular Kabuki actors of the day who appear in a balloon emanating out of the 'hammer of chaos', the attribute of the popular god of wealth, Daikoku. . Each actor holds various attributes, which are linked with the months, whilst dressed as if they are performing one of the many versions of the *Soga Drama (Soga no taimen)*, the 12th-century vendetta story of the Soga brothers. The Soga drama was traditionally staged in the first month by the three major theatres of Edo. Linking the attributes with specific months, the actors playing male roles *(tachiyaku)* seem to represent the long months of the lunar calendar and the actors in female roles *(onnagata)* the short months. Thus, the print appears to be an unusually large calendar print *(egoyomi)* for the year 1802.

The attributes held by the actors are (from right to left):
a court cap and a fan for the short first month; a foxes mask alluding to the Inari festival in the long second month; two dolls for the Doll festival on the third day of the third month, held by Nakayama Tomisaburō (lived 1760-1819); some branches for the short fourth month held by Segawa Rokō III (1801-7), as Maizuru, the mistress of one of the Soga brothers; a sword for the Boys' festival on the fifth day of the fifth month held by Ichikawa Hakuen (lived 1741-1806), as the villain Kudō Suketsune; a helmet for the short sixth month; branches with paper slips for Tanabata, the festival of the Weaver star on the seventh day of the seventh month, held by Matsumoto Kōshirō V (1801-38); a vase of pampas grass, symbol of the long

eighth month, held by an actor in the role of Soga no Jūrō; chrysanthemums in a vase for the long ninth month or 'chrysanthemum month' *(kikugatsu)*, held by an actor as Soga no Gorō; fish alluding to the festival of Ebisu, god of daily food and fish, celebrated in the short tenth month; a Kabuki programme for the opening performances of the new theatrical season, the *kaomise*, in the long eleventh month and held by Ogino Isaburō II (1799-1822); branches with rice balls attached to them, *mochibana*, for the short twelfth month.

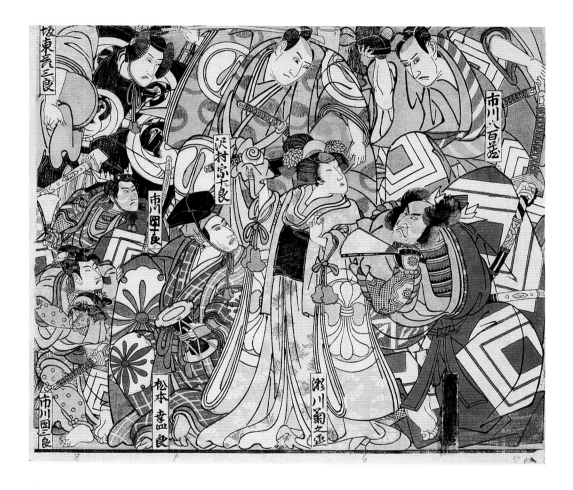

103. Attributed to Utagawa Toyokuni (1769-1825)
Unsigned
Published anonymously, 1795-98
Woodblock, *ōban* (trimmed), 227 x 256

Rijksmuseum voor Volkenkunde, Leiden 1353-2131

A *tableau de la troupe* of Kabuki actors: (top right) Ichikawa Yaozō III (1779-1804); (bottom right) Ichikawa Danzō IV (1773-1808); (top centre) Sawamura Sōjūrō III (1771-1801); (bottom centre) Segawa Kikunojō III (1774-1801); (top left) Bandō Hikosaburō III (1770-1813); (below him) Ichikawa Danjūrō VI (1791-99); (bottom left, holding a drum) Matsumoto Kōshirō IV (1772-1801); and (bottom far left) Ichikawa Dansaburō IV (lived 1788-1845).

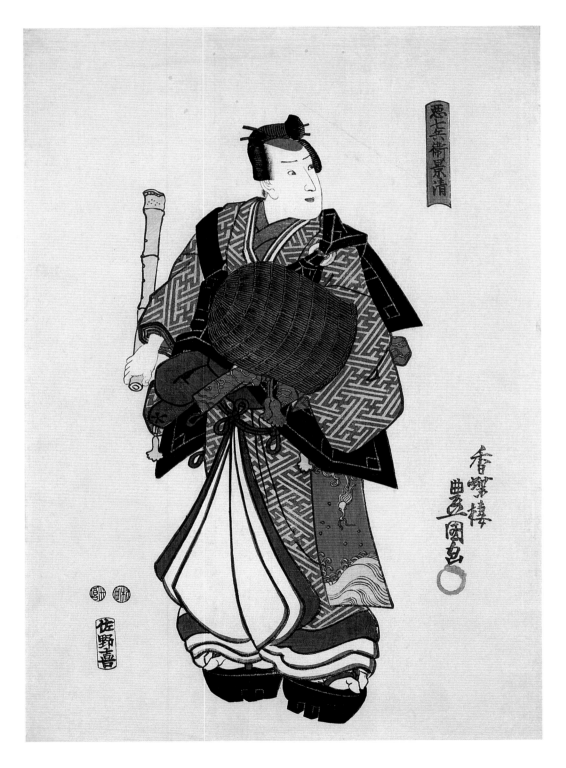

104. Utagawa Kunisada (1786-1865)
Signed *Kōchōrō Toyokuni ga*
Censors' seals of Mera and Murata
Published by Sanoya Kihei, 1849
Woodblock, *ōban*, 375 x 260

Gemeentemuseum Den Haag PRM-0000-2394

The Kabuki actor Ichikawa Danjūrō VIII
(1832-54) appears as the hero Akushichibyōe
Kagekiyo, whose role is based on the warrior
Taira no Kagekiyo (d. 1195). He is dressed as
a travelling begging monk and carries a
shakuhachi in his right hand. The print
illustrates a scene from the play *Kagekiyo*,
which was performed from VIII/1849 at the
Kawarazakiza.

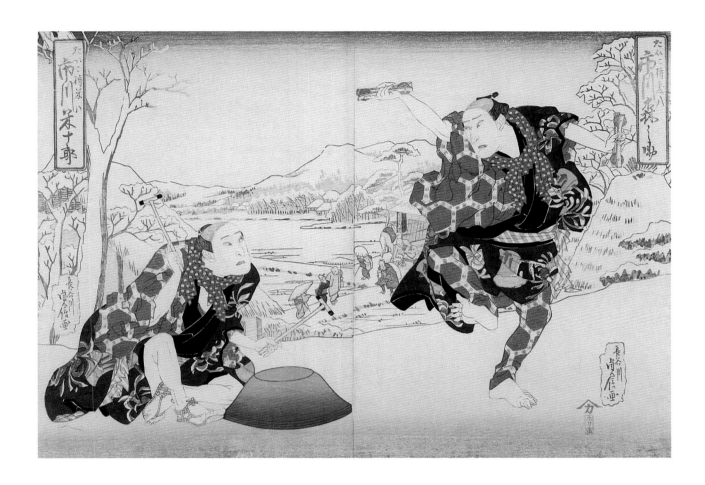

105. Hasegawa Sadanobu (1809-79)
Signed *Hasegawa Sadanobu ga*
Blocks cut by Hori Kane
Published by Ueda (in Osaka), c. 1830s
Woodblock, *chūban* diptych, 250 x 357

Gemeentemuseum Den Haag PRM-1987-0001

Set against a snow-covered landscape with a view of a lakeside village, the actor Ichikawa Morinosuke in the role of Taikomochi ..(?)hachi as he dances with a set of horsebells in each hand to the rhythm beaten out by the actor Ichikawa Eijūrō on an overturned bowl. Eijūrō appears in the role of Taikomochi Eihachi.

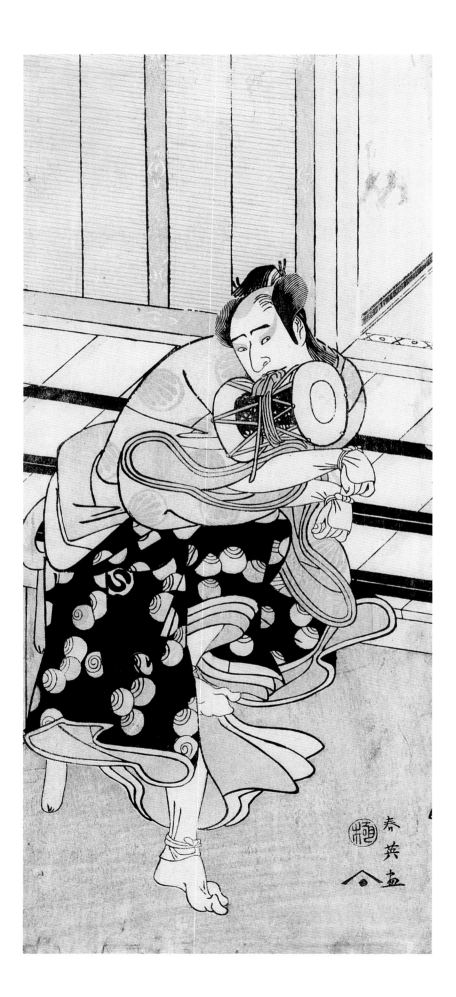

106. Katsukawa Shunei (1762-1819)
Signed *Shunei ga*
Kiwame censorship seal
Publisher unidentified, 1791
Woodblock, *hosoban* (probably part of a triptych), 306 x 137

Gemeentemuseum Den Haag PRM-0000-2342

The Kabuki actor Sawamura Sōjūrō III (1771-1801) dances like a fox, a hand-drum between his teeth. He performs the role of Kitsune no Tadanobu from the play *Yoshitsune senbonzakura,* which was performed at the Ichimuraza from VI/1791.

107. Katsukawa Shunkō (1743-1812)

Signed *Shunkō ga*

Published anonymously, c. 1784

Woodblock, *hosoban*, 309 x 149

Gemeentemuseum Den Haag PRM-0000-2346

The Kabuki actor Ichimura Kamezō II (1762-
85) appears in the role of a street performer.
he plays a *hatchōgane*, a series of eight bronze
bells attached to straps that hang from a sash
around his waist.

A MS-inscription at the top, written by
the previous owner, Kawanabe Kyōsai (1831-
89), probably records the date of acquisition:
'Meiji 17 (1884), Year of the Monkey, first
month 29th day'.

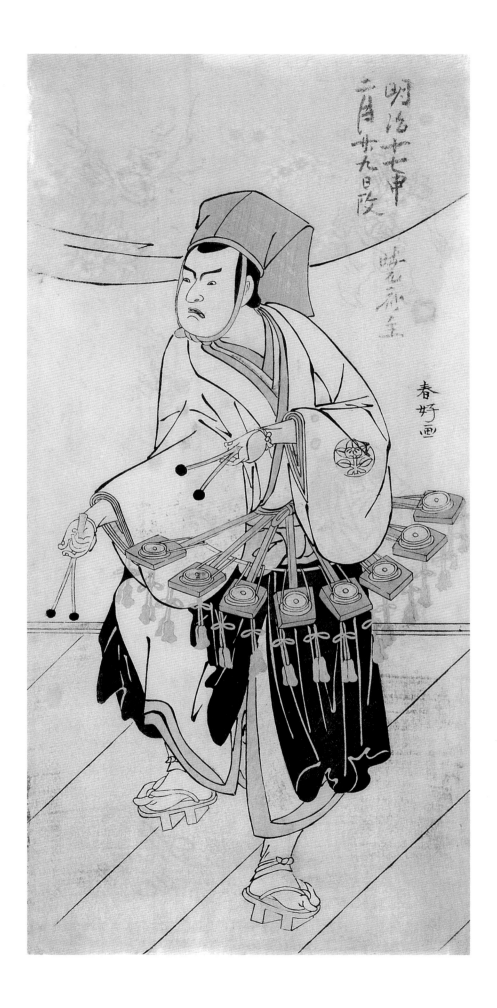

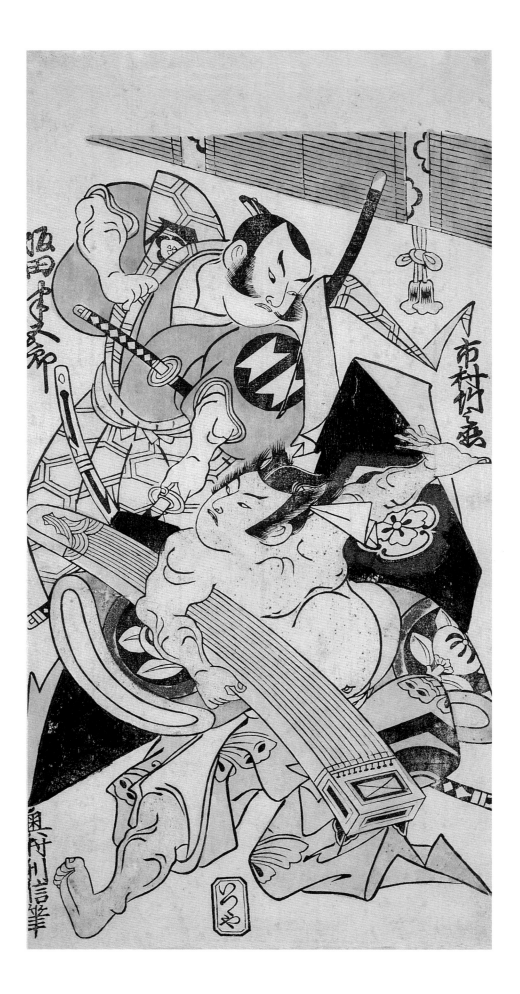

108. Okumura Toshinobu (act. c. 1717-50)
Signed *Okumura Toshinobu hitsu*
Published by Izutsuya Sanemon(?), 1724
Woodblock, hand-coloured *tan-e, hosoban*,
318 x 160

Rijksmuseum voor Volkenkunde, Leiden 2980-1

Bare-breasted and carrying a *koto* under his
arm the actor Ichimura Takenojō IV (1703-37),
in the role of Oniō, engages in a fight with
the actor Sakata Hangorō (lived 1683-1735).
Hangorō appears as Matano Gorō. This scene
is from the play *Yomeiri Izu nikki*, which was
performed at the Ichimuraza from I/1724.
Traditionally the three major theatres of Edo
would stage variations on the 12th-century
vendetta tale of the Soga brothers, the *Soga
Drama (Soga no taimen)*, for New Year
performances. In this case, there is an obvious
association to the popular armour-pulling
scene *(kusazuribiki)* from the drama, when
Soga no Gorō, the younger of the brothers,
attacks Asahina Saburō. However, Asahina, a
samurai in the service of the Soga's enemy,
has already joined the Soga camp.

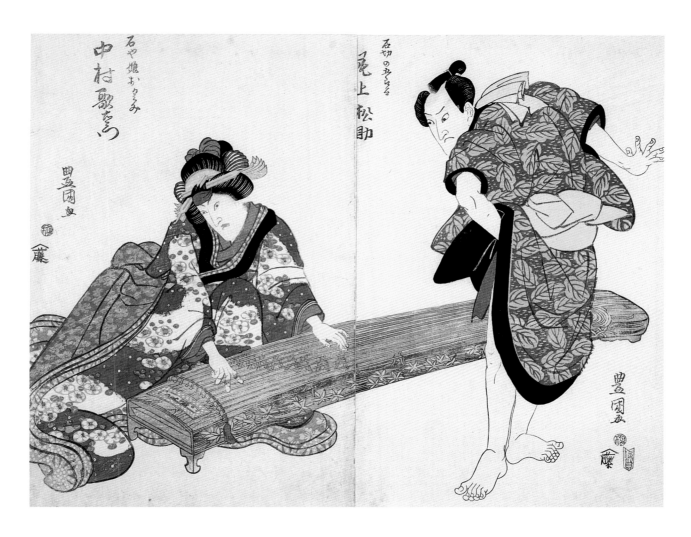

109. Utagawa Toyokuni (1769-1825)
Signed *Toyokuni ga*
Kiwame censorship seal and censor's seal of Igaya
Kanemon
Published by Yamashiroya Tōemon, 1812
Woodblock, *ōban* diptych, 364/365 x 229/241 (each)

Rijksmuseum voor Volkenkunde, Leiden 1327-214

Onoe Matsusuke II (1809-14) is seen as Ishigiri no
Gorōbei and Nakamura Utaemon III (1791-1835) as
Ishiya's daughter Okumi, seated at left and playing the
koto. This is a scene from the play *Chūshin kōshaku*
performed at the Nakamuraza in VII/1812.

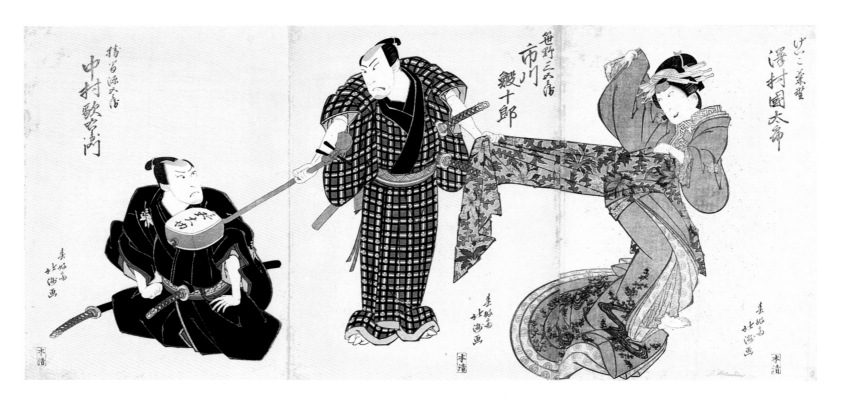

110. Shunkōsai Hokushū (act. 1810-32)

Signed *Shunkōsai Hokushū ga*

Published by Honya Seishichi (in Osaka), 1826

Woodblock, *ōban* (three sheets from a tetraptych),
355 x 754

Rijksmuseum voor Volkenkunde, Leiden 1353-680

A scene from the Kabuki play *Godairiki koi odoshi* with the actor Sawamura Kunitarō II (1819-36, right) in the role of the geisha Kikuno and the actor Ichikawa Ebijūrō (1815-27, centre) as Sasano Sangohei. Sangohei pulls Kikuno by her *obi* and swings a *shamisen* in the face of Nakamura Utaemon III (1791-1835, seated to left), who appears in the role of Katsuma Gengobei. The play was staged at the Nakaza of Asao Yosaburō in Osaka from IX/1826.

111. Katsukawa Shunchō (act. c. 1780-90)
Unsigned
Published by Fushimiya Zenroku (in Edo),
1787
Woodblock, *ōban*, 362 x 240

Gemeentemuseum Den Haag PRM-0000-2430

A scene from a Kabuki play with the actor
Yamashita Yaozō (d. 1812) as Shizuka Gozen.
She beats a hand-drum whilst seated on the
verandah of a house, rolled-up bamboo
blinds over her head. Nakamura Nakazō
(1760-90) is seen to the left in the role of the
fox-spirit Satō Kitsune no Tadanobu. This is a
scene from the play *Yoshitsune senbonzakura*,
which was staged at the Nakamuraza in
Osaka from the 27th day of II/1787. It was
such a great success that it was performed for
the unusually long period of forty-two days.
The MS-inscription at top was written by a
contemporary collector.

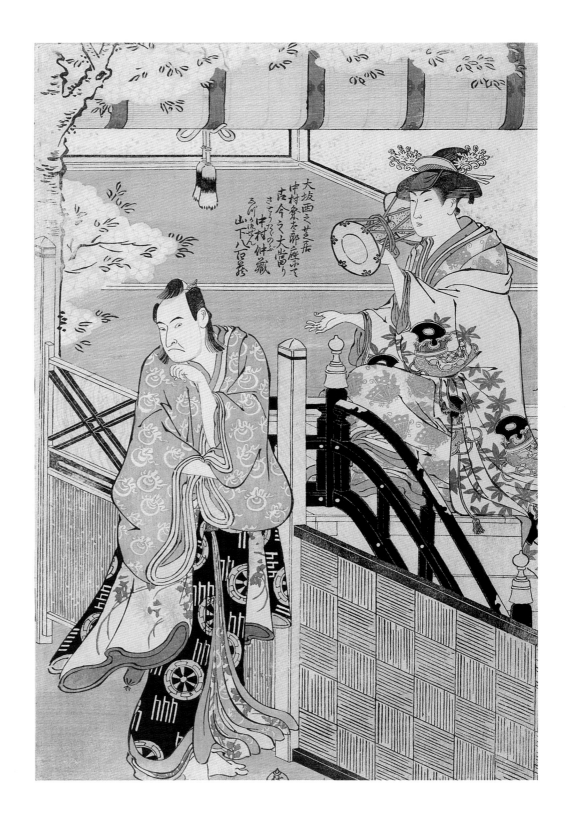

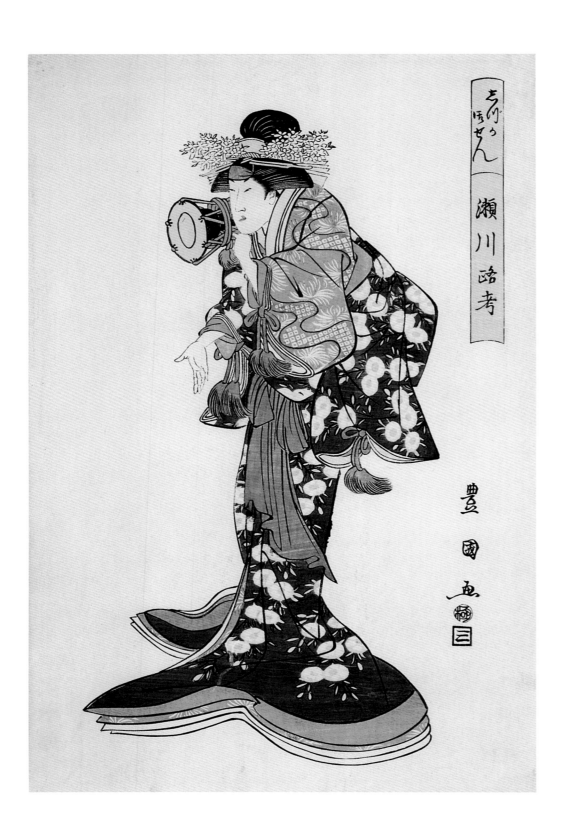

112. Utagawa Toyokuni (1769-1825)
Signed *Toyokuni ga*
Kiwame censorship seal
Published by Shimizu, 1805
Woodblock, *ōban*, 373 x 250

Rijksmuseum voor Volkenkunde, Leiden 1353-1415

The actor Segawa Rokō III (1801-7) is depicted in the role of Shizuka Gozen, the mistress of Minamoto no Yoshitsune. She is dressed in an overkimono ornamented with asters and her hair is elaborately decorated. She beats a hand-drum. This scene is from a performance of the play *Senbonzakura* in IX/1805 at the Nakamuraza. Shizuka Gozen (1168-87) became the favorite concubine of Yoshitsune (1159-89) when she was successful in pleasing the gods with her dancing after attempts by ninety-nine dancers had failed. Her dancing was so agreeable that a severe draught, which had plagued the country in 1182, came to an end. Thereafter, she accompanied Yoshitsune on all his journeys.

113. Torii Kiyonaga (1752-1815)

Signed *Kiyonaga ga*

Published by Nishimuraya Yohachi, 1784

Woodblock, *ōban*, 389 x 256

Rijksmuseum, Amsterdam 1980:1

A scene from a *shosagoto* dance with the two protagonists of the play *Amijima* and the *michiyuki* scene 'Nobe no kakioki' before the orchestra. To the right is the *shamisen* player Namisaki Tokuji and to his left the chanters Tomimoto Buzendayū and Tomimoto Itsukidayū. The actors are Sawamura Sōjūrō III (1771-1801) as Jihei and Iwai Hanshirō IV (1765-1800) as the courtesan Koharu. Their ill-fated love story, which ended in a double suicide, was originally written for the puppet theatre by Chikamatsu Monzaemon (1653-1724) in 1715 under the title *Shinjū ten no Amijima*. This print is from a performance of the play at the Nakamuraza in VIII/1784.

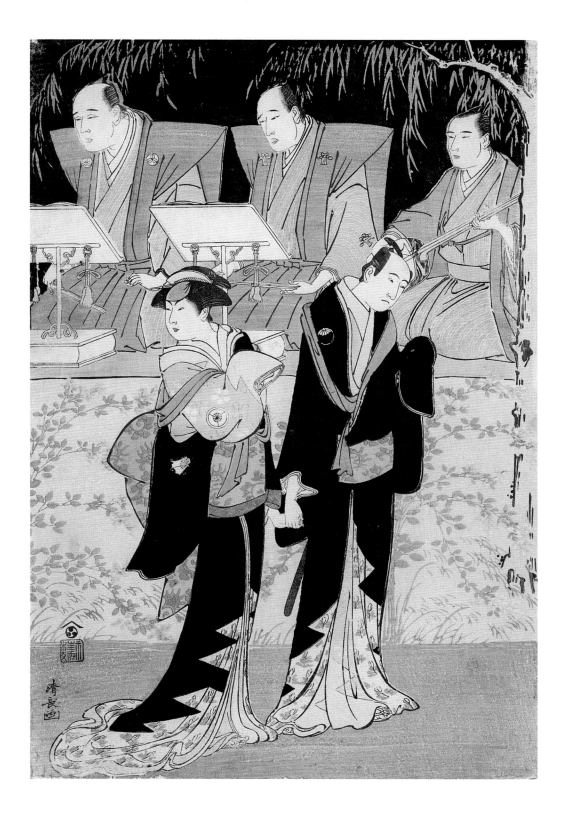

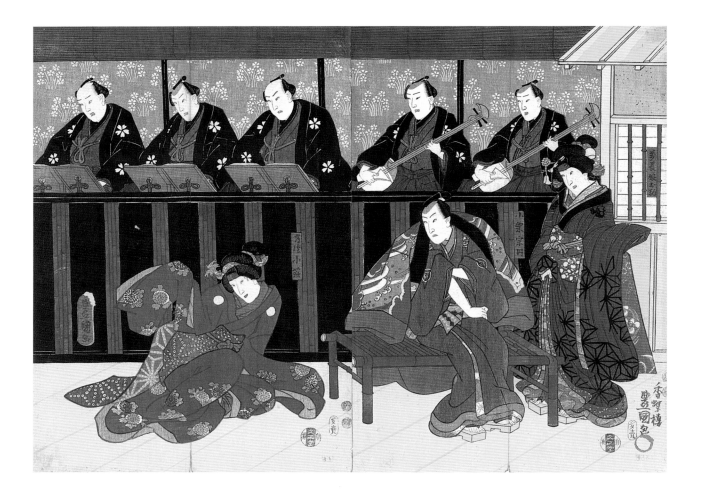

114. Utagawa Kunisada (1786-1865)
Signed *Kōchōrō Toyokuni ga* with *Toshidama* seal
Censors' seals of Mera and Watanabe and *shitauri* seal
Published by Kobayashi Taijirō, 1851
Woodblock, *ōban* diptych, 367 x 499

Rijksmuseum voor Volkenkunde, Leiden 1455-37

A scene from a Kabuki play with Iwai Kumesaburō III (1832-64) in the role of Okoma, the daughter of Mannaga; Bandō Takesaburō (lived 1832-77) as Oguri Muneaka seated on a bench; and Onoe Kikujirō II (1835-56, 1858-75) as Kohagi. The orchestra is positioned on an elevated platform behind them. The print is from a performance of the play *Yukari no iro koi no somekinu* at the Nakamuraza from IV/1851.

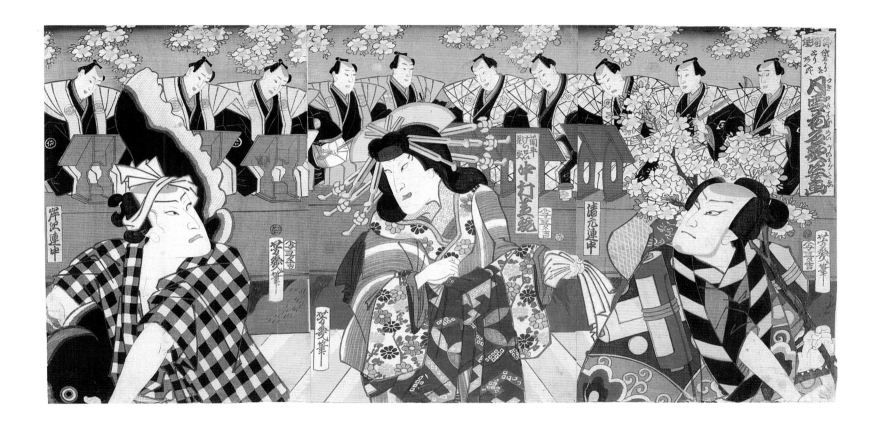

115. Utagawa Yoshiiku (1833-1904)
A scene from the play *Tsuki yuki hana meigu no sugatae*,
Signed *Yoshiiku hitsu*
Aratame censorship seal and date seal corresponding to
Year of the Ox 4 (IV/1865)
Published by Ōtaya Takichi, 1865
Woodblock, *ōban* triptych, 356 x 726

Rijksmuseum voor Volkenkunde, Leiden 1455-17

A scene from a Kabuki performance: in the centre the
actor Nakamura Shikan IV (1860-99) as the courtesan
Misane and to the right and left possibly the actors
Onoe Baikō VI (1864-?) as the Seigen party and
Nakamura Fukusuke (1861-67) as the Kishisawa party,
respectively. The title of the print is the same as the play
from which this scene was drawn. The play was
performed at the Moritaza from III/1865.

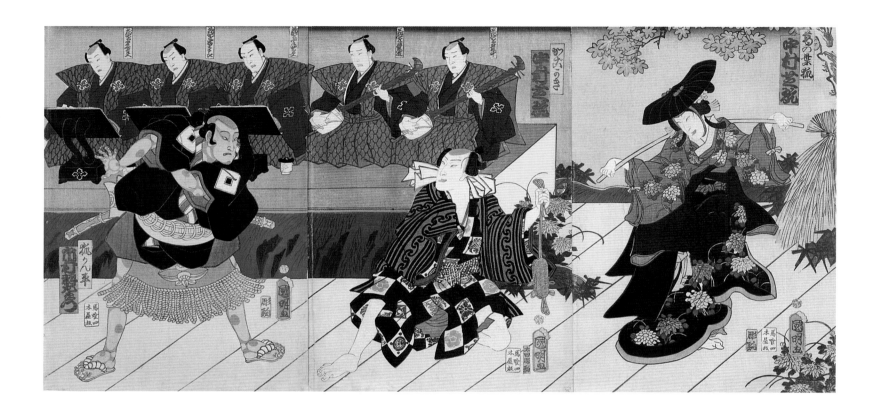

116. Utagawa Kuniaki II (1835-88)

Signed *Kuniaki ga* within *Toshidama* cartouche

Blocks cut by Ōta Komakichi (sealed *hori Koma* [right and left sheets]; *Ōta hori Koma* [centre sheet])

Aratame censorship seal and date seal corresponding to Year of the Cock 9 (IX/1861)

Privately issued by Kiya Sōjirō, 1861

Woodblock, *ōban* triptych, 365 x 257 (each)

Gemeentemuseum Den Haag PRM-1981-0003

A scene from an unidentified Kabuki play with the actor Nakamura Shikan IV (1860-99) in a double role: to the right as Kuzunoha no Kitsune, who dances with a stick behind her shoulders, and in the centre as Tsubokaki, who kneels by some chrysanthemums and holds a pair of straw sandals. To the left Ichimura Uzaemon XIII (1851-62) appears as Kitsune Kanbei. The orchestra is behind them on a dais.

117. Okumura Masanobu (1686-1764)

c. 1740s

Woodblock, *beni-e*, 420 x 632

Rijksmuseum voor Volkenkunde, Leiden 3416-1

A wide perspective view of the crowds on the Nakanochō, the central street of the Yoshiwara. Several samurai in the foreground appear to be paying an illicit visit to the pleasure quarters. In the crowd a pedler of tobacco pouches, a trunk on his back, advertises his wares as 'tobacco pouches in a large assortment'. The print title, signature and publisher's mark have been trimmed from this work.

118. Utagawa Kunisada (1786-1865)
'The eight famous views of Edo in one glance' (*Shinpan
Edo meisho hakkei ichiran*), XII/1809
Signed *Kunisada ga* (right sheet); *Gototei Kunisada ga* (left
sheet)
Published by Nishimuraya Yohachi
Woodblock, *ōban* (two sheets of a pentaptych), 379 x 506

Rijksmuseum voor Volkenkunde, Leiden 1327-100

These two sheets are the left-hand part of a larger
composition encompassing the theme of the 'Eight
famous views of Edo' (*Edo meisho hakkei*). The backdrop
is a panoramic view of the Sumidagawa with the bridge,
Ryōgokubashi, to the right. The Sensōji at Kinryūzan,

Asakusa is visible in the middle ground as 'Lingering
snow at Kinryūzan' (*Kinryūzan no bosetsu*) from the
'Eight views'. The celebrated Ofuji of the Yanagiya is
shown selling toothbrushes in the foreground. To the
left is the Mimeguri shrine, its entrance gate just
perceptible over the embankment of the river. This is an
illustration of 'Descending geese at Mimeguri'
(*Mimeguri no rakugan*). The courtesans parading along
the central avenue of the pleasure quarter in the
foreground represent the scene 'Evening rain in the
Yoshiwara' (*Yoshiwara no yoru no ame*).

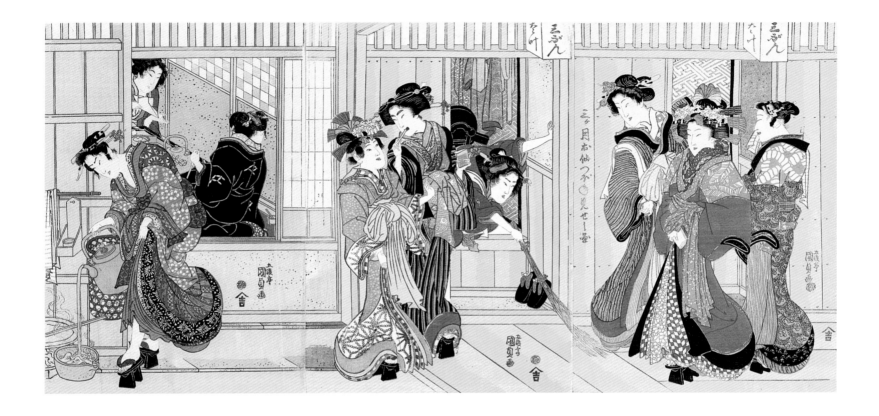

119. Utagawa Kunisada (1786-1865)

'View of the Mikazuki Osen brothel' (*Mikazuki Osen tsubone mise no zu*), c. 1817

Signed *Gototei Kunisada ga*

Kiwame censorship seal

Published by Enomotoya Heikichi

Woodblock, *ōban* triptych, 380/386 x 261/264 (each)

Rijksmuseum voor Volkenkunde, Leiden 360-2351

This triptych portrays the interior of the Mikazuki Osen brothel, one of the low-class brothels situated on the edge of the Yoshiwara. It probably only accommodated individual clients. To the right, a courtesan and her two attendants return from the bathhouse. One of the group dries her ears, another has a towel over her shoulder. In the centre, a courtesan addresses a young attendant (*shinzō*) whilst brushing her teeth, and to the left a courtesan pours hot water into a washing basin. The print also provides a glimpse of other courtesans in various interior rooms; one woman, for example, is seen sweeping the verandah. This work is a reprint from the same blocks used earlier by the firm of Hagiwara, a publisher known to have primarily worked with the young Kunisada.

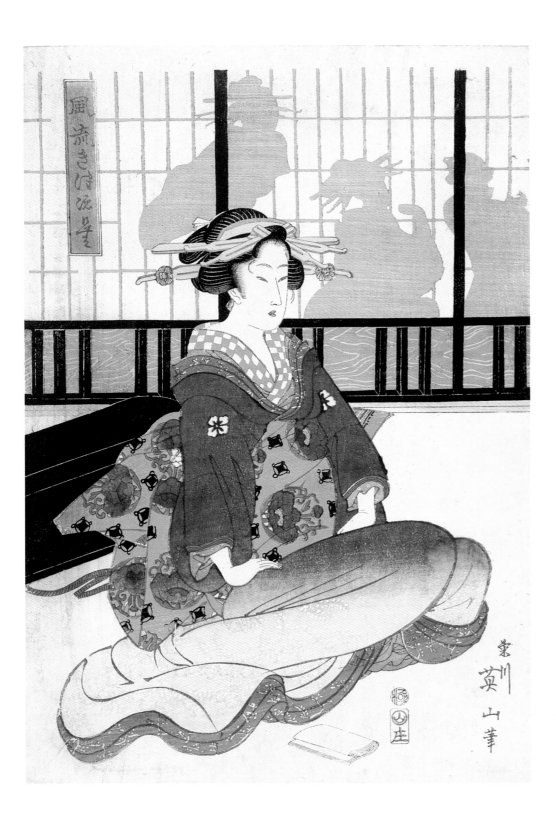

120. Kikugawa Eizan (1787-1867)
'The play of *kitsuneken* in a fashionable
manner' *(Fūryū kitsuneken)*, c. 1825
Signed *Kikugawa Eizan hitsu*
Kiwame censorship seal
Published by Yamadaya Shōjirō
Woodblock, *ōban* (left-hand sheet of a
triptych), 392 x 264

Rijksmuseum voor Volkenkunde, Leiden 1-4470-59

A geisha is seated, hands on her legs, with a
shamisen case behind her on the floor. This is
actually the left-hand sheet of a triptych of
three geisha in a room, who are playing the
game of *kitsuneken*, a game of hand
movements. In the background, a party is
taking place behind *shoji* panels with a group
dancing to the accompaniment of *shamisen*
music. This is a reprint from blocks issued
earlier in VIII/1814 under the title 'Three
elegant beauties drinking and enjoying'
(Fūryū shugisan bijin). There are a number of
modifications, especially in the clothing
patterns.

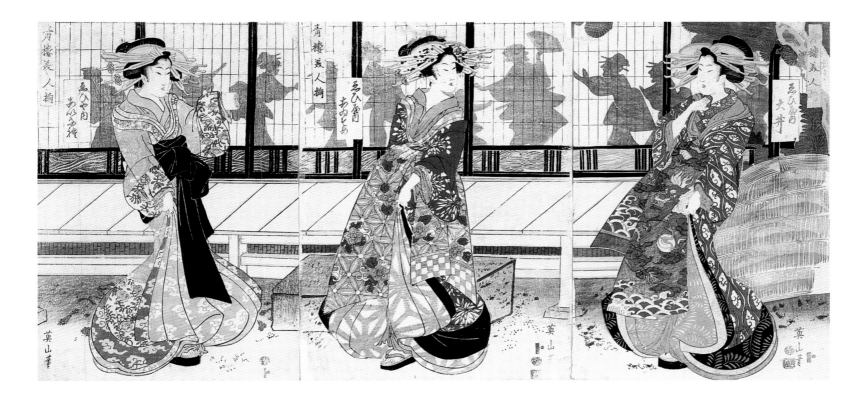

121. Kikugawa Eizan (1787-1867)

From the series *A series of beauties from the licensed quarters (Seirō bijinzoroi)*, c. 1813

Signed *Eizan hitsu*

Kiwame censorship seal and censor's seal of Nishinomiya

Published by Yamaguchiya Tōbei

Woodblock, *ōban* triptych, 374/377 x 256/267 (each)

Rijksmuseum voor Volkenkunde, Leiden 360-2353

Three courtesans of the Ebiya brothel are in a garden which affords a view across a verandah of a party taking place behind closed doors. The party-goers are portrayed in silhouette through the closed *shoji* panels. From right to left, the courtesans are Ōi, Aizome and Ainami.

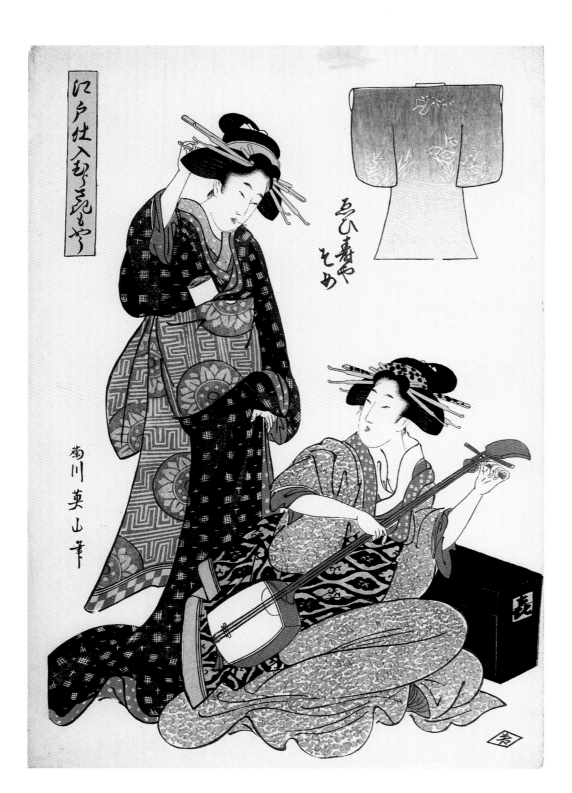

122. Kikugawa Eizan (1787-1867)

'Dyes from Ebisu's shop' *(Ebisuyazome)* from
the series *The latest designs in purple available
in the shops of Edo (Edo shiire murasaki moyō)*,
c. 1805-8
Signed *Kikugawa Eizan hitsu*
Published by Wakasaya Yoichi
Woodblock, *ōban*, 386 x 265

Rijksmuseum voor Volkenkunde, Leiden 1353-1718

This print depicts two geisha, one standing
and adjusting her hair, the other seated and
tuning her *shamisen*, its lacquered case at her
side. An inset top right features a kimono
with a dyed pattern, apparently one of the
newly available patterns from the Ebisuya.
Prints like this one were most likely
subsidised in part by such shops as a form of
advertisement.

123. Keisai Eisen (1791-1848)

From the series *Courtesans as a board game along the road - the Yoshiwara as the fifty-three stations (Keisei dōchū sugoroku - Mitate Yoshiwara gojūsantsui)*, c. 1825-26
Signed *Keisai Eisen ga*
Kiwame censorship seal
Published by Tsutaya Kichizō
Woodblock, *ōban*, 371 x 253

Rijksmuseum voor Volkenkunde, Leiden 1-4470-S

The courtesan Kumoi of the Tsuruya brothel in the Yoshiwara is clad in an elaborate overkimono patterned with various traditional musical instruments and maples above. An inset top right features a landscape at Kanagawa, one of the stations along the Tōkaidō, the main highway connecting the cities of Edo and Kyoto.

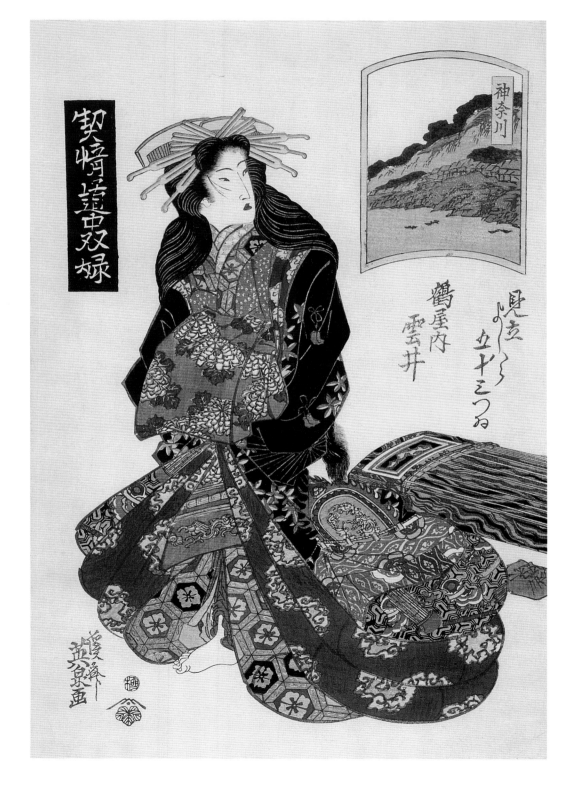

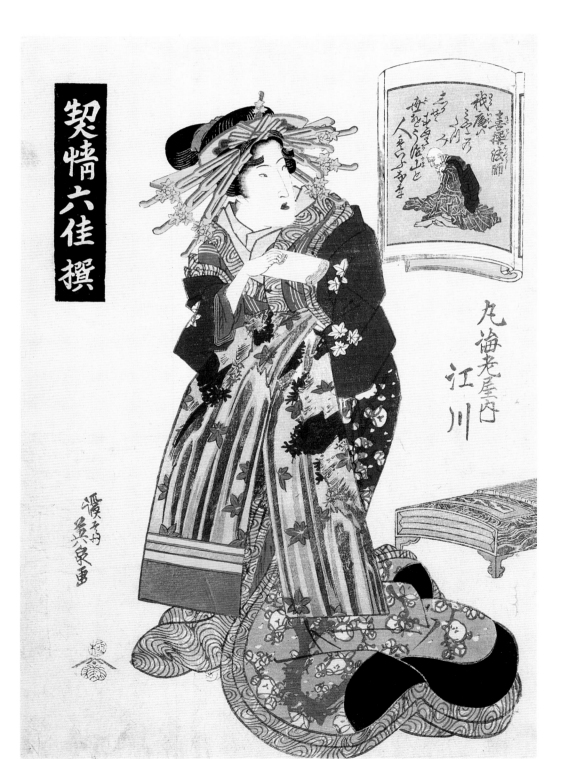

124. Keisai Eisen (1791-1848)

From the series *Courtesans as the six classical poets (Keisei rokkasen)*, late 1820s
Signed *Keisai Eisen ga*
Kiwame censorship seal
Published by Tsutaya Kichizō
Woodblock, *ōban*, 355 x 247

Rijksmuseum voor Volkenkunde, Leiden 1327-324

The courtesan Egawa of the Maruebiya brothel is dressed in a deep blue kimono decorated with flowering plum and an obi ornamented with a pattern of maple leaves falling on a cascade. She leaves her *koto*, a roll of tissue paper in her hands, probably on the way to the toilet. The inset top right is in the shape of an open book and features a portrait of the poet Kisen Hōshi with one of his poems inscribed above:

My simple hut
lies to the southeast of the capital
and thus I choose to dwell -
the world in which I live
men have called the Mount of Sorrow.

Waga io wa
Miyako no tatsumi
shika zo sumu
yo wo Ujiyama to
hito wa yu nari.

This particular series comprises six prints.

125. Attributed to Utagawa Kunisada (1786-1865)

From the series *Beauties and the fifty-three stations of the Tōkaidō (Bijin awase gojūsantsugi)*, Unsigned
Privately issued, late 1820s
Woodblock, *surimono*, 189 x 127

Rijksmuseum voor Volkenkunde, Leiden 591-9b

A courtesan takes a break from her *koto* playing, the instrument resting on her legs. An inset above shows one of the stations of the Tōkaidō, the main highway connecting the cities of Edo and Kyoto. In this instance, the scene is of the station of Hodogaya.

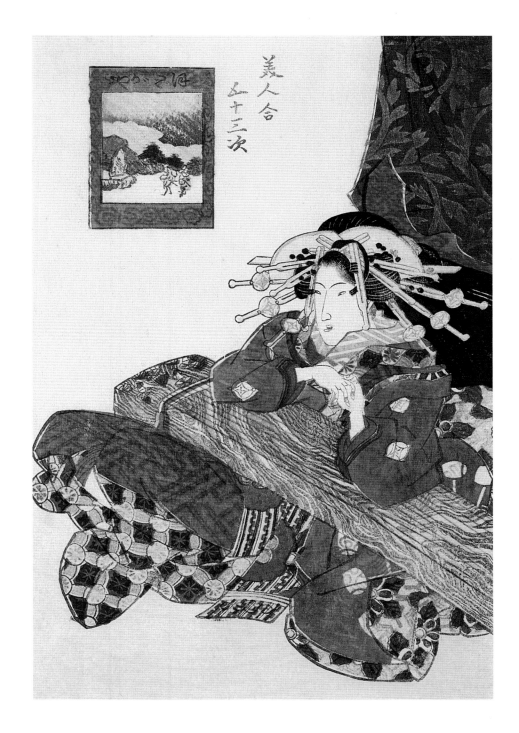

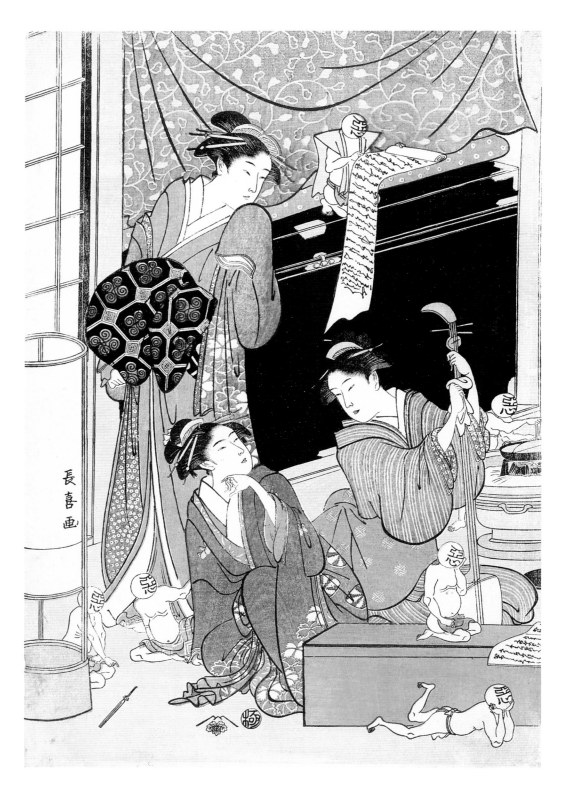

126. Eishōsai Chōki
(act. c. 1780s-early 19th century)
Signed *Chōki ga*
Kiwame censorship seal
Published by Tsutaya Jūsaburō, c. 1798
Woodblock, *aiban* (left-hand sheet of a
triptych), 324 x 222

Gemeentemuseum Den Haag PRM-0000-2340

A house of pleasure is being haunted by evil
spirits which appear as small homunculi with
spherical heads inscribed with the character
for 'evil' *(aku)*. In the foreground a geisha
interrupts her *shamisen* playing to chat with
another geisha kneeling behind her. A
courtesan stands behind them. One of the evil
spirits reads a letter on a bed which is
positioned on a black-lacquered chest. Chōki
seems to have been quite fascinated with
these 'evil spirits', which appear in several
other designs by him. They were even more
common in the popular novels of the time.

127. Kitagawa Utamaro (1753-1806)

Tsūgen from the series *A romantic vision of the eight immortals (Enchū hassen)*, c. 1793
Signed *Utamaro hitsu*
Kiwame censorship seal
Published by Tsuruya Kiemon (no seal on print)
Woodblock, *ōban*, 360 x 240

Gemeentemuseum Den Haag PRM–1981-0002

The courtesan Hanabito of the Ōgiya brothel holds up a gourd flask. To the surprise of the young trainee *(kamuro)* a white rat appears from its opening. A *koto* is behind the courtesan and the rat's cage is in the foreground. The names of Hanabito's two *kamuro*, Sakura and Momiji, appear next to hers. The title of the print, 'Tsūgen', is another name for Chōkarō, a Chinese Daoist immortal who used to travel on a white mule which he kept in a gourd when not needed. The white rat in this print alludes to the mule in this myth.

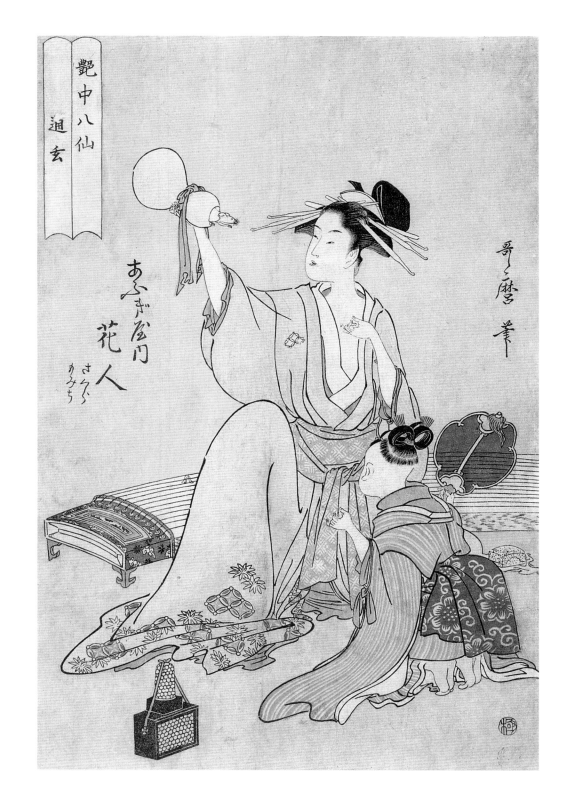

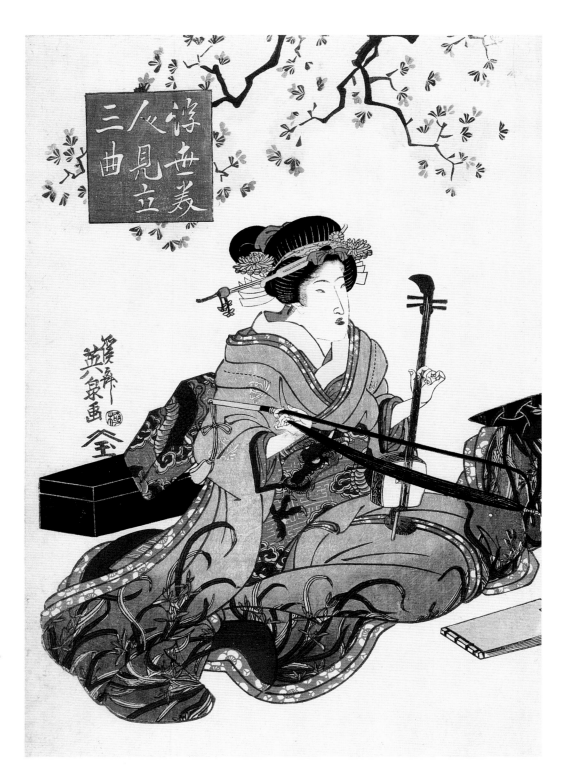

128. Keisai Eisen (1791-1848)

From the series *Beauties from the floating world as the classical trio (Ukiyo bijin mitate sankyoku)*, c. 1825

Signed *Keisai Eisen ga*

Kiwame censorship seal

Published by Moritaya

Woodblock, *ōban* (possibly left-hand sheet of a triptych), 372 x 259

Rijksmuseum voor Volkenkunde, Leiden 1-4468-559

A woman plays the *kokyū*, a songbook is set before her and the lacquered case of the instrument is seen behind her. A branch of flowering cherries is above.

129. Keisai Eisen (1791-1848)

From the series *Beauties from the floating world
as the classical trio (Ukiyo bijin mitate sankyoku)*,
c. 1825
Signed *Keisai Eisen ga*
Kiwame censorship seal
Published by Moritaya
Woodblock, *ōban* (possibly right-hand sheet of
a triptych), 374 x 257

 Rijksmuseum voor Volkenkunde, Leiden 1-4468-558

A woman plays the *shamisen*, a lacquered
instrument case behind her. A branch of
flowering cherries is above.

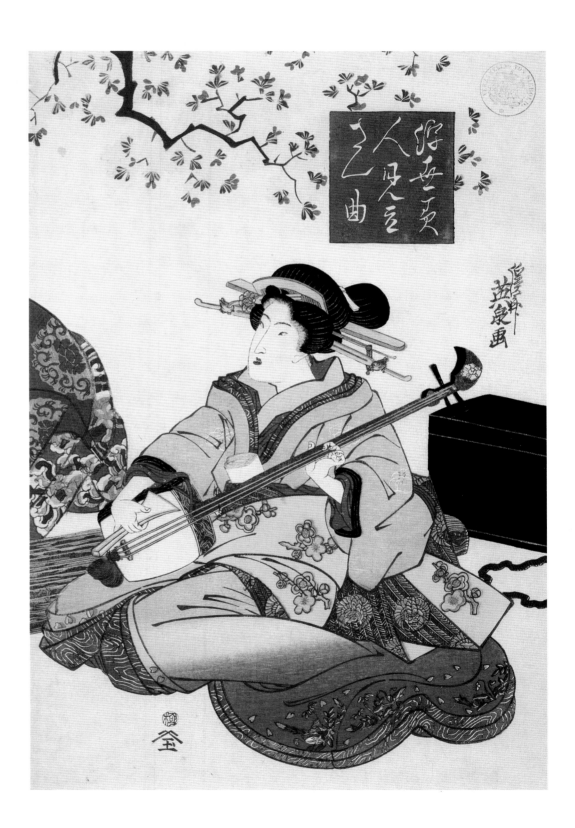

130. Utagawa Kunisada (1786-1865)
'Morning glory' *(Asagao)* from the series
Modern views of summer (Tōsei natsu keshiki),
c. 1826
Signed *Gototei Kunisada ga* with *Toshidama* seal
Woodblock, *ōban*, 382 x 259
Published by Matsumuraya Tatsuemon

Rijksmuseum voor Volkenkunde, Leiden 1-4469-45

A geisha interrupts her *shamisen* playing to
read over the text of her next song. An inset
top right illustrates a potted morning glory
(asagao); this flower is also the title of the
print. This series of five prints was designed
as a sequel to an earlier, successful series
devoted to spring views.

131. Keisai Eisen (1791-1848)

'Cheerful type - Sumida river' *(Omishirosō - Sumidagawa)* from the series *Twelve views of beautiful women of today (Imayō bijin jūnikei)*, c. 1825-26

Signed *Keisai Eisen ga* with seal *Sen* (Eisen's seal)

Kiwame censorship seal

Published by Izumiya Ichibei

Woodblock, *ōban*, 371 x 251

Rijksmuseum voor Volkenkunde, Leiden l-4468-23

The young geisha here represents the 'cheerful' type. Each print in the series depicts a specific type of women. Only ten sheets from this series of twelve prints are known. She has interrupted her *shamisen* playing, her plectrum tucked into her *obi*, to play a game of hand movements called *jankenpon* ('scissors, paper and stone'). A popular variant of this game among geisha was one in which the loser had to remove a piece of clothing. The scroll at the top illustrates a view of a covered boat on the Sumidagawa. Steps leading to the Mimeguri shrine, where two boats are moored, are visible on the distance bank.

With the publication of this series Eisen continues a tradition already begun by Kitagawa Utamaro (1753-1806) in the late 18th century. During the same period Utagawa Kunisada (1786-1865) would venture the production of an even larger set of thirty-two prints of this type.

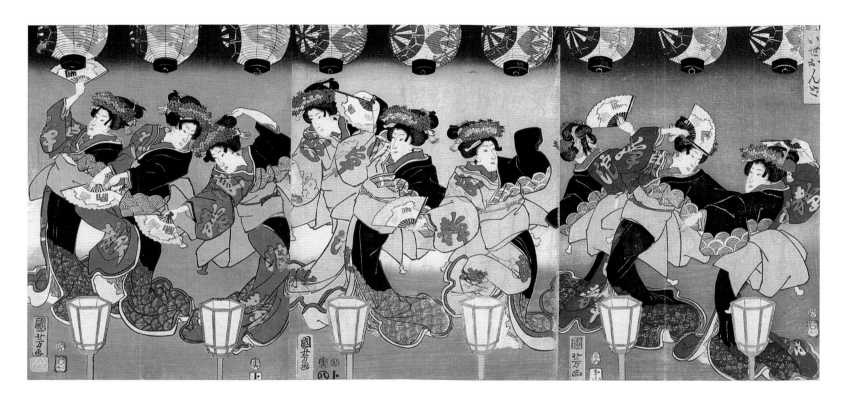

132. Utagawa Kuniyoshi (1797-1861)
'Ise dance' *(Ise ondo)*, VI/1854
Signed *Kuniyoshi ga* with *kiri* seal
Aratame censorship seal and date seal corresponding to
Year of the Tiger 6 (VI/1854)
Published jointly by Yamaguchiya Tōbei and Mikawaya
Kihei
Woodblock, *ōban* triptych, 349 x 735
Gemeentemuseum Den Haag PRM-0000-2448

A party of nine women are performing the Ise dance
(Ise odori or *Ise ondo)*, a style of dancing that originated
in the Ise area but whose popularity soon spread
throughout the country.

133. Hosoda Eishi (1756-1829)

Signed *Eishi ga*

Published by Izumiya Ichibei (no seal on print), c. 1790-92

Woodblock, *ōban* (one sheet from a pentaptych), 356 x 245

Gemeentemuseum Den Haag PRM-0000-2443

A view of a party on a pleasure boat on the Sumidagawa near Ryōgokubashi with people enjoying the evening cool. Two men are seated on the roof of a boat; one smokes a pipe. A group of geisha entertains the guests on the boat with music on the *shamisen* and small drums *(kotsuzumi)*. Spending summer evenings this way was popular, especially after the opening of the river that was celebrated annually with fireworks (see also cat. nos. 64/65).

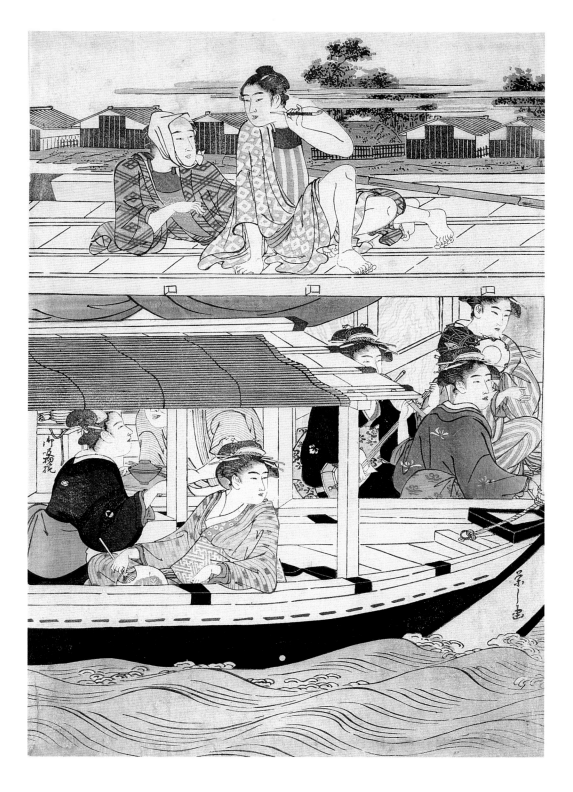

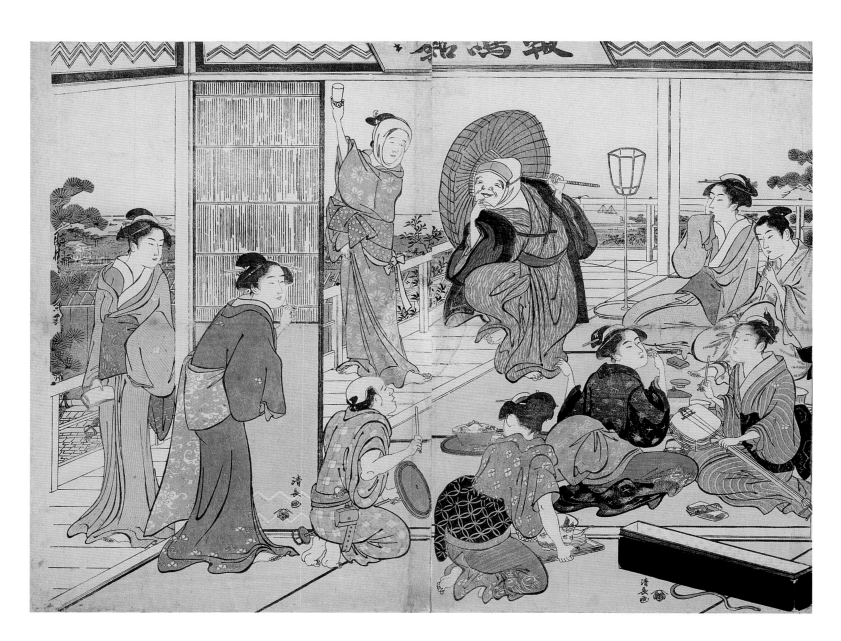

134. Torii Kiyonaga (1752-1815)

Signed *Kiyonaga ga*

Published by Tsutaya Jūsaburō, c. 1790

Woodblock, *ōban* diptych (centre and left-hand sheets of a triptych), 385 x 246/262 (each)

Rijksmuseum, Amsterdam 1956:834

A scene at the Komeikan teahouse in Susaki by the Sumidagawa. A party is in full swing: a masked dancer performs whilst holding an umbrella and his partner, dressed as a courtesan with a scarf around her face, stands to the left. A woman to the right beats time with a stick on her *shamisen* and a man in the foreground does the same against a candlestick. The male visitor to the right does not seem particularly interested in the celebrations, and in the left foreground some teahouse servants look on from behind bamboo blinds. The name of the teahouse appears on the plague hanging over the door.

135. Torii Kiyonaga (1752-1815)

Signed *Kiyonaga ga*

Published anonymously, c. 1780

Woodblock, *hashira-e*, 706 x 121

Rijksmuseum, Amsterdam 1956:688

A street-performer passes one of the brothels in the Yoshiwara, its inhabitants watching him in amazement from behind barred windows. He balances two swords on a pole whilst playing the flute *(yokobue)*. This performer is apparently one of a troupe of performers going about Edo around New Year's. Such performances were known as *daikagura*.

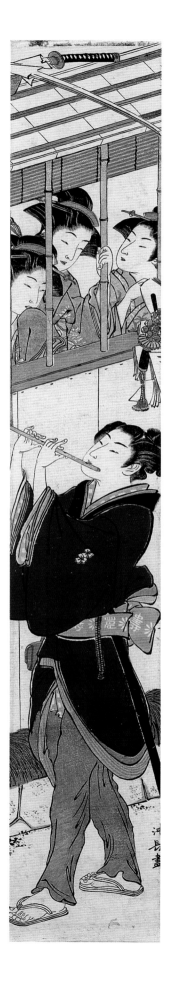

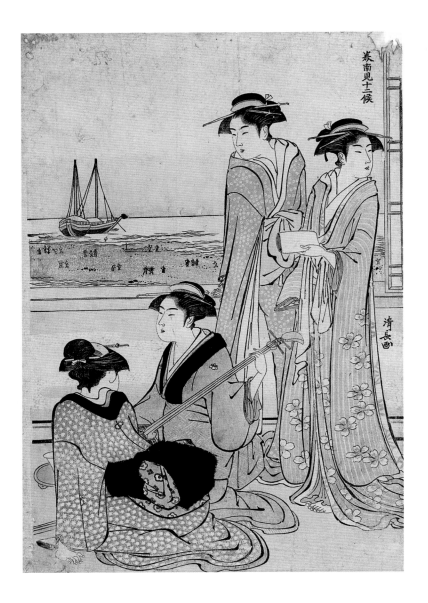

136. Torii Kiyonaga (1752-1815)

From the series *Twelve views of the southern districts in all seasons* (*Minami jūnikō*), c. 1784

Signed *Kiyonaga ga*

Published anonymously

Woodblock, *ōban* (right-hand sheet of a diptych), 386 x 264

Rijksmuseum voor Volkenkunde, Leiden 2602-281

A party at one of the restaurants by Shinagawa bay, located to the south of the city of Edo. A geisha plays the *shamisen* whilst two courtesans stand to the right. People are seen gathering shellfish on a beach in the distance. This composition is the right-hand sheet of a diptych illustrating the fourth month. The left-hand sheet illustrates a young man being entertained, a maidservant offering him some sake as he interrupts his meal to smoke a pipe.

137. Utagawa Toyokuni (1769-1825)

Signed *Toyokuni ga*

Kiwame censorship seal

Published by Izumiya Ichibei, c. 1790-92

Woodblock, *ōban* (right-hand sheet of a triptych), 392 x 256

Rijksmuseum voor Volkenkunde, Leiden 1353-1230

An evening party at one of the water-side restaurants offering a broad view of Shinagawa bay. A geisha is tuning her *shamisen* whilst another rests her arms upon a lacquered *shamisen* case. A woman standing to the right addresses the first geisha. A portrait of one of the popular actors of the day, probably from the Ōtani family of actors, is portrayed on a fan in the foreground.

138. Keisai Eisen (1791-1848)

From the series *Forty-eight bad habits of the floating world - part two (Ukiyo shijūhachi kuse - nihen)*, c. 1826

Signed *Keisai Eisen ga*

Kiwame censorship seal

Published by Ōtaya Sakichi

Woodblock, *ōban*, 385 x 265

Rijksmuseum voor Volkenkunde, Leiden 360-2349

A geisha makes her way to a party, a manservant is behind her with a *shamisen* case wrapped in a cloth wrapper *(furoshiki)* over his shoulders. The inset top left shows Mount Fuji behind a castle, possibly at Odawara on the Tōkaidō, the main highway linking the cities of Edo and Kyoto. An inscription top right refers to the bad habit illustrated in this print; this series of prints is a sequel to that in catalogue number 146.

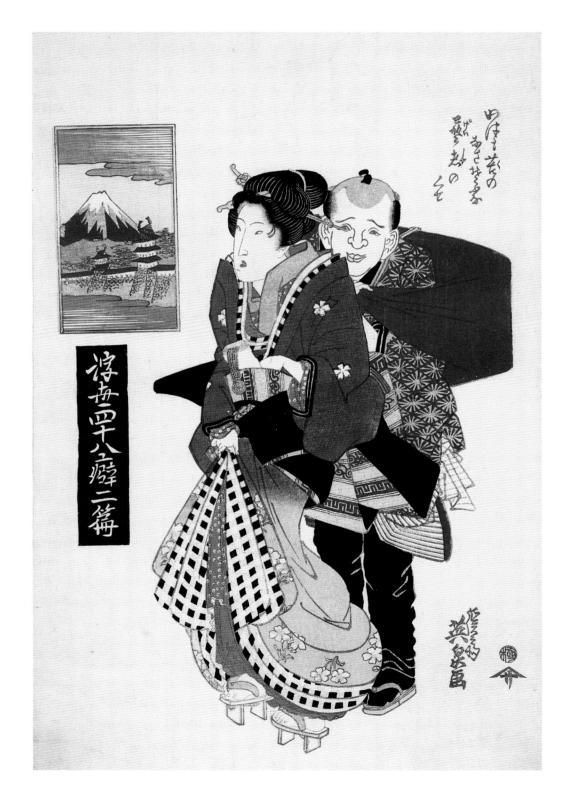

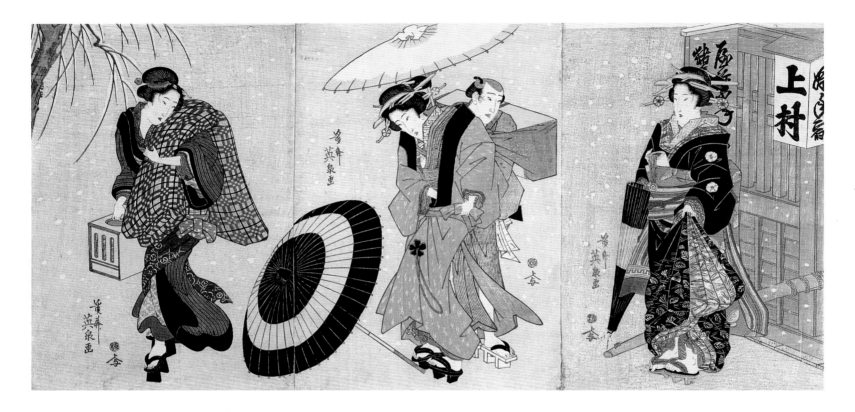

139. Keisai Eisen (1791-1848)

Signed *Keisai Eisen ga*

Kiwame censorship seal

Published by Uemura Yohei, c. 1822

Woodblock, *ōban* triptych, 379/380 x 259/264 (each)

Rijksmuseum voor Volkenkunde, Leiden 360-2347e-f; 2348c-1

A geisha makes her way to a party during a snowstorm; she stops as her maidservant drops her umbrella. Behind her a manservant holds an umbrella over her head and carries her *shamisen* case wrapped in a cloth wrapper *(furoshiki)* over his shoulders. To the right another geisha waits outside a house named Uemura, possibly a reference to the publisher.

140. Kikugawa Eizan (1787-1867)

From a series *A series of elegant beauties (Fūryū bijinzoroi)*, c. 1826

Signed *Eizan hitsu*

Kiwame censorship seal

Published by Nishimuraya Yohachi

Woodblock, *ōban*, 390 x 264

Rijksmuseum voor Volkenkunde, Leiden 360-2348a

A geisha and her maidservant are holding an umbrella as they walk through a snowstorm. The maidservant is carrying the case containing the geisha's *shamisen*.

Two designs are known from this series, one of a moon scene and this print of snow, which suggests that the series is based on the theme of snow, moon and flowers *(setsugekka)*.

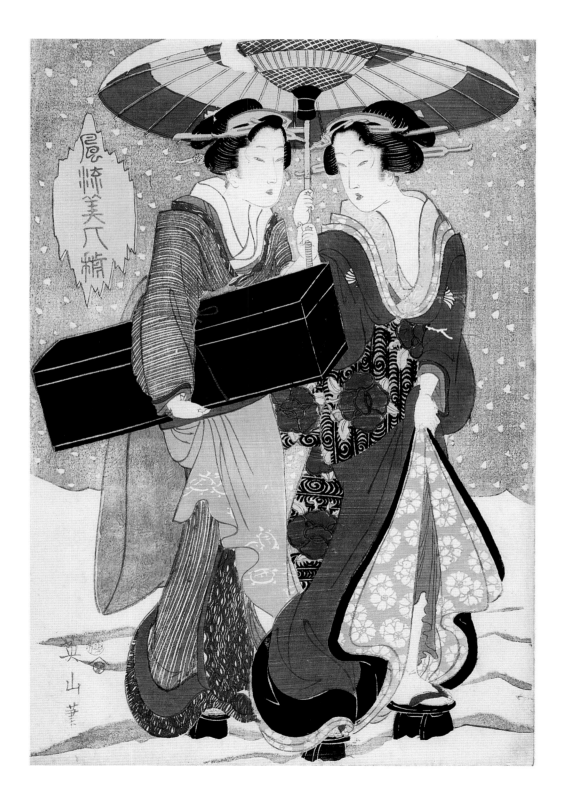

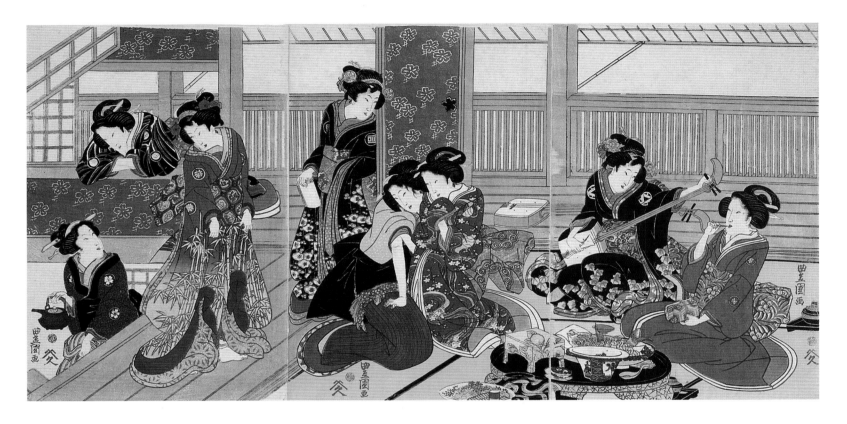

141. Utagawa Toyokuni (1769-1825)

Signed *Toyokuni ga*

Kiwame censorship seal

Published by Yamamoto Kyūbei, c. 1822

Woodblock, *ōban* triptych, 388/394 x 261/264 (each)

Rijksmuseum voor Volkenkunde, Leiden 360-2351-Z, 2353-G, U

The interior of a house. A group of women are gathered around a table on which an extensive meal has been served; a woman to the right plays the *shamisen*.

142. Keisai Eisen (1791-1848)

'Evening breeze at Tsukudajima' *(Tsuku no oki no yūkaze)* from the series *Eight fan views of prostitutes pledging to meet (Augi hakkei),* c. 1826

Signed *Keisai Eisen ga*

Kiwame censorship seal

Published by Kawaguchiya Uhei

Woodblock, *ōban*, 376 x 258

Rijksmuseum voor Volkenkunde, Leiden 1-4470-21

A geisha climbs the stairs to the first storey of a brothel carrying a *shamisen* in a lacquered case. Saucers on a lacquered table with extensive mother-of-pearl inlay appear in the foreground. An inset within an opened fan top left features a view of the 'Evening breeze at Tsukudajima', the title of this print. It also contains a reference to one of the traditional 'Eight views' *(Hakkei)*, a common theme in Japanese art.

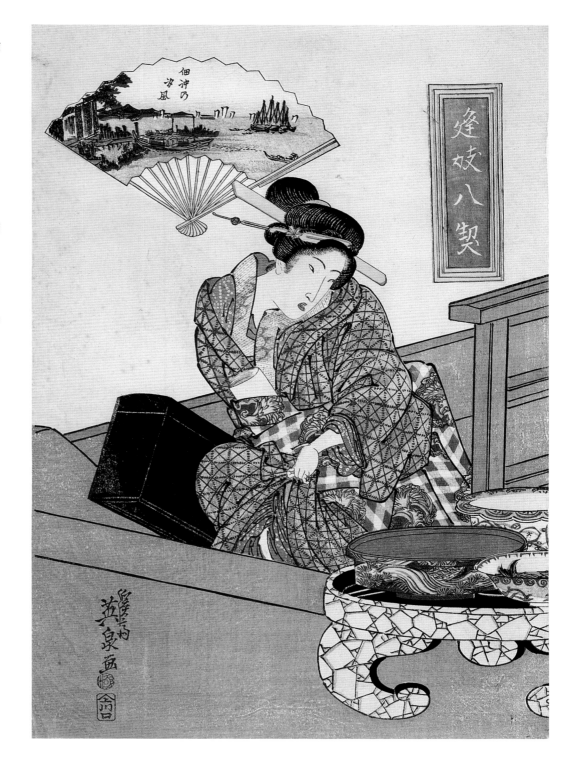

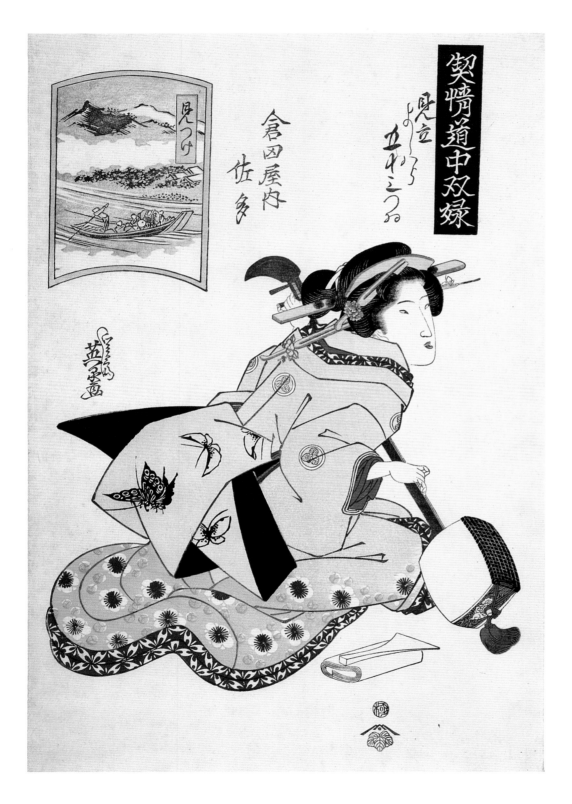

143. Keisai Eisen (1791-1848)
From the series *Courtesans as a board game along the road - the Yoshiwara as the fifty-three stations (Keisei dōchū sugoroku - Mitate Yoshiwara gojūsantsui)*, c. 1825-26
Signed *Keisai Eisen ga*
Kiwame censorship seal
Published by Tsutaya Kichizō
Woodblock, *ōban*, 376 x 256

Rijksmuseum voor Volkenkunde, Leiden 1-4470-6

The courtesan Sata of the Kuradaya brothel in the Yoshiwara tunes her *shamisen*. She is wearing a delicate, simple kimono with an *obi* displaying butterflies in dark blue against a light blue ground. An inset above features a landscape at Mitsuke, one of the stations of the Tōkaidō, the main highway connecting the cities of Edo and Kyoto.

144. Keisai Eisen (1791-1848)

From the series *Courtesans as a board game along the road - the Yoshiwara as the fifty-three stations (Keisei dōchū sugoroku - Mitate Yoshiwara gojūsantsui)*, c. 1825-26
Signed *Keisai Eisen ga*
Kiwame censorship seal
Published by Tsutaya Kichizō
Woodblock, *ōban*, 377 x 256

Rijksmuseum voor Volkenkunde, Leiden 1-4469-250

The courtesan Kaoyo of the Tamaya brothel in the Yoshiwara, dressed in a kimono patterned with morning glories, prepares to tie her *obi*. She is standing by a folding screen, a *shamisen* behind her on the floor and its unlacquered *keyaki* wood case to the right before the screen. An inset above features a landscape at Kanbara, one of the stations of the Tōkaidō, the main highway connecting the cities of Edo and Kyoto.

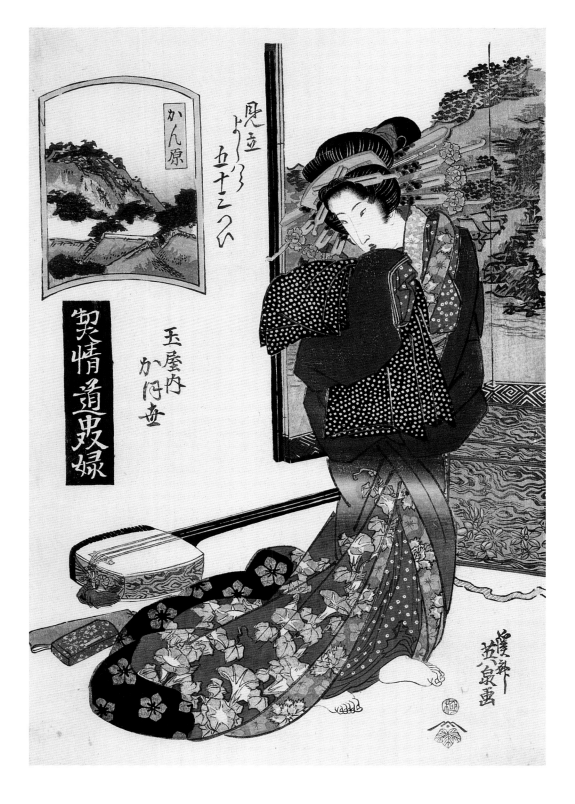

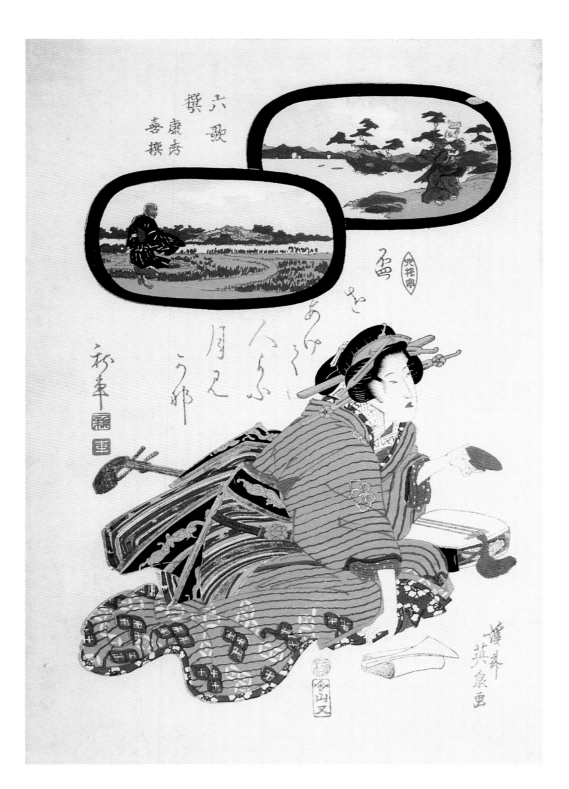

145. Keisai Eisen (1791-1848)

From the series *The six classical poets
(Rokkasen)*, c. 1822
Signed *Keisai Eisen ga*
Kiwame censorship seal
Publisher unidentified
Woodblock, *ōban*, 386 x 267

Rijksmuseum voor Volkenkunde, Leiden 360-2350-V

In this print from a series of three, a geisha
dressed in a green striped kimono interrupts
her *shamisen* playing to ask for a cup of sake.
She has laid her instrument at her side, the
ivory plectrum on a roll of tissue paper. The
insets above feature two of the six classical
poets *(rokkasen)*, Bunya no Yasuhide (right)
and Kisen Hōshi (left), in a landscape with
clouds influenced by western stylistic
convention.

A haiku poem appears above:

The drunkard
lifts his sake cup
what a marvellous moon.

Sakazuki o
agete hito you
tsukimi kana.

146. Keisai Eisen (1791-1848)

From the series *Forty-eight bad habits of the
floating world (Ukiyo shijūhachi kuse)*, c. 1825
Signed *Keisai Eisen ga*
Kiwame censorship seal
Published by Ōtaya Sakichi
Woodblock, *ōban*, 379 x 252

Rijksmuseum voor Volkenkunde, Leiden 1-4470-28

A geisha sits on a low chest with sliding
doors that are decorated with a view of
Mount Fuji as seen from Sagami bay. She
looks up whilst playing the *shamisen*. An
inscription top right refers to the bad habit
illustrated here: 'pulling the plectrum when
the melody comes is as bad as revenging
oneself'.

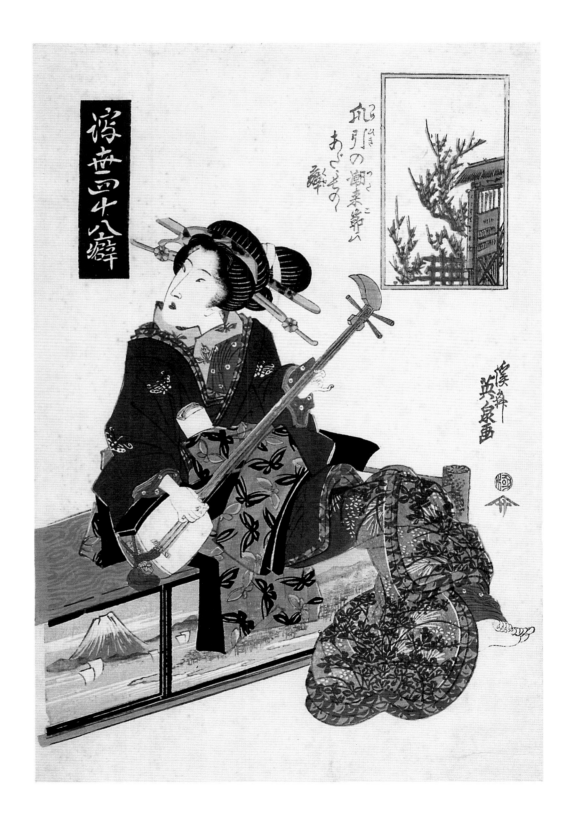

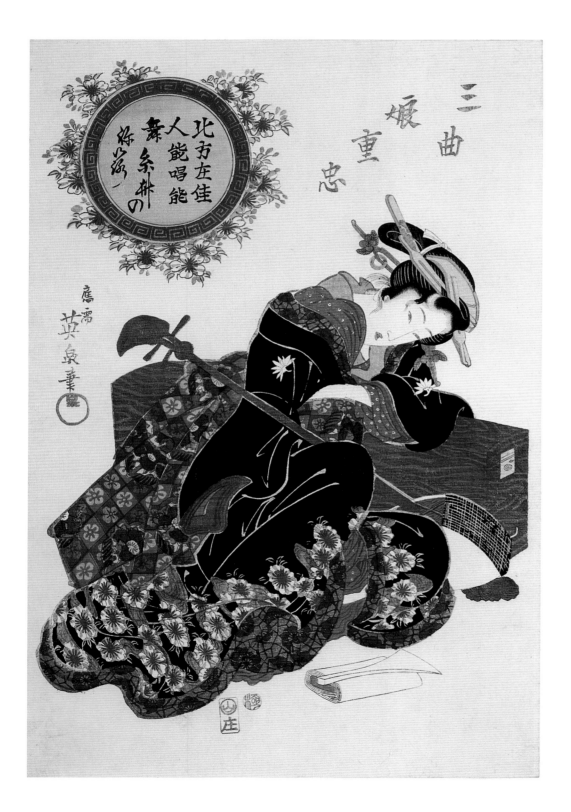

147. Keisai Eisen (1791-1848)

From the series *Young girls making an orchestra*
(*Sankyoku musume shigetada*), c. 1825
Signed *motome ni ōjite Eisen ga* with seal *Sen*
(Eisen's seal)
Kiwame censorship seal
Published by Yamadaya Shōjirō
Woodblock, *ōban*, 388 x 261

A geisha, perhaps tired of singing and
making music, or just a little drunk, leans
upon the wooden case of her *shamisen*. The
instrument rests on her legs. A text in the
circular inset appears above.

148. Kikugawa Eizan (1787-1867)

'Moon' *(Tsuki)* from the series *Fashionable scenes of snow, moon and flowers (Fūryū setsugekka)*, c. 1826

Signed *Kiku Eizan hitsu*

Kiwame censorship seal

Published anonymously

Woodblock, *ōban*, 384 x 258

Rijksmuseum voor Volkenkunde, Leiden 1-4469-G

A geisha, dressed in a delicate purple kimono lined with green fabric, leans upon her *shamisen* whilst adjusting her hair. The black-lacquered instrument case is behind her on the floor. The cartouche top left consists of two open fans, one showing the moon shining over plants, the other inscribed with the print's title. This work is most likely a reprint of an earlier edition issued in the early 1820s.

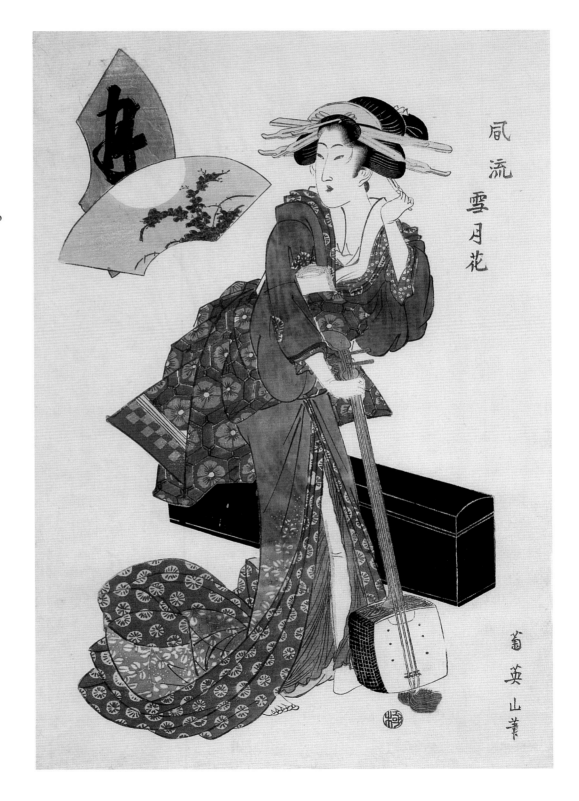

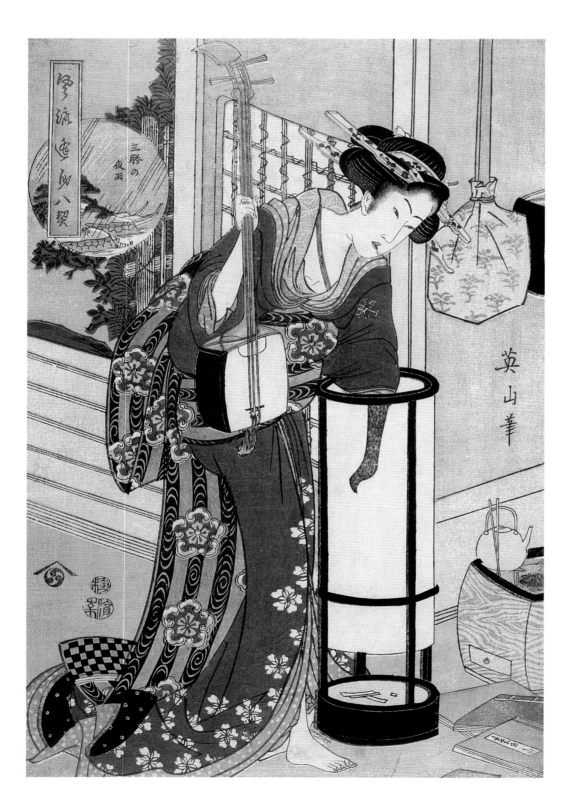

149. Kikugawa Eizan (1787-1867)
From the series *Eight views of elegant meetings*
(*Fūryū Ōmi hakkei*), c. 1811
Signed *Eizan hitsu*
Kiwame censorship seal and censor's seal of
Hamamatsuya Kōsuke
Published by Nishimuraya Yohachi
Woodblock, *ōban*, 370 x 253

Gemeentemuseum Den Haag PRM-0000-2412

Apparently after the last guest has left, a
geisha, a toothpick in her mouth,
extinguishes a standing lamp. She holds a
shamisen in her right hand. Two more
instruments, partly wrapped in silk cloth, are
hanging from the wall. Some songbooks are
scattered on the floor by the brazier. The
circular cartouche top left has a small
landscape entitled 'Evening rain at Mikatsu'
(*Mikatsu no yoru no ame*).

150. Kikugawa Eizan (1787-1867)

From the series *Eight views at Tomigaoka: a series of elegant beauties (Tomigaoka hakkei - Bijin fūzoku awase)*, c. 1826

Signed *Kikugawa Eizan hitsu*

Kiwame censorship seal

Publisher unidentified

Woodblock, *ōban*, 380 x 259

Rijksmuseum voor Volkenkunde, Leiden 1-4470-85

A geisha takes a *shamisen* out of its lacquered case, turning her head as if someone addresses her from behind. The inset top right shows an open book with an illustration of 'Clearing weather at the Sanjūsangendō, a temple in the Tomigaoka district of Edo' (*Sanjūsangendō no seiran* [written as *Nijūsangendō*]). In an earlier impression of the print, probably dating from the late 1810s, the geisha is wearing a striped kimono.

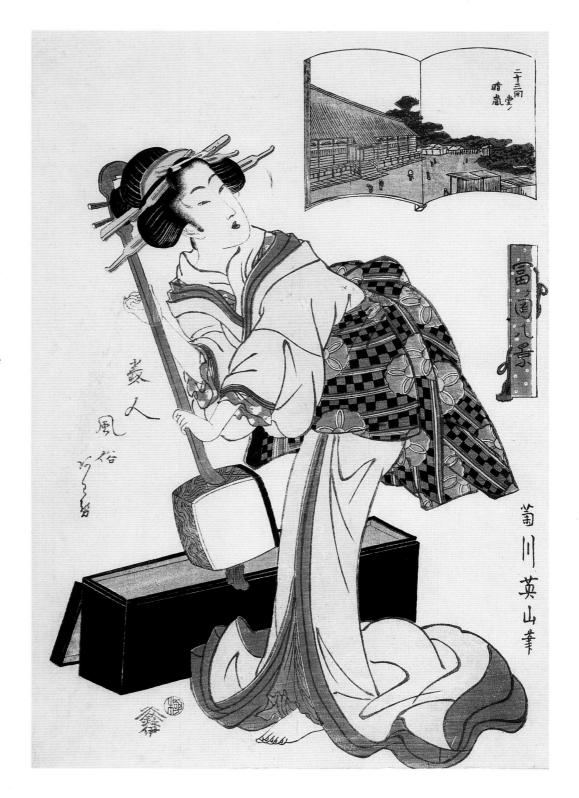

Indexes

Musical instruments

Numbers in italic refer to the numbers of the 'catalogue - instruments', those in roman type refer to page numbers, and thoses in bold type to the numbers of the 'catalogue - prints'.

Names

This index contains the names of artists, publishers and engravers; as well as the names of actors, courtesans and historical persons depicted on the prints. Numbers refer to the numbers of the 'catalogue - prints'.